The
ANATOMY
of
ANTIQUES

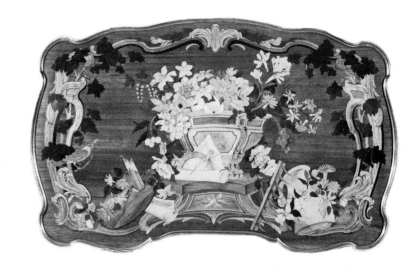

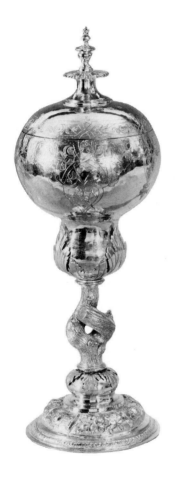

The ANATOMY

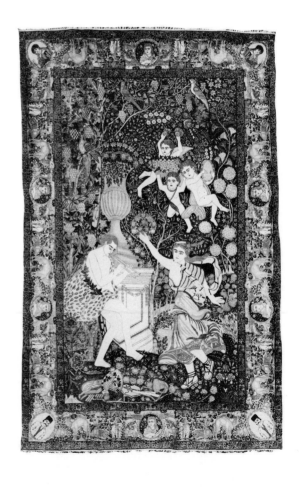

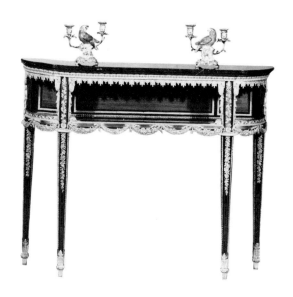

A Collector's Guide

of ANTIQUES

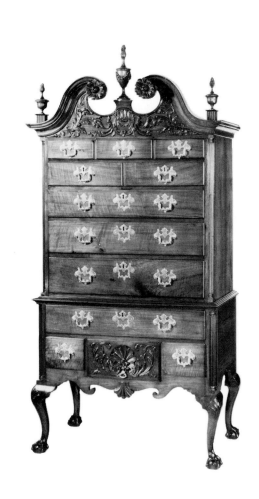

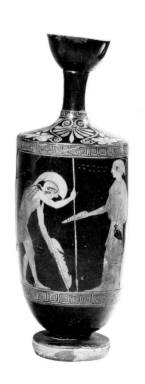

Austin P. Kelley

and the Staff of
Sotheby Parke Bernet

NELSON

Thomas Nelson and Sons Ltd
36 Park Street London W1Y 4DE

PO Box 18123 Nairobi Kenya

Thomas Nelson (Australia) Ltd
597 Little Collins Street Melbourne
Victoria 3000 Australia

Thomas Nelson and Sons (Canada) Ltd
81 Curlew Drive Don Mills Ontario

Thomas Nelson (Nigeria) Ltd
PO Box 336 Apapa Lagos

© Austin P. Kelley and Sotheby Parke Bernet, 1974
First published in the USA
First published in Great Britain
by Thomas Nelson and Sons Ltd in 1974
ISBN 0 17 149032 0
Printed in the USA

FOREWORD

The decorative arts—furniture, silver, porcelain, glass, textiles, and similar basically utilitarian objects—were never meant to be enshrined in museums or galleries; they were intended for use and enjoyment.

The Anatomy of Antiques attempts to remove the velvet ropes and glass cases that have come to surround this spectrum of collectibles, and to present the whole field of decorative arts in proper perspective. In doing so, some one hundred treasures, typically encountered in antique shops, museums, auction rooms, and the homes of collectors, have been singled out and presented photographically on these pages with pertinent notes that describe not only each piece as a whole, but specifically each part that makes up the whole. Thus, one quickly and easily learns of their origin—why, how, when, and by whom they were made—their merits, aesthetic and functional, and the various terms for their component parts. While turning the pages of the book, the reader can identify familiar pieces and quickly learn of less familiar ones, as well as the techniques and terms that have hitherto baffled him and have perhaps caused him to view art and antiques as something for the specialist only.

It is hoped that this volume will help to close the gap between art in function and art in form, and, at the same time, be considered a valuable reference book, a compendium of facts and artifacts to be referred to time and again.

ACKNOWLEDGMENTS

While assistance in preparing this volume has sprung from a great many sources, very special thanks must be expressed to Edward Lee Cave and Thomas E. Norton, senior officers of Sotheby Parke Bernet. Not only have they played key roles in developing and shaping *The Anatomy of Antiques*; they have helped to draft significant portions of its contents. A like vote of appreciation must go to Jerrell L. May, my friend and business associate of many years, who has taken an enormous interest in this project and has played a vital role in its completion.

Gratitude is also expressed to a number of the specialists at Sotheby Parke Bernet, without whose knowledge and assistance this book would lack a great deal, if, indeed, it could have been completed at all. They include Robert Woolley, head of the Decorative Arts Section; Armin B. Allen, of the Porcelain Department; Kirk A. Igler, of the European Furniture Department; Joseph Kuntz, of the European Works of Art Department; Ronald de Silva, of the American Furniture Department; Jean Randolph, of the Russian Works of Art Department; Pam Maker and Kevin Tierney, of the Silver Department; and Richard Keresey, of the Antiquities Department. Special thanks are also extended to Barbara Evans, who helped to assemble and coordinate the copy and photographic elements used in the book.

Three other principals of Sotheby Parke Bernet should be thanked for their inspiration, their support, and their many expressions of confidence. They are Mary Vandegrift, until her recent retirement Executive Vice-President of The Galleries; Peregrine Pollen, former President of Sotheby Parke Bernet, now with Sotheby's in London; and John Marion, President since 1971 and Head Auctioneer of Sotheby Parke Bernet.

CONTENTS

SILVER, SHEFFIELD PLATE, AND PEWTER

CERAMICS AND GLASS 73

FURNITURE 109

TEXTILES, TAPESTRIES, AND RUGS

The
ANATOMY
of
ANTIQUES

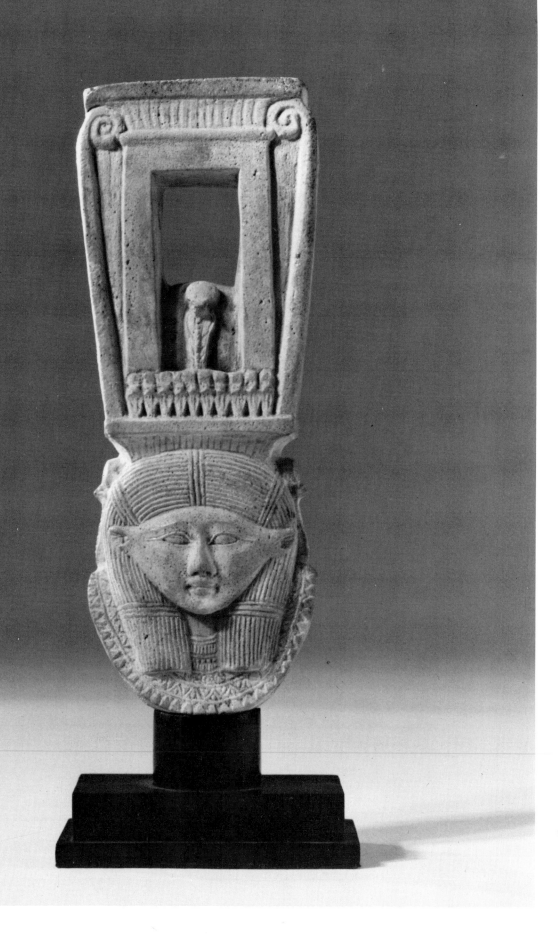

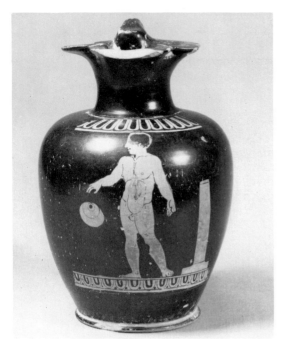

Fig. 2

Greek painted pottery attained its highest artistic level during the sixth and fifth centuries B. C. During this period the production of the black- and the red-figure vessels at Athens raised pottery from a utilitarian craft to an art form in its own right.

The black-figure technique, first practiced at Corinth and typified by bold, vigorous designs influenced by the Orient, was refined by the Athenians. In classic Athenian vases more attention was paid to the human figure, depicted in scenes combining both gravity and charm, as in the vase illustrating Medea and the Daughters of Pelias (Fig. 1).

The red-figure technique developed in the fourth quarter of the sixth century permitted a more naturalistic approach. During the early classical period, when the *lekythos* on the opposite page was made, red-figure painting reflected a mood of serene grandeur.

In the second half of the fifth century the quality of Greek vase painting declined, partly because the other arts, notably sculpture and architecture, claimed much of the best talent. The heroic element, which gave a mythic character to even the most mundane subjects, suffered most of all. It is absent in the figure of a youth with aryballus on the small pitcher (Fig. 2), which nevertheless has a naïve simplicity more appealing than some of its increasingly florid contemporaries.

In the fourth century, dominance in the field passed from Athens to the Greek colonies in the south of Italy, where a flamboyant decadence, not without merits of its own, prevailed. Some of the best fourth-century vases were decorated with humorous scenes, even burlesquing the gods and heroes; for example, the Hairy Ogress pursuing a traveler (Fig. 3). The golden age of Greek painted pottery ended on this ironic note, but the shapes and proportions developed by the Greeks survived as classic standards for all later European pottery.

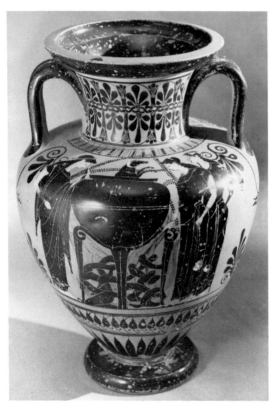

Fig. 1

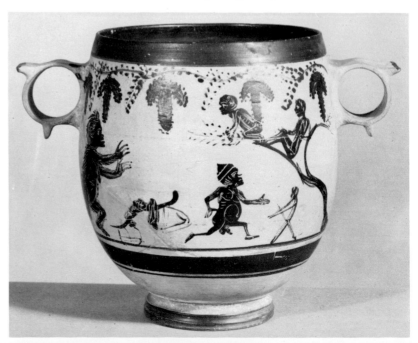

Fig. 3

THE CROWN—The Egyptian king wore several crowns. This one is called the *Khepresh* or, more popularly, the Blue Crown. It was indeed blue, and ornamented with small circles. The cobra, or uraeus, almost always appears on the forehead of the king.

TECHNIQUE—The figure is carved in relief on a tablet of fine white limestone, but the visible chisel marks show that it was never finished.

STYLE—The relief is carved in the sensuous and fairly realistic manner of the Ptolemaic period (305–30 B.C.). Especially characteristic are the sinuous curves of the fingers and the hint of a double chin.

THE GRID—A pattern of regular squares, fixed by a master sculptor, helped the craftsman to achieve the then conventional proportions for the human body. The presence of a grid does not imply that such reliefs were made as models, as was once thought. They were an end in themselves and served as votive offerings.

SUBJECT—A kneeling king, probably Ptolemy II or III, offering the gods a statuette of Ma'at, daughter of the sun-god, Re, and personification of Truth and Justice. After Egypt's conquest by Alexander the Great, Ptolemy I was appointed governor. At the dissolution of Alexander's empire, Ptolemy declared himself king and founded the dynasty of which Cleopatra was the last ruler.

THE TAIL—A ceremonial animal's tail, perhaps that of a bull, was sometimes worn by a king in imitation of the gods, among whom he too was numbered.

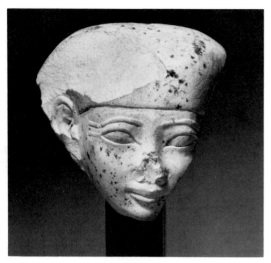

Fig. 1

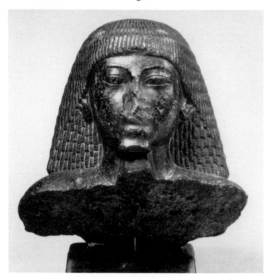

Fig. 2

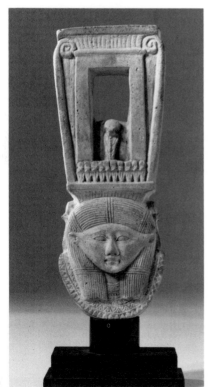

Fig. 3

When the relief illustrated opposite was carved, the civilization of ancient Egypt was in its twilight. Almost three thousand years had passed since a pharaoh first occupied the throne of a united Egypt. No art had so long a history or remained so loyal to conventions established in its infancy. The Egyptian was deeply conservative, a result both of his country's relative isolation from contemporary civilizations in the Near East and the enormous influence on his life of the river Nile, rising each year to fertilize the land. He found order and continuity in nature and regarded his environment as fundamentally friendly. This attitude is reflected in every aspect of Egyptian art, giving its works their characteristic tranquillity and reserve.

The objects shown here all originated in periods of political stability, when the power of the king was firmly established. Then the arts flourished. Strength of form and elegance of line were combined in works in every medium.

The limestone and granite heads (Figs. 1 and 2) belong to the eighteenth dynasty (1554–1305 B.C.), when Egypt was the greatest power in the world. The limestone head was made in or near the reign of Queen Hatshepsut (1503–1482 B.C.) when grace, appropriately feminine, was introduced into the sculptural style. The proud granite head represents a nobleman who lived during the reign of Amenhotep III (1403–1365 B.C.). During the rule of that monarch, the elaborate wig was fashionable, and the slanting eyes reflect the manner in which the king was depicted.

The other pieces are from the twenty-sixth dynasty (664–525 B.C.), an era of revival which followed years of political and cultural disintegration. Although art of this period relied on the inspirations of earlier ages, a certain vitality is found in many of its smaller objects.

The faience sistrum, a symbolic musical rattle used in the worship of gods (Fig. 3), is of particularly fine workmanship and manifests a trend toward the softer and more sensuous style apparent in the votive relief.

The lion sculpture (Fig. 4) was probably the model for a chair leg. Though small in size, it is monumental in feeling and shows how the finest characteristics of a style can be found in even the humblest objects.

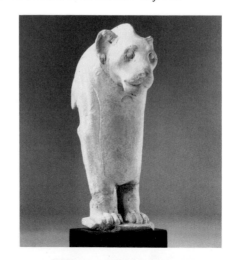

Fig. 4

ANTIQUITIES

The field covered by the word "Antiquities" (as distinct from the even broader term "Antiques") spans several thousand years and includes art and artifacts of all those ancient civilizations that are considered to be the precursors of and major contributors to Western European civilization.

Those objects that have survived are intensely studied, collected and revered, due largely to the powerful influence these ancient civilizations have continued to exert.

The ancient Romans were probably the first "collectors," and during the Renaissance in Europe it was only natural for noblemen to emulate them by collecting antiquities, often to the detriment of the temples and graves the sculptures ornamented. Indeed, the demand for antiquities was so great in Florence during the fifteenth century that Michelangelo's first sale was of a statue he had cleverly made to look like a Roman antique and with which he fooled an unsophisticated buyer.

The most ancient objects—the fetishes and tools of primitive societies—are generally of very specialized interest. With the rise of stable communities, such as that of Egypt toward the end of the fourth millennium B.C., even utilitarian objects began to be infused with a feeling for proportion, grace, and ornamentation that remains aesthetically appealing to us today. In fact, to eyes conditioned by the art of the past fifty years, the simplified, abstract quality of much ancient art is perhaps more satisfying than it was to previous generations, which tended to see most of it as "primitive."

Commonplace materials, such as stone and clay, and primal needs, such as eating, hunting, worshiping, and burying the dead, account for the creation of most ancient art. The honesty and strength of these antiquities manage to come through in even the humblest objects. The greatest works of antiquity are in the major museums, and present-day laws in the countries of the Middle East and the Mediterranean make the acquisition of new finds a very remote possibility.

Nevertheless, there is an abundant quantity of objects, large and small, that have survived and are still in private hands. Aspiring collectors can, with study, patience, and comparatively modest sums of money, follow in the footsteps of the first "collectors" and own a fragment of antiquity.

15

SHAPE—This form of pottery vase, a container for perfumes and toilet oils, is known as a *lekythos*. Like most Greek pottery, this vessel was made for everyday use, although *lekythoi* with a white background were made only for funerary use.

TECHNIQUE—The technique employed here is called "red-figure," a reversal of the earlier black-figure style. The subject is left in the color of the clay, and the background painted black. Details are drawn freely with pen or brush in shades of black and occasionally other colors.

ORNAMENT—The majority of painted vases of this period were simply glazed black, or ornamented with such purely formal motifs as the palmettes encircling the shoulder of this vessel.

SUBJECT—In the fifth century B.C. scenes from daily life, as well as those from myth, were commonly portrayed. Here a warrior who is leaving home bows before a woman (his wife or mother) who offers a libation. On his shield appears the head of a bull, the blazon of his regiment. This vase dates to about 460 B.C.

PAINTER—The vase is attributed to the "Alkimachos Painter." It is among the great majority of surviving pieces that are not signed and therefore are assigned to a particular painter on the basis of style. If the painting in question cannot be identified with a signed vase, then a generic name is given to the anonymous artist. The "Berlin Painter," for example, is so called because of an important vase by the same hand now in Berlin.

19

GREEK SCULPTURE

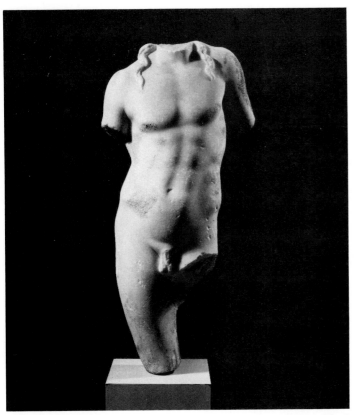

Fig. 1

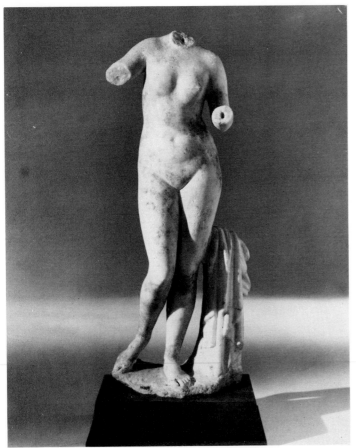

Fig. 2

Greek sculpture from the classical period is exceedingly rare. Our knowledge of it is due in great measure to the Romans, who made numerous copies of the works they most admired. The problem is that while Roman craftsmanship was often superb, their artistry very seldom captured the inner life that marks an original work. The figures of Apollo and Aphrodite (Figs. 1 and 2) appear to be Roman copies of lost works by Praxiteles, the greatest sculptor of the late classical period. Both capture the graceful outlines and sensuous modulations of surface that were the chief attributes of his style. The deeper beauty of the originals can only be imagined by looking at the famous group of Hermes with the Infant Dionysus, generally thought to be by Praxiteles' own hand.

The rarity of original Greek sculpture has given the Greek grave monuments a particular importance. The stela opposite and the fragment illustrated (Fig. 3) are among the few which survive carved with scenes from life. In terms of workmanship they do not equal the sculptures in Figs. 1 and 2. Their importance derives from the fact that they are original works and thereby seem to attain a level of art that goes beyond physical grace alone. The beauty here is inner, marked by a tender pathos that was the most profound attribute of Greek sculpture in this period.

Fig. 3

FORM—The more important gravestones of the Greek classical period take an architectural form. In this stela (Attic, c. 360–350 B.C.) pilasters support the side edge of a temple roof. Over the edge are five antefixes, which covered the ends of the roof tiles.

INSCRIPTION — Greek stelae of all periods were inscribed with the name of the deceased, whether or not he was represented. This gravestone is among a small group inscribed with an epitaph concerning the deceased: "Farewell, Philokydis, daughter of Aristokles and Timagora. Eukleia is longing for you, whom you left to her grandparents."

MATERIAL—This close-grained and milky-white colored marble is known as Pentelic, after the site on Mount Pentelicus where it was quarried. Athens developed the quarries there in the early fifth century B.C.

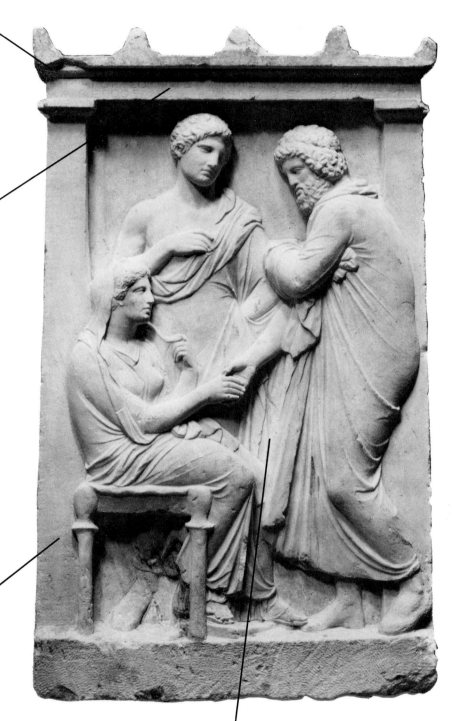

COMPOSITION—The scene depicts the deceased, a woman of middle age, seated before a youth and an older man. However, neither the mother nor the daughter of Philokydis, mentioned in the epitaph, is represented. This lack of clear relation between epitaph and figured scene is often the case in grave monuments of the fourth century. Presumably they were frequently made in advance of commissions. It seems that the sculptor's intention in this stela was to show the older man as the deceased, with his wife and son bidding him farewell.

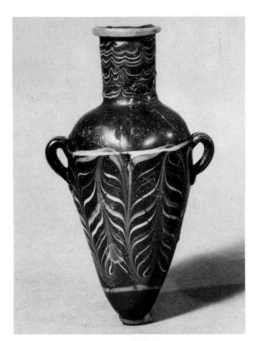

Fig. 1

The earliest glass vessels known date from the eighteenth dynasty in Egypt, c. 1559–1319 B.C., and were distinguished by fine workmanship and splendid colors. Due in great measure to the laborious technique of manufacture, glass was precious, and it was made to contain equally precious unguents and perfumes. Very simply, the technique consisted of molding molten glass over a shaped sand core, which was scraped away once the vessel had solidified. Threads of glass in decorative colors could be pressed into the matrix while both were still molten. Obviously, this method did not permit large production, and glass was considered a great luxury.

Not until fourteen centuries later, when glass blowing was invented, could objects in glass be produced quickly and in quantity. Roman period vessels were shaped in a mold, which could be used again, while others were free-blown. Both of these techniques remain basic in glassmaking today.

The simple form and harmonious proportions of early Roman glass (Fig. 1) were inspired by the shape of contemporary pottery and bronze vessels which they in part replaced as objects of everyday use. By the end of the fourth century A.D. the freedom permitted by the new technique was fully realized (Fig. 2).

Most Roman glass known to us comes from the eastern provinces of the Empire, especially Palestine, Syria, and Egypt. When the Empire collapsed in the West, glass production there virtually died out. In the East glass continued to be manufactured into the Byzantine and Islamic periods (Fig. 3). Forms became increasingly fanciful, often with a profusion of applied decoration (Fig. 4). When trade was established between the Moslem East and medieval Venice, the glass industry began to prosper in Italy and eventually spread to other European centers.

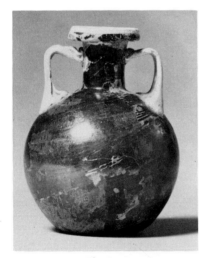

Fig. 2

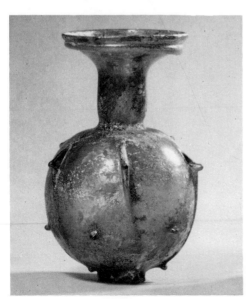

Fig. 3

Fig. 4

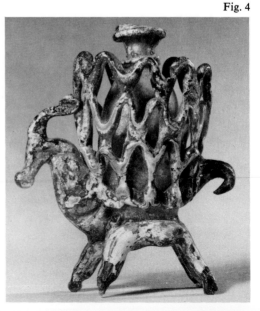

COLOR—The vessel is iridescent, the result of the chemical reaction from the earth during the centuries the piece was buried. The glass itself is a warm amber color.

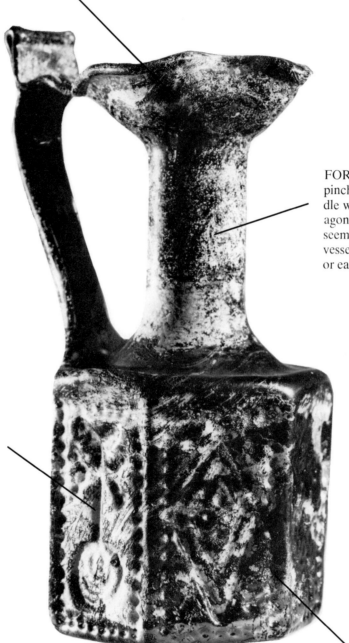

FORM—The vessel has a pinched mouth, hollow handle with thumb rest, and hexagonal body, a shape that seems to occur only in ritual vessels of this period (sixth or early seventh century A.D.).

DECORATION—Like modern glass, most ancient glass was mainly functional and relied for its effect on form and color. Symbolic ornament was especially rare. The six sides of this pitcher are impressed with Christian symbols—three types of crosses (one of which seems to represent the commemorative cross standing on Golgotha until 614), alternating with three lozenge motifs, which may represent bindings of the Scriptures. Vessels of precisely the same form were also made with Jewish symbols, and both types were made in the same factory, probably at Jerusalem. These were sold to pilgrims and served as containers of holy oils from sacred places in and near that city.

TECHNIQUE—The hexagonal body was blown into a piece mold, and the rim reinforced by folding it inward, a common method in ancient glass. The handle was made from a hollow tube of glass and is therefore both sturdy and lightweight.

23

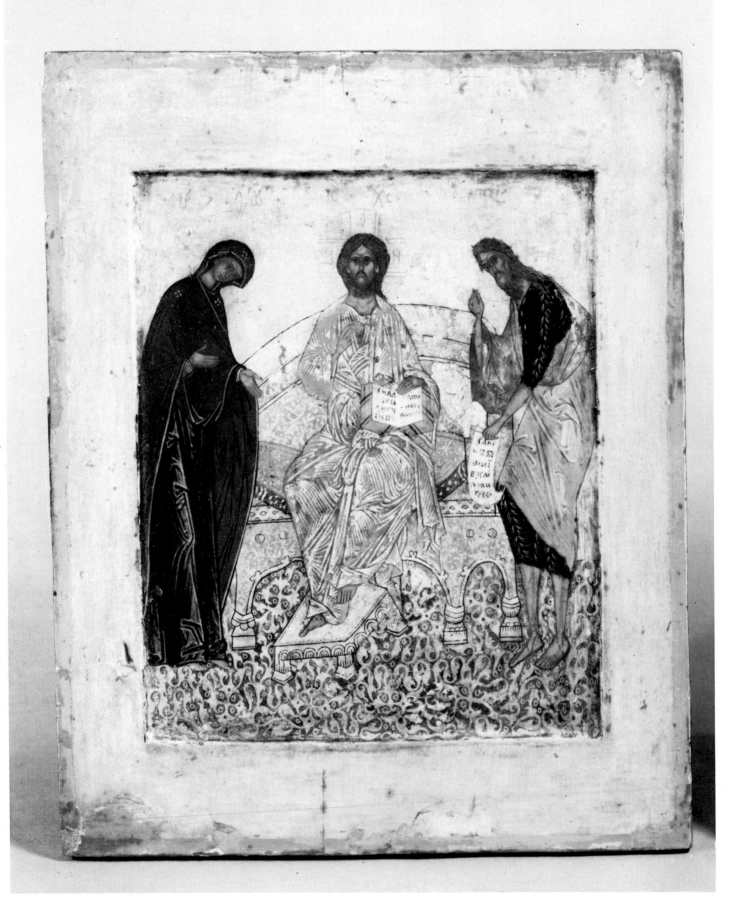

WORKS OF ART

The term "works of art," as it is used here, covers sculpture and metalwork from the early Middle Ages up to the nineteenth century. Paintings, mosaics, and monumental works, however, are considerd in a separate category.

During the Dark Ages, the period following the barbarian invasions of Europe, art, at least as the handmaiden of the Church, became a commonplace phenomenon in Europe. With the growth of personal wealth, private devotional objects were created which vied in beauty, if not in size, with sculptures and paintings produced or commissioned by the Church. Wealthy merchants and noblemen were also interested in acquiring decorative objects of a secular nature.

The influence of humanism in the Renaissance era and the growth of commercial prosperity brought with them an increased output, much of which was man-centered, inspired by classical art rather than intended exclusively for spiritual edification.

Since the mid-nineteenth century many of these objects have become increasingly popular with collectors because they are representative of the period when European civilization again began to flourish. Developments in theology, philosophy, education, government, and science are all reflected in the changing styles of works of art.

So long taken for granted, their numbers diminished by neglect, the ravages of war, and the extremes of religious and political controversy, the objects included in this category of collecting are still—even in fragmented form—intensely studied and passionately sought through dealers and by the auction rooms.

Fig. 1

IVORY CARVINGS

The form of early Christian carvings was borrowed from the consular diptychs, or two-leaved plaques, of ancient Rome, which were presented as awards at annual festivals. The subject matter of these highly stylized bas-reliefs changed, however, an image of Christ or of one of the saints replacing the figure of a Roman official.

The ivory relief of Saint Gangulf illustrated in Fig. 1 is believed to be of Spanish or Rhenish origin and to have been carved in the eleventh century.

During the period of high Gothic art many devotional plaques were created in ivory. A standard iconography of scenes of the life of Christ enhanced by elegant Gothic architectural details was produced in Paris. The diptychs were originally brightly colored, but in most existing examples, such as that in Fig. 2, the paint has disappeared.

Ivory carving became more exuberant during the Renaissance and Baroque periods. Mythological themes were particularly appealing to carvers, especially Francis van Bossuit, whose ivory relief of Hermes, Argus, and Io, as a heifer, is illustrated in Fig. 3, and whose ivory relief of Apollo and Marsyas is shown opposite. During the baroque period plaques were often set into pieces of furniture or were surrounded by elaborate jeweled frames.

In the nineteenth century more sophisticated carving tools were available, and increased trade with Africa resulted in an abundant supply of ivory. As a result, numerous ivories were produced, especially in Dieppe, and often in eclectic styles. The Dieppe carving in Fig. 4 is a mythological scene depicting Hector and Andromache with their son, Astyanax, before the gates of Troy.

Fig. 2

Fig. 4

Fig. 3

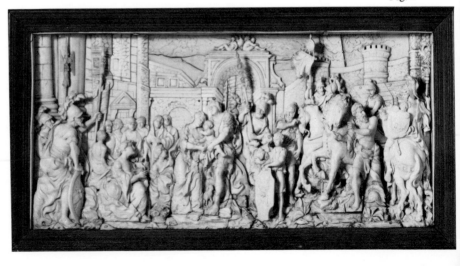

SUBJECT—The Flaying of Marsyas is a subject typical of the recurring interest in mythological themes, which sometimes focused on the strange or grotesque—in this instance, the tale of the Phrygian lute player who challenged Apollo to a contest of skill and was flayed alive for his presumption.

SHAPE—Deeply carved and possibly made to be set into an elaborate cupboard or chest with other decorative elements, this example is typical of many rectangular reliefs.

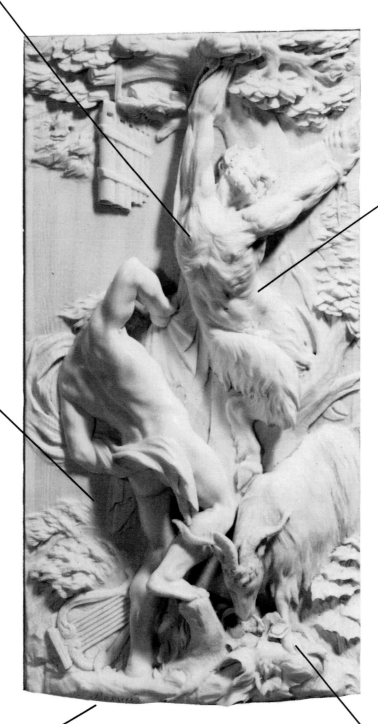

STYLE—Full of baroque exuberance, the carving displays tremendous skill in creating an illusion of depth within the limitations of space—a depth less than three-quarters of an inch.

SIGNATURE—*F. Bossuit*, for the sculptor Francis van Bossuit (Brussels 1635–1692 Amsterdam). It is rare to find signed ivories. Most carvers remain anonymous.

MATERIAL—Ivory has been used extensively in the art of Western Europe since the early Christian era; it reflects the active trade carried on with the more distant outposts of the Roman Empire, especially Africa. A smooth grain and soft creamy-white coloring distinguish ivory from the coarser-textured bone, also used for small carvings.

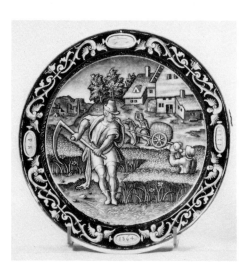

Fig. 1

LIMOGES ENAMELS

Enamel decoration reappeared in the Romanesque period, dating approximately from the eleventh century to the thirteenth. At that time gilded bronze or copper religious articles, such as architectural reliquaries, bird-form ciboria, and small crucifixes, were decorated with *champlevé*, a technique by which colored enamels were poured into gouged-out crevices of a stylized pattern, as in the religious book cover in Fig. 1.

In the thirteenth century the Limoges ateliers, or workshops, declined, and in 1371 they were destroyed by Edward, the Black Prince, son of Edward III of England. A revival of Limoges enamel occurred in the second half of the fifteenth century, when secular objects were produced by a new technique which permitted the entire surface to be painted in enamel. The demands for the work increased, and in the next century many new workshops were founded at Limoges. Notable among these was the atelier of Pierre Reymond. A number of his pieces are initialled "P.R.," and some also bear a date.

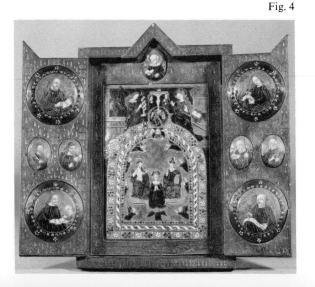

Fig. 2

Fig. 4

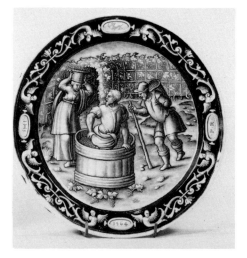

Fig. 3

The Reymond plates shown in Figs. 2 and 3, representing the months of July and September, presumably part of a set of twelve, were painted *en grisaille,* the shades of gray and white heightened with gilt and flesh tones. These plates are dated 1564.

The revival of interest in Gothic and Renaissance styles in the nineteenth century resulted in a great demand for Limoges enamels. Authentic early examples were scarce, and new pieces were produced in a variety of shapes and subjects. Many of these were facsimiles of famous enamels, others were pastiches based on Gothic or Renaissance types. They are often extremely decorative and their workmanship technically excellent (Fig. 4).

MARK—"IC" for Jean de Court and his workshop. De Court was one of the most famous of the Limoges enamelists. Many of his signed pieces are in museums throughout Europe and America.

SUBJECT—The central female figure is inscribed *"Gramatique,"* symbolizing Grammar, one of the seven liberal arts in the Renaissance definition of higher learning.

TECHNIQUE—In enameling, a copper or bronze surface is decorated with vitreous paints (ground glass and pigments) and fired until they achieve a hard lustrous finish fused onto the metal.

DECORATION—The use of reflecting foils on a dark ground beneath the translucent enamel gives a particularly glowing, transparent effect. The decorative elements relating to the allegory are adapted from designs by Luca Penni engraved by Nicolas Beatrizet in 1556.

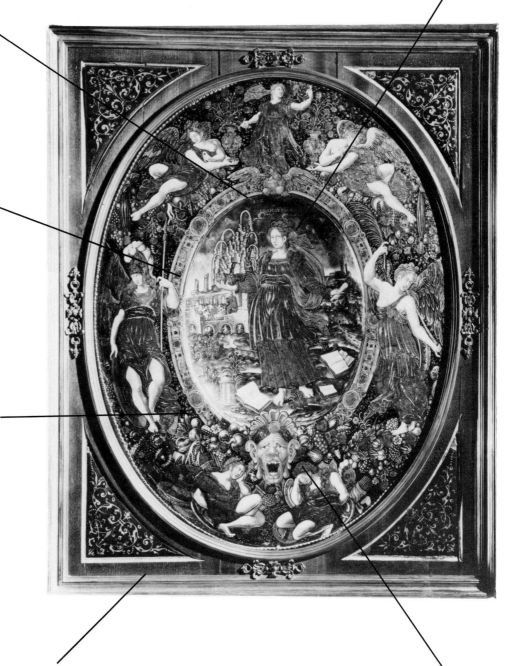

LIMOGES—The French city of Limoges has been a center for the manufacture of enamel since the Romanesque period. Much later it became associated with the production of porcelain dinner services.

STYLE—Many Limoges designs and motifs were influenced by the School of Fountainebleau. The grotesque mask and the winged figures surrounding the central medallion typify Renaissance decorative themes introduced into France by Italian artists during the sixteenth century.

NORTHERN EUROPEAN WOOD CARVINGS

Some of the most admired wood carvings are the polychromed sculptures produced in northern Europe, particularly in Germany and the Low Countries, during the fifteenth and sixteenth centuries. Despite the ravages of war, many fine and large groups, with their original paint surface intact, are to be found in cathedrals and museums. Figures still appear on the market, but usually these are relatively small. Examples that retain their original brilliant coloring are extremely rare.

Numerous regional schools existed during that productive period, and the names of some of the artists are recorded. Perhaps the best known is the Franconian sculptor Tilman Riemenschneider (c. 1460–1531). A piece by another well-known carver, Daniel Mauch, is shown in Fig. 1, and a smaller example, a figure of Saint Barbara (whose maker is unidentified), is seen in Fig. 2.

The particular charm of wood sculpture of this kind is the extremely sensitive and appealing expression on the faces. It is especially apparent in the Virgin and Child groups (Fig. 3), which are also notable for their lavishly painted and gilded drapery. These figures are splendid examples of the culmination of Gothic tradition in the north, when it was as yet little affected by the revival of classicism, already dominant in Italy by 1500.

Fig. 1

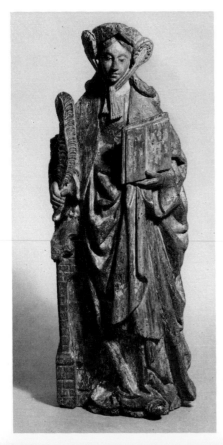

Fig. 2

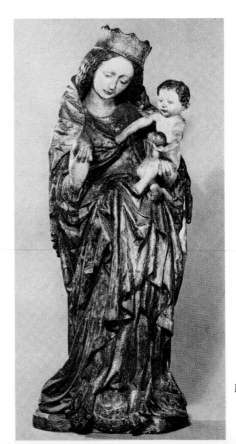

Fig. 3

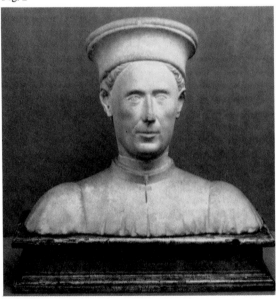

Fig. 1

TITUS·ANNIUS·MILO

MARBLE PORTRAIT
SCULPTURE

The tradition of marble portraiture dates back to the Roman Republic (first century B.C.), when the idealized characteristics of Greek sculpture were replaced by ultrarealistic portrayals of military and political leaders (Fig. 1).

During the classical revival of the fifteenth century, Donatello, Verrocchio, and other sculptors executed busts and monuments of the leading figures of the era in marble as well as in terra cotta and bronze. Marble remained the favorite medium, however, recalling, as it did, the traditions of antiquity. The life-size bust of a man wearing a biretta and a tunic (Fig. 2) is a good example of this.

Styles changed from the humanist conceptions of the early Renaissance, to the more formal and grandiose tendencies of the sixteenth century and the baroque period

Fig. 2

Fig. 3

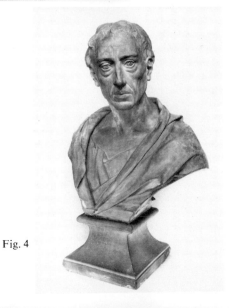

Fig. 4

(as exemplified by the bust of Cosimo III de Medici in Fig. 3, attributed to Giovanni Battista Foggini), to the naturalism of the eighteenth century, and then to the stiff dignity so admired in the neoclassical era of the early nineteenth century.

Perhaps England's major contribution to the art of sculpture is to be found in the eighteenth and early nineteenth centuries, a period when portrait busts linked the late baroque to the neoclassical style. One of the finest and most sensitive works is the portrait of Alexander Pope (Fig. 4), made c. 1738 by Louis François Roubiliac, a French Huguenot who had settled in England and attracted the notice of Prime Minister Walpole and other notables.

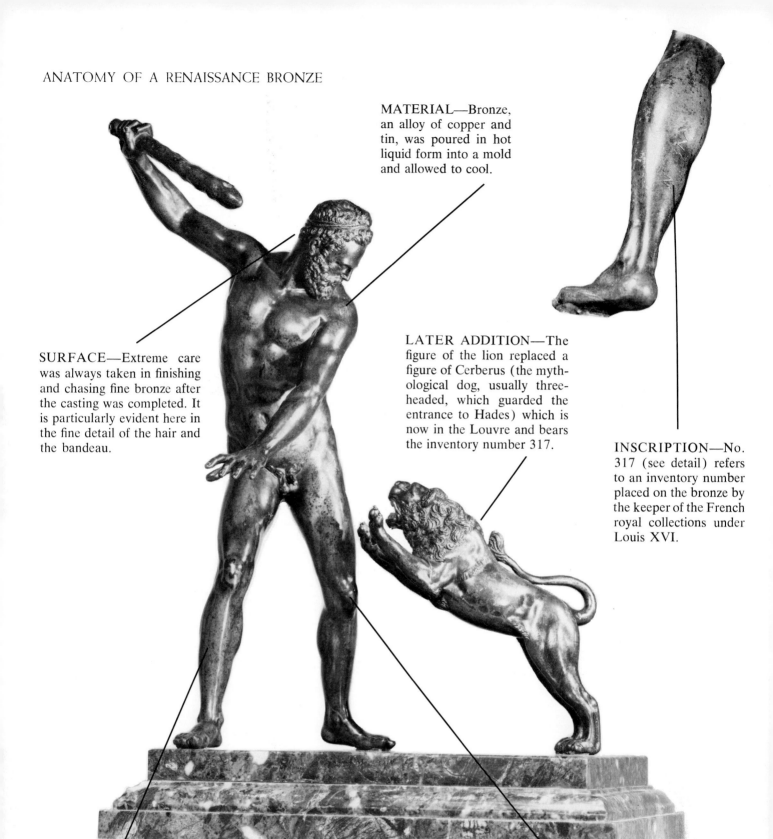

MATERIAL—Bronze, an alloy of copper and tin, was poured in hot liquid form into a mold and allowed to cool.

SURFACE—Extreme care was always taken in finishing and chasing fine bronze after the casting was completed. It is particularly evident here in the fine detail of the hair and the bandeau.

LATER ADDITION—The figure of the lion replaced a figure of Cerberus (the mythological dog, usually three-headed, which guarded the entrance to Hades) which is now in the Louvre and bears the inventory number 317.

INSCRIPTION—No. 317 (see detail) refers to an inventory number placed on the bronze by the keeper of the French royal collections under Louis XVI.

STYLE—Known as *serpentinata*, this style is characteristic of the work of Giovanni da Bologna. Bologna revived the classical tradition of sculpture; the subject was effective when viewed from any angle.

COLOR—Renaissance bronzes were chemically treated to produce rich variegated patinas in imitation of the incrusted surfaces of excavated ancient bronzes. This example has a golden-brown patina. The deep tones contrast with the lighter areas that centuries of rubbing and polishing have produced.

BRONZE SCULPTURE

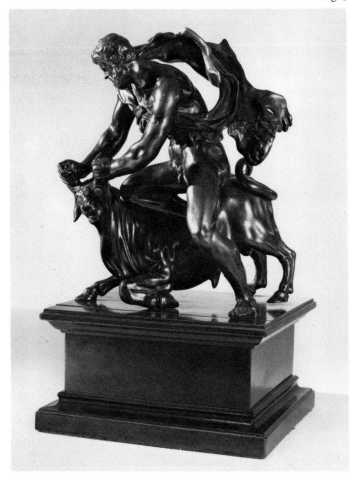

Fig. 1

Bronze casting was practiced in ancient Greece and has continued until the present day. In earlier centuries the human figure, represented in the image of a god or a hero, was the usual choice of subject matter, and of these Hercules might be said to be the single most popular "profane" subject to be found in Western bronzes.

The Herculean images created by the Flemish sculptor Giovanni da Bologna (1529?–1608) are particularly fine examples. The marriage of the mannerist style of the later sixteenth century with the superb craftsmanship of Bologna's workshop produced objects of lasting appeal.

Other examples of Bologna-inspired Hercules groups appear in art galleries and the auction room from time to time. A fine workshop cast of "Hercules and the Bull" from the Cranbrook Academy collection (Fig. 1) was presented in 1907 by the great scholar, Wilhelm von Bode, in his standard reference *Italian Bronze Statuettes of the Renaissance*. Bologna's models continued to be cast for more than three centuries. The later castings, although less valuable than those made during the sculptor's lifetime, are attractive and, of course, available (Figs. 2 and 3).

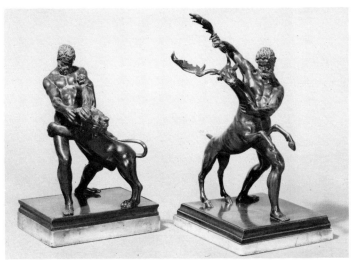

Fig. 2 Fig. 3

Fig. 4

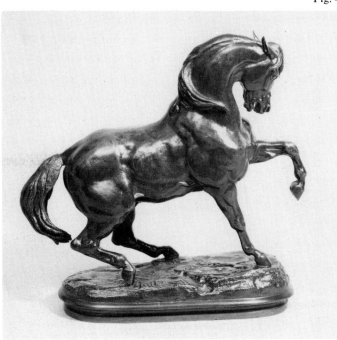

While it is still possible to find good Renaissance bronzes, many collectors are attracted to the bronzes of other periods. In the nineteenth century Antoine Louis Barye (1795–1875), often considered the last great *bronzier* in the Renaissance tradition, established the popularity of the animal bronzes for which he is so well known (Fig. 4). Extremely fine autograph works are to be found occasionally, but more common are commercially produced models, usually cast by the Barbedienne foundry of Paris and bearing the stamp of the *fondeur* in addition to the incised name of the artist.

ICONOGRAPHY—The standing Virgin, wearing a crown as Queen of Heaven, supports the Child, who raises His right arm in blessing and holds an orb symbolizing the world He has redeemed.

SUBJECT—The theme of the Virgin and Child occurs constantly in German wood sculpture, as do the popular images of saints.

DECORATION—Extensive traces of the original bright paint remain over the gesso (plaster coating) and fabric ground. Every effort was made to satisfy the popular demand for realism and brilliant coloring in these images.

MATERIAL—Wood, especially oak, limewood, and boxwood, was used widely in Northern Europe. It is often helpful in the attribution of a work to determine the type of wood used. In southern Europe pine, which deteriorates more quickly than other woods, was usually employed.

STYLE—The carving combines realism and mannerism, the former exemplified by the expressive hands and faces, and the latter by the exaggerated angular fold of the drapery, which reveals little of the human form beneath.

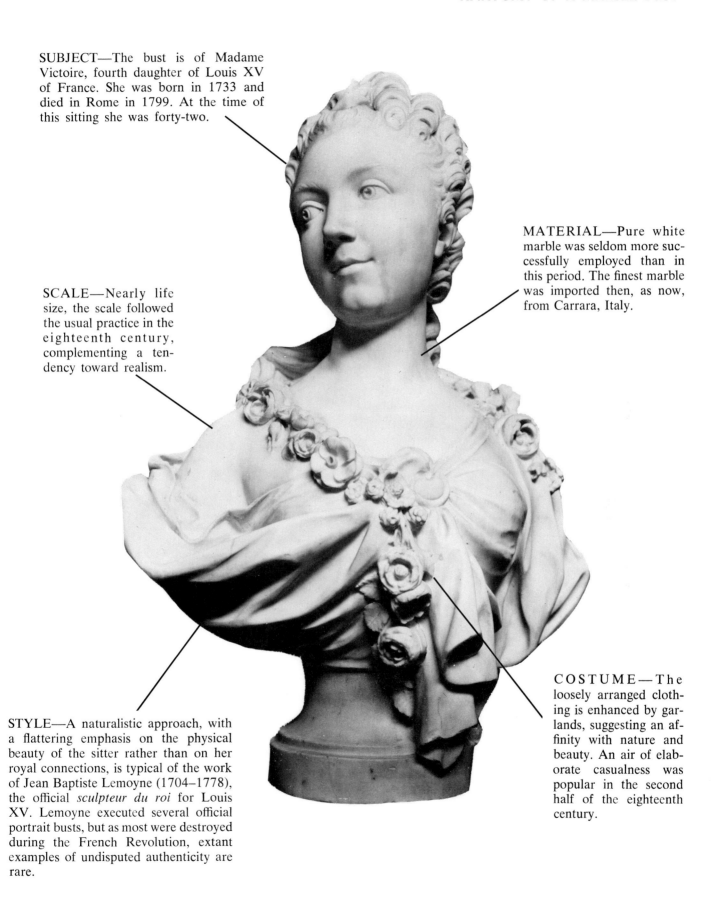

SUBJECT—The bust is of Madame Victoire, fourth daughter of Louis XV of France. She was born in 1733 and died in Rome in 1799. At the time of this sitting she was forty-two.

MATERIAL—Pure white marble was seldom more successfully employed than in this period. The finest marble was imported then, as now, from Carrara, Italy.

SCALE—Nearly life size, the scale followed the usual practice in the eighteenth century, complementing a tendency toward realism.

COSTUME—The loosely arranged clothing is enhanced by garlands, suggesting an affinity with nature and beauty. An air of elaborate casualness was popular in the second half of the eighteenth century.

STYLE—A naturalistic approach, with a flattering emphasis on the physical beauty of the sitter rather than on her royal connections, is typical of the work of Jean Baptiste Lemoyne (1704–1778), the official *sculpteur du roi* for Louis XV. Lemoyne executed several official portrait busts, but as most were destroyed during the French Revolution, extant examples of undisputed authenticity are rare.

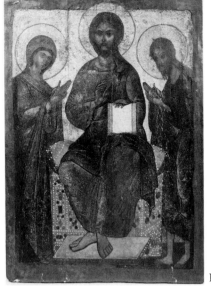

Fig. 1

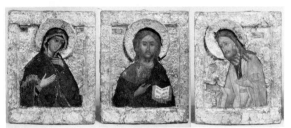

Fig. 2

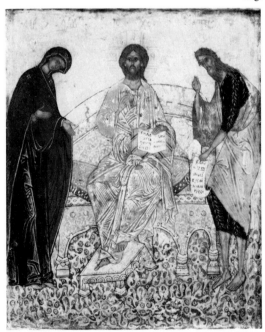

Fig. 3

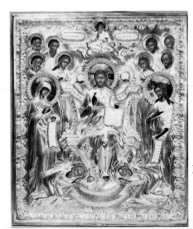

Fig. 4

RUSSIAN ICONS

Christianity and icon painting came to Russia by way of Byzantium in the late tenth century. In Russia both the religion and the icon took on the national and artistic characteristics of the country.

Since the purpose of the icon, or religious image, is the depiction of spiritual experience and the enhancement of worship, the content of the painting is of utmost importance. Therefore, in accordance with the medium's functional role, each icon painter was bound to adhere to the form established by the earliest representation of a particular icon. External influences are subordinated to the central subject, but time, place, and artist affect such things as the amount of detail, the color scheme, and the inclusion of incidental characters. Although no two icons are exactly alike, the basic composition of the Orthodox icon remains the same.

The examples illustrated here date from the fifteenth through the nineteenth centuries and are all of the Deisis (Christ flanked by the Virgin and John the Baptist). However, the treatment varies in each case.

The icon in Fig. 1 retains much of the feeling and monumentality of Byzantium. In Fig. 2 the Deisis is in the form of three separate icons, the painting is somewhat less stern, and each icon is fitted with a gilded-silver *okhlad*. Although the icon in Fig. 3 displays the characteristic composition of the Deisis, the setting and Christ's throne are more elaborate, typifying the style of the seventeenth century. Fig. 4 shows a traveling iconostasis, in which the Deisis in its extended form is incorporated as the lower register or *tchin*.

On the opposite page the icon of the Last Judgment shows how the Deisis has been used in conjunction with other themes. Fig. 5 shows the Deisis extended; i.e. Christ, the Virgin, and John the Baptist are accompanied by the Archangels Michael and Gabriel and various apostles, saints, and church fathers. This icon is fitted with a *repoussé* silver *riza,* an icon covering in which only the painted faces, hands, and sometimes feet are visible. This treatment became particularly popular in the nineteenth century.

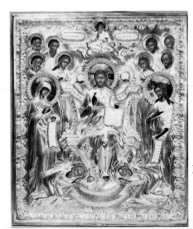

Fig. 5

THE ICON—Basically a wooden panel painted with a religious scene or personage, the icon was intended either for private devotional use or to be displayed in a church.

SUBJECT—Although it may be a single image, often, as here, a more elaborate plan is involved. The first register is an extended Deisis, of Christ with the Virgin Mary and the Archangel Michael on His left, and on His right John the Baptist and the Archangel Gabriel.

Also on either side are various apostles, saints, and church fathers. The second register depicts the Throne of the Millennium, before which all men must come at the Last Judgment. The throne is flanked by groups of angels. The third and fourth registers depict saints, martyrs, and church fathers.

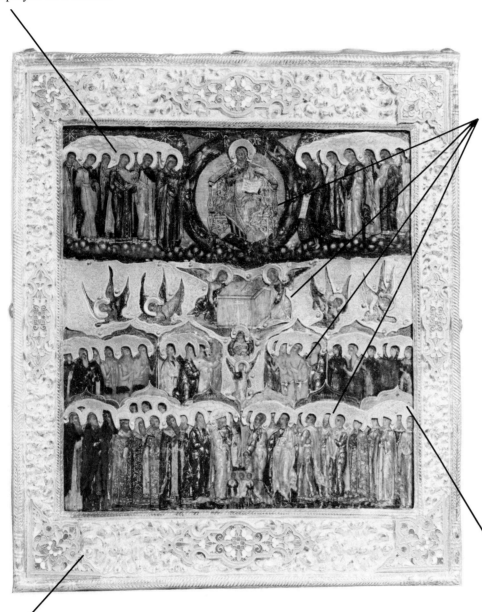

FRAME—The gilded-silver and cloisonné enamel frame was added during the late nineteenth century. It is chased with scrolling vines and decorated with stylized flowers and foliage in multicolored enamels.

METAL COVERING—The icon is fitted with an incised brass *okhlad* and halos. An *okhlad* is a metal covering which conceals the background of an icon, leaving the painted figures and faces visible. Occasionally the *okhlad* is not contemporary with the icon itself.

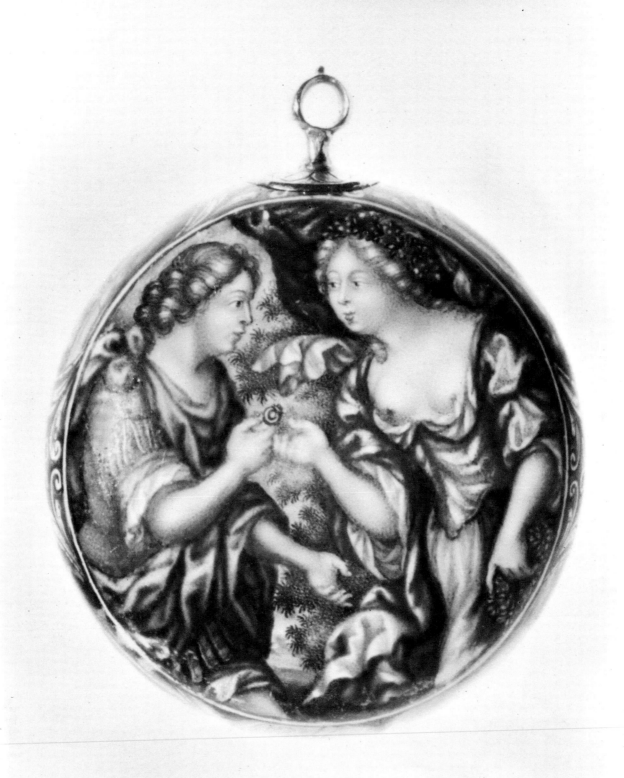

OBJECTS OF VERTU

The term "objects of vertu" has been conveniently applied by art historians to all the rare and precious objects that man has created from the Renaissance onward to amuse himself and astonish his fellow men.

Jewelry for personal adornment has been popular with every civilization, as classical and even prehistoric fragments reveal. During the Dark and subsequent Middle Ages personal vanity was discouraged, and artisans concentrated on reliquaries and religious vessels that glorified God.

During the 1700s the new wealth available to the courtiers of Europe created a demand for dazzling parures for their favorites, and snuffboxes, etuis, and other curiosities for themselves. Goldsmiths and jewelers vied in creating boxes of extraordinarily fine and detailed workmanship in precious substances. At the same time, new scientific and technical advances made possible timepieces for individual use.

The production of elegant small objects survived the early Industrial Age in nineteenth-century Europe and flourished under the genius of Carl Fabergé in Russia, who took his inspiration from the treasures of the eighteenth century and created whimsical trinkets for the czar and his court.

All of these extraordinary objects are appreciated today as marvels of technical excellence.

Fig. 1

The *kovsh,* a traditional Russian vessel, is generally of low boat shape with a raised handle like a ladle. Originally carved from wood, it was used for the drinking of mead, *kvass,* or beer. In rural Russia this form, with its purpose, was kept until recent times.

Throughout its history the *kovsh* has gradually lost its functional purpose. As early as the fourteenth century *kovshi* of precious metals were produced for the nobility. By the middle of the seventeenth century *kovshi* were used as symbols of honor, being presented by the czars as awards for military conquests or other services to the State. Such a presentation *kovsh,* made at the time of Peter the Great (1682–1725), is illustrated in Fig. 1.

With increasing Western influence, *kovshi* of the eighteenth century became increasingly ornate and complex. This decorative trend continued and developed throughout the nineteenth century.

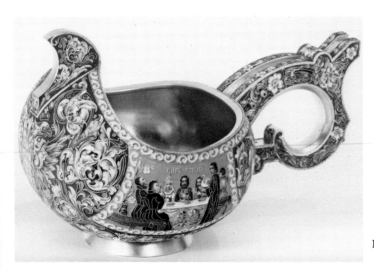

Fig. 2

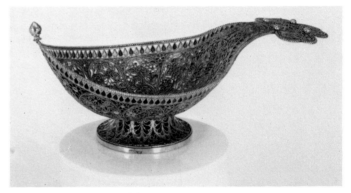

Fig. 3

Although the purpose of the *kovsh* changed during its history, the traditional boat shape was retained. The *kovshi* illustrated here represent a few of the many styles and techniques possible. The *repoussé* silver *kovsh* in Fig. 2 incorporates *vitiazi,* or legendary warriors. In Fig. 3 the *kovsh* is executed in *plique à jour* enamel surrounded by gilded-silver filigreework. The example in Fig. 4 is decorated in shaded tones of enamel incorporating the Russian Imperial Eagle and scenes of the Choosing of the Bride and the Wedding Feast. The *kovsh* in Fig. 5 is quite unusual because of its bird form and biscuit enameling.

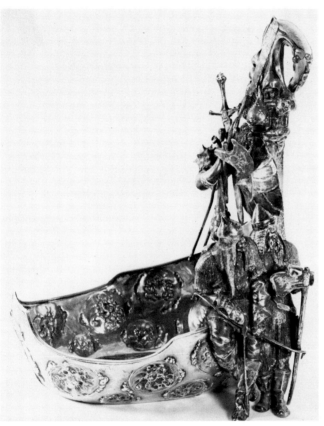

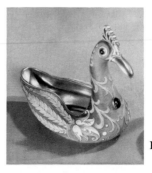

Fig. 4 Fig. 5

ANATOMY OF A RUSSIAN *KOVSH*
(See also Color Plate 17)

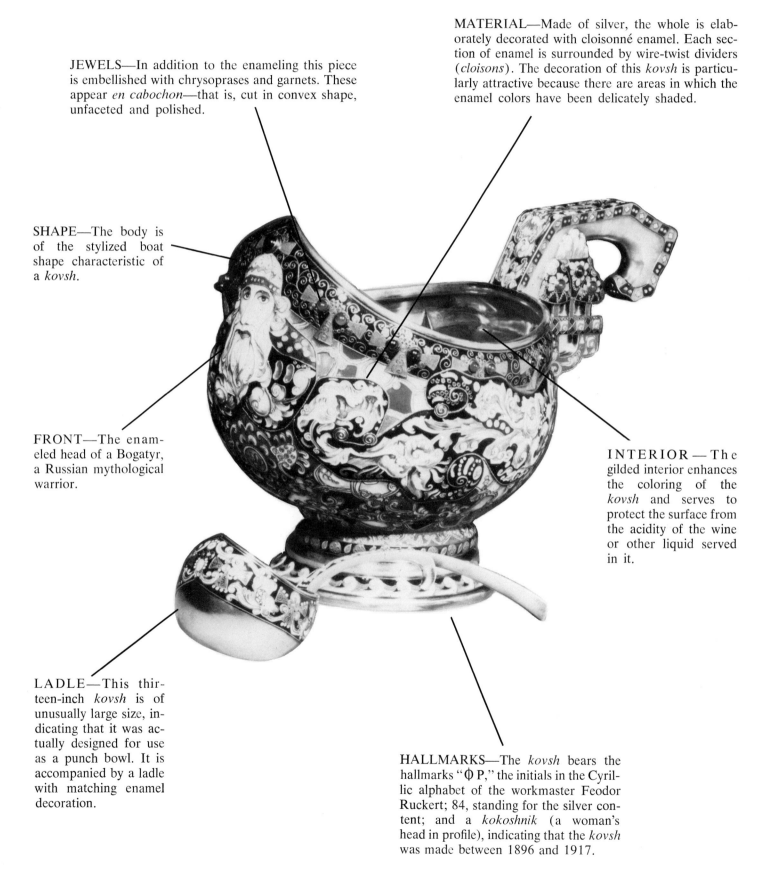

MATERIAL—Made of silver, the whole is elaborately decorated with cloisonné enamel. Each section of enamel is surrounded by wire-twist dividers (*cloisons*). The decoration of this *kovsh* is particularly attractive because there are areas in which the enamel colors have been delicately shaded.

JEWELS—In addition to the enameling this piece is embellished with chrysoprases and garnets. These appear *en cabochon*—that is, cut in convex shape, unfaceted and polished.

SHAPE—The body is of the stylized boat shape characteristic of a *kovsh*.

FRONT—The enameled head of a Bogatyr, a Russian mythological warrior.

INTERIOR—The gilded interior enhances the coloring of the *kovsh* and serves to protect the surface from the acidity of the wine or other liquid served in it.

LADLE—This thirteen-inch *kovsh* is of unusually large size, indicating that it was actually designed for use as a punch bowl. It is accompanied by a ladle with matching enamel decoration.

HALLMARKS—The *kovsh* bears the hallmarks "Ф Р," the initials in the Cyrillic alphabet of the workmaster Feodor Ruckert; 84, standing for the silver content; and a *kokoshnik* (a woman's head in profile), indicating that the *kovsh* was made between 1896 and 1917.

Fig. 1

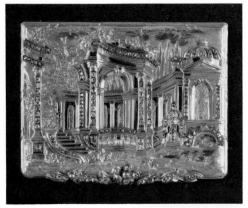

Fig. 2

Fig. 3

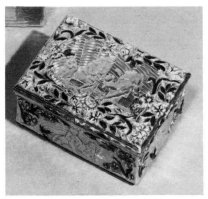

Fig. 4

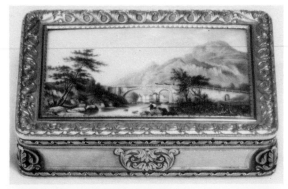

Fig. 5

GOLD BOXES

Early gold boxes were often designed to contain *râpée*—a strong snuff made from dark tobacco that had to be grated before it was inhaled. However, by the early eighteenth century snuff was marketed already ground, and this prompted the use of smaller snuffboxes.

Small gold boxes were also made to contain scent and might be fitted with two glass bottles and a funnel. An unusual seventeenth-century scent box (Fig. 1) is shaped like a glass factory, with "brickwork" outlined in engraving. On the sides are applied small enameled figures whose tasks illustrate the various stages of making glass.

In France, during the second quarter of the eighteenth century, the gold box reached its peak as a small and highly finished work of art. It connoted the owner's social rank and taste, and there was an exaggerated ceremony of use. Boxes of this period became elaborately shaped, and the chasing of the gold met the highest standards. Often boxes were signed by the *ciseleur* (chaser), as well as the maker. In the Louis XV architectural box (Fig. 2) the *ciseleur* used relief work to achieve an extraordinary effect of perspective. This is enhanced by a judicious application of diamonds in graduated sizes.

In Fig. 3 the pudding-stone snuffbox, probably German c. 1760, is in the shape of a dog with diamond eyes and teeth. The mottled surface of the stone was a particularly suitable choice for the dog's coat.

There are two traditional types of presentation snuffboxes. One is set with a portrait miniature, often surrounded by jewels; some of the best examples of these were the boxes the French Crown presented to its ambassadors as marks of office. The other type, known as a Freedom Box, was especially popular in Ireland. The lid of the Freedom Box was customarily engraved with the recipient's coat of arms, and the base with the arms of the city which presented it.

During the middle of the eighteenth century enameled boxes achieved an unsurpassed technical excellence. The enamel, which could be either opaque or transparent, was applied directly to the box and then fired and polished (Fig. 4).

By 1800 the Swiss had superseded the French as the pre-eminent makers of gold boxes. The Swiss favored miniatures, of either allegorical or landscape scenes, bordered by champlevé enamel (Fig. 5). In this technique the surface is cut away, then filled with enamel, often in conjunction with chased, four-colored gold borders.

By the mid-nineteenth century a preponderance of chased and engine-turned boxes was being made, often inartistically covered with diamonds. Few of these were of outstanding quality, until the advent of Fabergé. The twentieth century saw the end of the snuffbox market and the increasing popularity of cigarette boxes and compacts. The best were made by Cartier, who continued the high standard of Fabergé during the 1920s and the 1930s.

ANATOMY OF AN EIGHTEENTH-CENTURY SNUFFBOX

(See also Color Plate 7)

SHAPE—The oval form is typical of boxes in the neoclassical taste produced in France in the 1760s as a reaction to the shaped and *bombé* boxes of the rococo period. This particular example is a Louis XV oval four color box set with miniatures. It was made by Mathieu Coiny of Paris about 1766. Its length is 2¼ inches.

EDGING—The borders are finely chased in three colors of gold with C-scrolls, flower heads, and sprays of running foliage on a matted (granulated) ground.

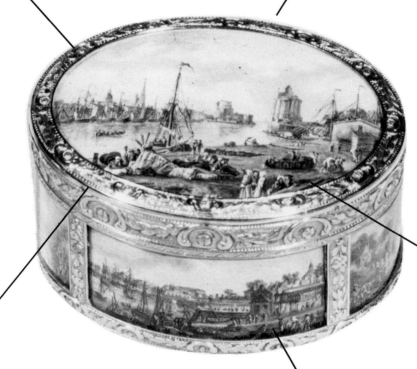

DECOR—The scenes show various ports of France: La Rochelle, Toulon, Bordeaux, Cette, and Bayonne. De Savignac based these views of French ports on paintings by Joseph Vernet, which are in the Palais de Luxembourg.

INSIDE—The interior is of plain gold and carries the maker's mark and Paris marks on base, cover, and side. On French boxes these are often hard to read, as they were struck on the gold before the box was shaped. A small discharge mark was struck on the rim of the box upon completion.

DESIGN—The box is set under glass with six different gouache (opaque watercolor on paper) miniatures, which are signed "de Lioux de Savignac, 1769." Edmé Charles de Lioux de Savignac was a pupil of Louis Nicolas van Blarenberghe, one of the most famous French miniaturists of the mid-eighteenth century. Both painters used an almost incredible degree of detail; their art has been characterized by Sir Sacheverell Sitwell as an "antlike industry."

43

FABERGÉ

Fig. 1

Fig. 2

Fig. 3

Fig. 4

Fig. 5

The ancestors of Peter Carl Fabergé (1846–1920) fled from France in 1685, but he himself was at least a third-generation Russian. His father, Gustav Fabergé, was a goldsmith and jeweler, having set up his own business in St. Petersburg in 1842. As a young man, Carl Fabergé traveled and studied throughout the artistic capitals of Europe, and in 1870, at the age of twenty-four, he took over the management of his father's jewelry business.

Under Carl Fabergé's direction, the firm expanded its St. Petersburg branch and opened workshops and outlets in Moscow, Odessa, Kiev, and London. Although Fabergé generally confined himself to designing and guiding production, the entire firm, which employed numerous craftsmen, was imbued with Fabergé's personality and inventiveness.

Perhaps Fabergé's greatest contribution to the decorative arts field was his decision to depart from the production of conventional jewelry. Instead, he made objects of considerable beauty, but often from materials of little intrinsic value. Rather than depending on the use of costly gems, Fabergé emphasized the aesthetic pleasure of the total object, concentrating on fantasy, individuality, expression, and craftsmanship. Until the House of Fabergé was closed by the Bolsheviks, it enjoyed patronage throughout Europe, as well as in Russia.

Although Fabergé is best known for the Imperial Easter eggs, the firm drew on the full gamut of artistic styles and media. The diversity of objects made by Fabergé can only be touched upon here.

The fine Fabergé buckle–pin in Fig. 1 is set with diamonds and rubies and is enameled in translucent white. This technique of enameling *en plein* is only one of the various enamel processes used by Fabergé. The enamel-covered jar in Fig. 2 illustrates the use of shaded cloisonné enamel, which is more typically Russian.

Although Fabergé drew inspiration from artistic styles of various countries, he produced many objects traditionally Russian in form, such as *kovshi* and *charki* or cups (Fig. 3).

Also, Fabergé's lapidaries successfully used hard stones of every type available. One of the numerous hard-stone animals produced by the firm is seen in Fig. 4.

An example of an object of beauty made from a material of small intrinsic value is the stained boxwood bell push (Fig. 5), which shows one of the fitted boxes made to accommodate many of his pieces. Even these boxes display his superb craftsmanship.

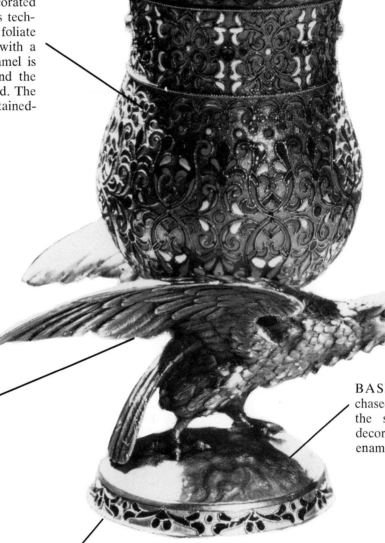

ENAMEL—This magnificent gold goblet, 4⅛ inches in height, is decorated with *plique à jour* enamel. In this technique a pattern (here a stylized foliate design) is pierced, then backed with a thin layer of silver. Next the enamel is painted on, the piece is fired, and the silver backing is removed with acid. The process achieves a translucent stained-glass-window effect.

MATERIALS—Contrasting with the gold and enamel bowl and base, the support is silver, finely chased in the form of a displayed eagle. In addition, the goblet is set with rose diamonds interspersed with cabochon rubies.

BASE—The gold base is chased to simulate earth, and the symmetrical border is decorated in *plique à jour* enamel.

HALLMARKS—Under the base the piece is stamped "A. T.," the initials of the Fabergé workmaster Alfred Thielmann; also 56, denoting the gold content; and a *kokoshnik* (a woman's head in profile), indicating that the piece was made between 1896 and 1917.

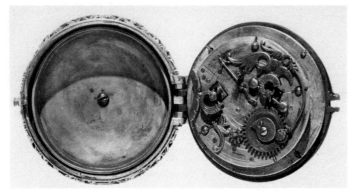

Fig. 1

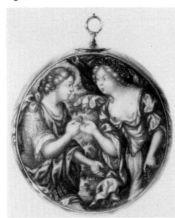

Fig. 2

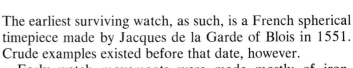

WATCHES

The earliest surviving watch, as such, is a French spherical timepiece made by Jacques de la Garde of Blois in 1551. Crude examples existed before that date, however.

Early watch movements were made mostly of iron, though as far back as 1580 brass was also used, particularly in France, where watchmaking gained supremacy. The Germans were also pioneers, but they employed an inferior accuracy-control device known as a stackfreed (Fig. 1). Compared to the cone-shaped fusee used by the French, the stackfreed was a poor performer. It consisted of a strong spring pressing against a cam wheel, contoured to retard movement when the watch was fully wound and to increase movement when it began to run down.

Timekeeping was far from accurate until the fourth quarter of the seventeenth century, and most watches had only one hand. In many of these early models trains of connected mechanical parts were included to strike the hour or function as an alarm.

The most common watch cases at this time were oval or circular. They were made of gilt metal or silver and were often pierced and chased with scrolling foliage. More important commissions brought watches of rock crystal, usually octagonal, with enameled gold mounts. Silver watches were sometimes made in the shape of stars, crucifixes, skulls, birds, or buds (Fig. 2).

In 1675 a new degree of accuracy was obtained by the introduction of the balance spring. This evened the oscillations of the balance wheel and made possible the introduction of a minute hand. The end of the seventeenth century saw the perfection of the painted enamel gold case. The example in Fig. 3 was made by the Huaud family of Geneva.

In the eighteenth century the pair-case watch became the rule. In these watches the movement was enclosed in a simple inner case and a decorative outer case. The late 1700s also witnessed the introduction of the automaton watch (Fig. 4), with moving figures and striking on gongs. These were sometimes fitted with panels that slipped apart to reveal an automated *scène galante*.

In the nineteenth century the universal verge movement was replaced by the cylinder and lever movements. By this time Abraham Louis Breguet of Paris (1747–1823), a great technical innovator, had earned a reputation as the foremost watchmaker in Europe. Even Breguet's simple *souscription* watches (Fig. 5), financed in advance by "subscribers" who guaranteed to purchase them, were superbly designed and accurate. By the end of the century the complicated Swiss watch reached a technical level not yet surpassed. A fine Patek Philippe watch would repeat the hours, quarter hours, and minutes on gongs by pressing a lever, would show the day, date, and month, even adjusting automatically for leap years, and would function as a stopwatch, often with two stop hands operating together or separately.

Fig. 3

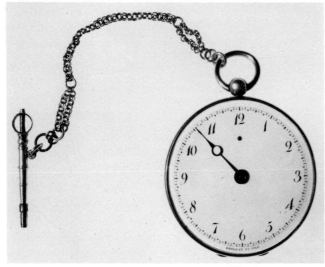

Fig. 4

Fig. 5

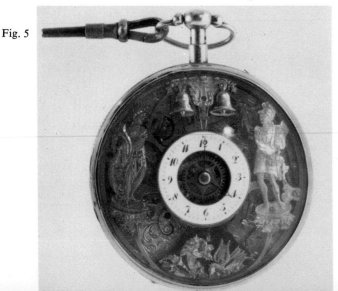

ANATOMY OF A WATCH

OUTER CASE—The outer silver case, which has no window, is Turkish and is chased in a shell design, with borders of flowers and scrolls. The execution is crude compared to that of the English work on the rest of the watch.

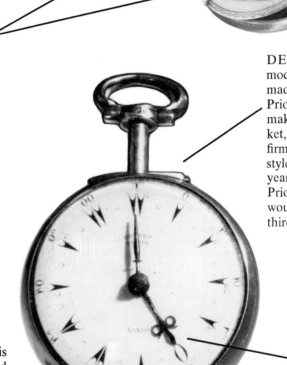

INNER CASES—The first case, like the second, is silver, hallmarked London, 1835. The third case is of brass, with silver borders; its back and bezel are overlaid with tortoiseshell decorated with silver studs. Both these cases have hinged covers with windows, so the time may be read without removing the watch.

DESIGN—The watch is one of the modest, almost mass-produced models made for export. Edward and George Prior of London were the most prolific makers of watches for the Turkish market, and as late as the mid-1900s their firm continued to produce watches in a style introduced more than one hundred years earlier. This watch, by Edward Prior, is three inches in diameter and is wound by a key—standard until the third quarter of the nineteenth century.

DIAL—The white enamel dial of this quadruple-case watch is decorated with black numerals and blued steel "beetle and poker" hands. The numerals indicate that the watch was designed for the Turkish market.

WORKMANSHIP—The back plate is mounted with a raised disk pierced and engraved with an urn of scrolling foliage. This cock is designed to protect the balance wheel. The back and front plates are joined by four decorative pillars, pierced with scrollwork. The movement is made of gilded brass and is hinged inside the first case.

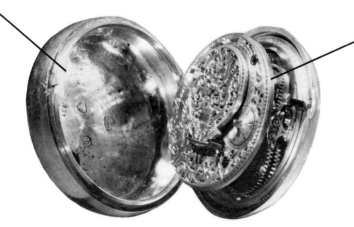

MOVEMENT—The movement—one of the earliest types—has a verge staff whereby the escape wheel runs vertically to the plates. Taking its name from the shape of its teeth, it is also known as the crown wheel. The accuracy is controlled by a fusee, a simple but clever cone-shaped device wound with a chain that is credited to Leonardo da Vinci. When fully wound, the mainspring is made to pull a high ratio, and when nearly run down, it pulls a low ratio, thus equalizing the torque.

PAPERWEIGHTS

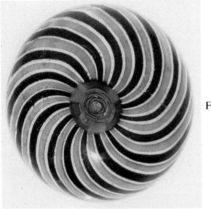

Fig. 1

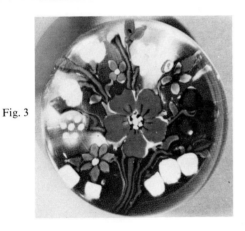

Fig. 2

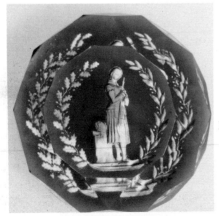

Fig. 3

Fig. 4

Little documentation exists to prove exactly how Venetian-Bohemian glassmaking techniques influenced the sudden rise and development of the French paperweight. Paperweights were also made in England, Italy, and America; however, relative secrecy was maintained among the European glass factories and, although the concept of paperweights was borrowed, the French excelled in and perfected their manufacture between 1845 and 1855.

Of the three French factories that produced paperweights, the Baccarat and St. Louis factories have long been rivals in the manufacture of crystal. The third factory, Clichy, founded about 1815, was as competitive and its products were as high in quality as those of the other two until it went out of business about 1885.

Paperweights were first produced as a sideline, often unrecorded in the factories' inventories and catalogues. However, the growing popularity of industrial exhibitions gave exposure to the form, which may account for the numerous similarities in the work of the three factories.

Typical paperweights of this period have been grouped into three general categories: millefiori weights (the word derives from the Italian "thousand flowers"), weights set with subjects, and sulphide weights. Of these, the first two groups were produced in the greatest number. The craft of sulphide "encrustation" remained an almost separate, independent art.

The paperweights of each factory have particular traits —the shapes and colors of their canes—by which they can be identified. Whereas Baccarat's known trademarks are brightly colored silhouettes, star dust, and arrowhead canes, St. Louis employed paler colors, almost pastels, in their crimped or star canes. A concentric "setup" in a mushroomlike tuft of St. Louis millefiori canes is shown in Fig. 1. This piece is dated in the outer row, "SL 1848." Dates are frequently found in Baccarat scattered and close millefiori weights, but rarely in St. Louis pieces.

Although Clichy weights were never dated, they were signed sometimes, either in full, which was rare, or with the letter C. The pleasing and delicate Clichy rose (Fig. 2) was a specialty of the factory. Clichy often used combinations of darker colors, such as mauve, crimson, or royal blue in setups of pastry-mold canes.

Factories are also distinguishable by the types of weights they produced. Swirl weights were made only by Clichy, jasper grounds and crowns only by St. Louis. Baccarat was the most prolific in the subject category, producing an endless variety of semi-naturalistic flower weights, the most imaginative of which were the vertical arrangements and flat bouquets (Fig. 3). In addition to flowers, the factories made weights set with fruit or butterflies and even, though rarely, snakes.

A rare Baccarat sulphide set with a cameo relief portrait of Joan of Arc is shown in Fig. 4. The clay medallion, molded and then imbedded in glass, generally represented a famous figure, medal, or a religious subject.

48

PATTERN—Set with two entwined trefoil garlands, one of whorls, the other of pastry-mold canes, the pair form loops that enclose silhouettes. The particular arrangement of the canes helps in the classification of types of millefiori weights, some being freely patterned on a clear glass ground, while others are tightly packed, giving a feeling of solidity—a characteristic inconsistent with the very nature of glass.

CANE DETAIL—The individual canes, or florettes, are cross sections cut from heated and stretched colored glass rods. The Baccarat factory is known in particular for its various intricately formed silhouette canes, star-dust canes, arrowheads, and whorls.

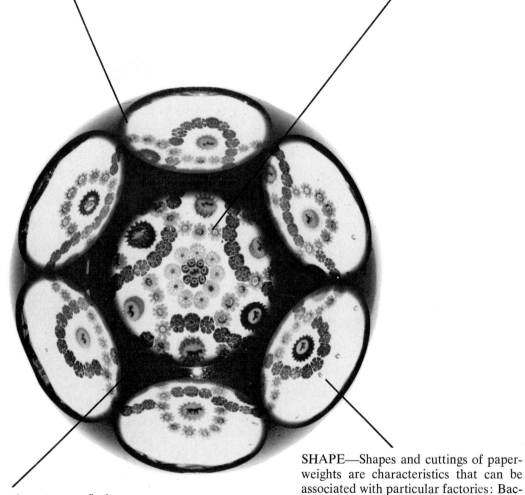

SURFACE—The translucent green-flash overlay, which is applied by "dipping" the object, is cut with windows, or printies, to allow various degrees of magnification and to bring into view the central setup of canes. An additional decorative device, overlays were hard to execute properly; hence weights of this type are rare.

SHAPE—Shapes and cuttings of paperweights are characteristics that can be associated with particular factories: Baccarat is known to have cut five or six windows around the sides, and the St. Louis factory is associated with honeycomb or triangular faceting.

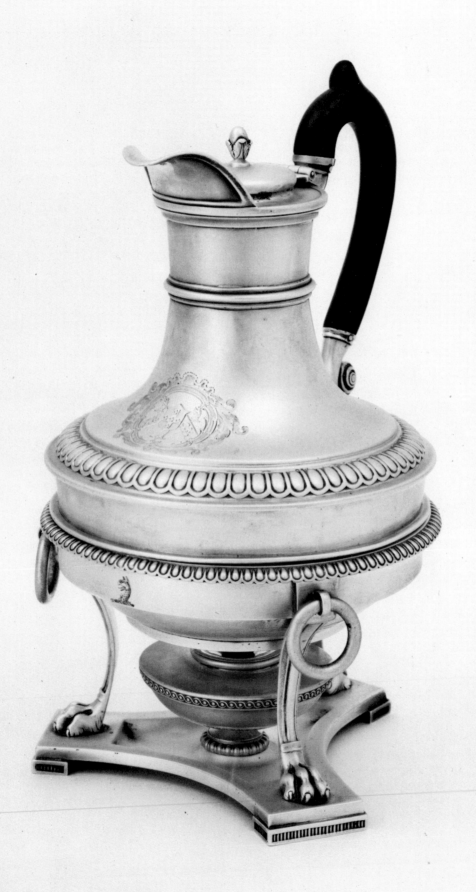

SILVER, SHEFFIELD PLATE, AND PEWTER

The manufacture of silver objects, for both practical and ornamental purposes, has been known since the beginning of recorded history. Few examples from antiquity exist, however. The reason, or certainly one of the reasons, for this is that the traditional use of silver has been for coinage, and during difficult times objects made of this precious metal or of gold have been melted down and turned into coins.

Later history has been somewhat kinder to the collector, and a great number and variety of silver objects made during the relatively stable post-Renaissance period in Europe have survived. Enriched by the flow of precious metals from the New World, European silversmiths produced a diversity of shaped silver items and an even greater quantity of plates for domestic, ecclesiastic, and ceremonial use.

Craftsmen working with silver have been subject to governmental and guild regulations,which have varied in severity and strictness of enforcement from one country to another. In England it was ordered that silver should be hallmarked, and as a result it is possible to tell in most instances not only which craftsman made a piece, but in what city and in what year.

The changing tastes of the centuries are reflected in silver. The sturdy decorations of the Renaissance period, and the florid baroque, gave way to the whimsy of the rococo, the severity of the neoclassical, and later to the eclectic excesses of the Victorians. A few makers—Paul de Lamerie, Hester Bateman, Paul Storr, Paul Revere, and a handful of others—are especially favored by today's collectors of silver. However, well-designed objects by lesser-known smiths can be equally exciting to discover and use.

Allied to silver, at least in its use, is pewter. This less-expensive material, an alloy of tin and lead, has been the traditional substitute for silver. Pewter tableware designs have generally followed the fashionable forms of silver throughout the ages. In the eighteenth century Sheffield plate, an early process of silver plating, appeared, to rival both pewter and silver in terms of design and serviceability; its great advantage was its relatively low cost.

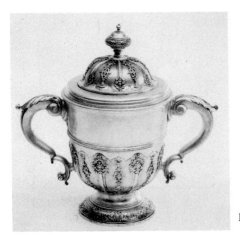

Fig. 1

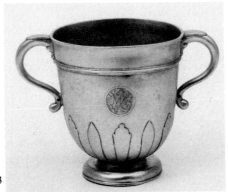

Fig. 2

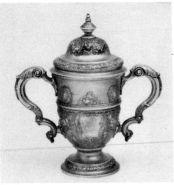

Fig. 3

Fig. 5

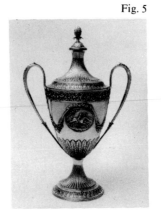

Fig. 4

COVERED CUPS

One of the most frequent commissions of silversmiths has been for cups and drinking vessels. The combination of good line, gleaming finish, and practicality has held great appeal to all who could afford such vessels. The infinite variety of design possibilities here is suggested by a quick look at the changes that took place during the seventeenth and eighteenth centuries.

The dramatic standing cups so in vogue during the late sixteenth and early seventeenth centuries were replaced at the middle of the century by two-handled cups with covers, called porringers or caudle cups. Caudle cups (Fig. 1) were usually of thin silver and had either cylindrical or bulbous bodies. Quite often they were hammered in high-relief designs of animals or birds surrounded by the large flower heads and foliage introduced to England with the Restoration in 1660. They generally featured cast scroll or caryatid handles and domed covers surmounted by a knob in the form of a bud or, sometimes, a grotesque head. This example, which carries the mark "H.G.," was made in London in 1659.

With the influx of French Huguenot craftsmen to London in the early 1700s, the thin embossed cups gave way to heavier two-handled cups and covers, often decorated with applied strapwork as in Fig. 2. Here, in a George II version by David Willaume of London, the strapwork is formed of pierced strips of silver with chased and scrolled moldings soldered to the body on matted (or granulated) reserves. A simpler example of strapwork can be seen on a two-handled cup by Simeon Soumaine of New York, made about 1730 and engraved at a slightly later date with a monogram of the Livingston family of New York (Fig. 3).

The two-handled cup did not change substantially in form through the eighteenth century, but the decoration usually followed the prevailing fashion. A rare two-handled Scottish cup by Colin Allen of Aberdeen, c. 1750 (Fig. 4), is chased with a provincial version of rococo ornament comprising shell and scrollwork and floral sprays interspersed with grotesque masks.

Many two-handled cups were given as race prizes. A large silver-gilt cup (Fig. 5) has an applied oval medallion chased with two horses racing and is decorated with the fluting and formal foliage typical of the last years of the eighteenth century. These appear to be the ancestors of today's trophy cups.

52

DECORATION AND MARKS—The body is engraved with a border of arabesques enclosed by strapwork, typical of late sixteenth-century ornament. It is also lightly pounced, or pricked, with armorials; the arms are those of the Wilbraham family of Woodhey, Chester, and the mark "S.B." indicates that the cup may have been made by Simon Brooke of London in 1585.

FINIAL—The cup is considerably heightened by raising the urn finial on a fluted disk above a reel-shaped plinth. A more common finial in English cups is a steeple, which might, from its shape, be more aptly called an obelisk.

SHAPE—The gourd shape of this Elizabeth I silver-gilt cup is basically German, though at least sixteen cups of this form are recorded with English hallmarks. On occassion, real coconuts and ostrich eggs were used with silver mounts. This particular cup is 11½ inches high.

STEM—Here the stem is formed as a partly lopped tree trunk. In German counterparts the tree trunk is usually accompanied by a woodsman holding an ax. The component pieces are screwed together, and the leaves that form a calyx for the bowl and foot are separate. The leaves are deliberately left in white silver to contrast with the gilding on the rest of the cup.

GILDED FINISH—Until the middle of the nineteenth century, gold was applied to silver surfaces by being mixed with mercury. The silver was then heated so that the mercury evaporated, leaving a thick layer of gold, usually of a soft lemon color. This process often resulted in mercury poisoning for the gilder. Since about 1850 gilding has been done by electrolysis. This method tends to result in a more brassy appearance, and the gilding is more prone to wear, but the process is less hazardous for the gilders.

BASE—The foot is embossed with fruit and has a die-stamped border of ovolos. Stamped rather than chased borders were a typical feature of Elizabethan silver.

CANDLESTICKS

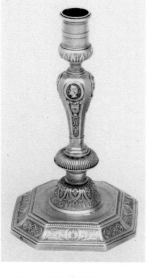

Fig. 1

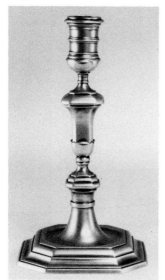

Fig. 2

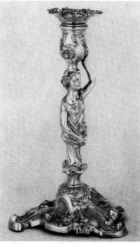

Fig. 3

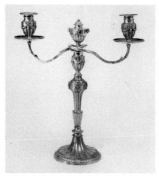

Fig. 4

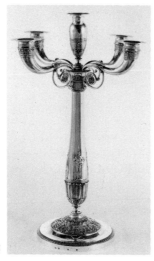

Fig. 5

Fig. 6

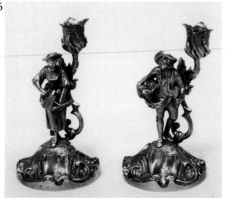

In the late seventeenth century cast candlesticks were introduced into England by refugee Huguenot craftsmen. Prior to that time embossed sheet-metal candlesticks (as opposite) were standard, although only a few domestic silver candlesticks survive from the pre-Restoration period.

Before the end of the first quarter of the eighteenth century the decoration on candlesticks had become formal, particularly in France, where highly detailed arrangements of strapwork enclosing husk pendants were popular. Frequently these were relieved at the shoulders by profiles of Roman emperors, suggesting the aspirations of Paris courts at this time (see the Louis XV candlestick by François Rigal in Fig. 1). Motifs were largely taken from the published designs of Daniel Marot, Jean Berain, and other fashionable sources.

English candlesticks and those manufactured in Holland, such as Eduard Elgersma's in Fig. 2, were characteristically plainer than the French. They were often octagonal or hexagonal in shape and set off by molded borders and engraved armorials. Dutch candlesticks are frequently distinguishable by the use of "tongue" motifs on the stems.

By the middle of the eighteenth century the height of candlesticks had increased. The popular length was approximately ten to eleven inches, as opposed to the seven- or eight-inch height of earlier examples. Candlesticks now also acquired the practical addition of detachable nozzles.

An interesting and typical rococo design was the caryatid candlestick (Fig. 3). In this example by William Grundy the sconce is supported by a partly draped female figure, raised on a shaped shell and scrollwork base.

The candelabrum also became popular during the last quarter of the eighteenth century, particularly in the neoclassical designs of Robert Adam and William Hamilton (Fig. 4). These candelabras of the 1770s combine most of the new influences in the vase-shape sconces, urn finials, satyr masks, and paterae. Classical influence extended, in simplified form, until after 1800, when it became more Greco-Egyptian than Roman. There was also a greater emphasis on cast and applied work. In the candelabrum in Fig. 5 the stem has applied figures of Apollo and Minerva, the sconces are formed as cornucopias and the finial as an amphora, and the borders are of anthemion, palm, and papyrus.

From about 1765, candlesticks were also made of relatively thin stamped silver, filled with a composition to give them stability. Made mostly in Sheffield, these were cheaper than cast sticks and thus reached a much wider market.

Victorian silver copied earlier styles and often combined them in experimental and, for the most part, heavier designs. It is interesting to note that while porcelain table articles tended to copy the shapes of silverware, occasionally the silversmith turned to porcelain for a prototype (Fig. 6). These candlesticks depict a boy and girl in eighteenth-century dress, playing at gardening.

STEM—The fluted column is one of the most obvious and frequently used devices to support a candle. In this piece, made before the introduction of cast candlesticks, the column and the rest of the candlestick is hand-raised from sheet metal. The columnar stick had been used in London in the seventeenth century, and this provincial example is comparatively late, reflecting the conservatism of the country silversmiths.

LOWER STEM—The reel-shaped stem, designed so that the candlestick may be held comfortably with a guard above to protect the hand from dripping wax, has chased vertical flutes bordered by matting, or granulation. The decoration includes a baroque cartouche surrounding a shield on which the owner's crest could be engraved.

BORDERS—The gadroon borders are *repoussé* or embossed. Gadrooning, the most typical of all silver decorations, consists of lobes alternating with flutes, either vertical or on a slant. Originally this was a hand technique, but in later examples the decoration was cast.

BASE—This has five stamped marks, four of which conform to a London pattern, the fifth being the town mark of Exeter. Apart from London, there were as many as thirty-six towns in the British Isles that used a hallmark system, some for a short time only. Exeter hallmarked silver from about 1571 until 1883. The marks read, clockwise from top left: (1) Maker's mark of J. Elston. Here the first two letters of the surname are used, a compulsory practice from 1697 to 1720. (2) Date letter *F* for 1706. (3) Britannia. (4) The lion's head erased to indicate the Britannia standard. This was introduced in 1697 and was compulsory until 1720, after which it became optional. (The Britannia standard is 958 parts silver in 1000; sterling is 925 parts in 1000.) Britannia Standard was introduced to prevent the melting of coinage for the purpose of making domestic silver. (5) The Exeter town mark, a triple-turreted castle.

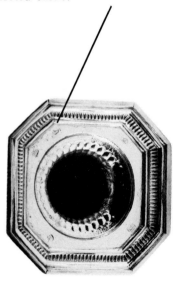

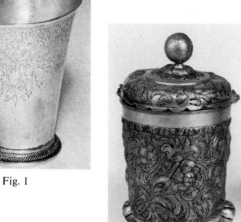

Fig. 1

Fig. 2

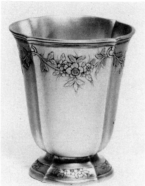

Fig. 3

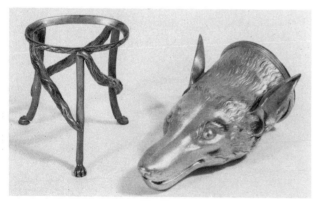

Fig. 4

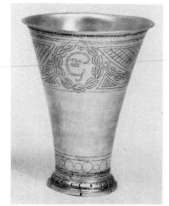

Fig. 5

Fig. 6

BEAKERS

Beakers were probably the first pieces of hollow ware made in silver. Few examples prior to the sixteenth century survive, but early in the seventeenth a great many were produced in Europe. Among the best examples are the tall, tapered, cylindrical Dutch beakers, which developed from the style illustrated on the opposite page. The engraving was often meticulously done and on some pieces is to be found on the base as well as the sides. The decoration might consist simply of strapwork and scrolling foliage enclosing stylized urns of flowers, as in Fig. 1, or it might show Biblical scenes, views of cities and maps, or oval portraits. The most common of these were Faith, Hope, or Charity.

The German beaker most often encountered is a plain tapered cylindrical vessel decorated with a broad granulated band. By the third quarter of the seventeenth century a new type had appeared, raised on three ball or pomegranate feet, sometimes with a cover and matching finial (Fig. 2). The decoration was usually *repoussé*, with chasing of large flower heads and scrolling foliage.

In the eighteenth century a French design evolved which, in outline at least, was copied for about 150 years. The tulip-shape beaker with rounded base in Fig. 3 (probably by Nicholas Lamiche) is raised on a cast foot and decorated in accordance with the prevailing fashion. Pierced strapwork, alternating with chased strapwork, is applied to the lower part of the body, and the lip is engraved to match.

Strasbourg is noted for its oval-shape beakers. These are different from the French and are usually gilded in the German taste (Fig. 4). This example is attributed to Jacques Henri Alberti. A number of double beakers in the form of barrels survive from the seventeenth and eighteenth centuries. This type was revived in English silver at the end of the eighteenth century. At that time a stirrup cup modeled in the form of a fox mask was also introduced, as, for instance, the one by Robert Salmon in Fig. 5. These cups were designed to be handed around at a meet before the hunt began. In the nineteenth century stirrup cups were sometimes designed in the form of the head of a hound, otter, or hare, but such examples are rare.

Norwegian beakers are of narrow trumpet form, the earlier ones being raised on animal-like feet and the sides decorated with pendent disks. Swedish beakers tend to be of broader proportions, and were partly gilded and decorated with "wiggle work"—or "wriggle work"—or zigzag borders at the lip and the base. They usually have a lightly chased or engraved band of flowers and foliage near the rim. Sometimes they are stamped with rows of foliate motifs; for example, Erik Lemon's beaker in Fig. 6. In spite of their large size, 6½ or 7 inches, they are usually a light 10 to 15 ounces in weight.

FORM—The tapered cylindrical design of this sixteenth-century silver beaker with a flared lip has been the most common form of beaker since the Middle Ages. The practical shape is also found in glass of the same period.

GILDING—The gilded inscription, borders, and feet contrast with the silver. The technique is called parcel gilding.

MARKS—Stamped on the base are the Amsterdam town mark, three saltires crossed below a crown representing the dams across the river Amstel, and the date letter *R* for 1585. The owner's initials and what may be a merchant's mark are also engraved on the base. A later French control mark, in use in Holland in 1812 and 1813, during the French rule, has also been added, along with other control and assay marks.

DECORATION—The body has twisted wire bandings applied at the middle and base. This style survived until the middle of the seventeenth century.

ENGRAVING—The lower part of the body is engraved with a popular style of Renaissance strapwork, enclosing portraits of Roman emperors and warriors, which, however, seem to retain very sixteenth-century features. The earliest evidence of this preoccupation with ancient Rome is in the bronze statues at Maximilian's tomb at Innsbruck, begun in 1519. The surrounding engraving was probably derived from the published pattern books of the *Kleinmeisters* of Augsburg. A rhyme is engraved on the rim: *Drinct by maten het sal v. baten—1585* ("To drink moderately is good for you").

FEET—These are typical of northern European work at the time. Animal feet, popular for many years on German and Scandinavian beakers, are not usually found on Dutch examples after 1600. Lions holding shields were another popular decorative motif; these are also found on covered cups, statues, and clocks.

TEA CADDIES

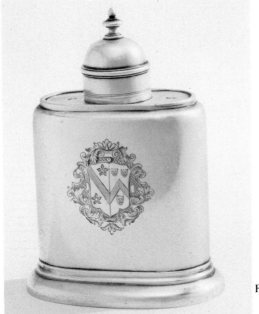

Fig. 1

Caddies were seldom made before 1700. Tea drinking became popular in the West at that time, and the precious leaves had to be stored. Early caddies were usually of upright, oval, rectangular, or oblong form, with sliding bases or covers to permit the insertion of a lead lining. They were topped with a slip-on cap that served as a measure (Fig. 1). The name is derived from the Malay word *kati*, for a measure equaling approximately 1⅕ pounds.

Containers were usually made in pairs for black (Bohea) and green (Viridis) tea. By the middle of the eighteenth century the tea caddy was often combined with a matching sugar bowl and cover in a silver-mounted case of mahogany, fishskin, or, occasionally, mother-of-pearl or ivory. The case was fitted with a lock to prevent pilfering of what was until the end of the eighteenth century a very costly commodity.

Fig. 2

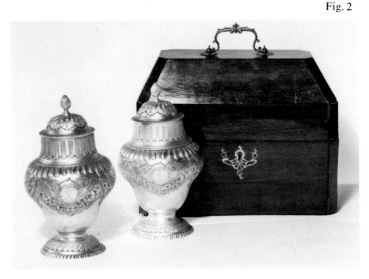

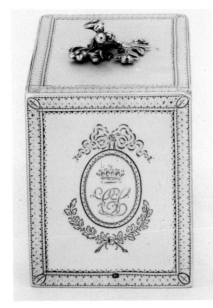

Fig. 3

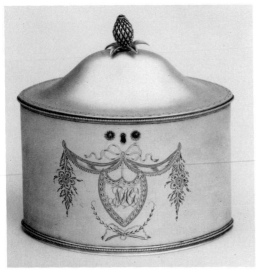

Fig. 4

Caddies also came in the shape of vases (as illustrated in Fig. 2), or in a form reminiscent of the wooden chests in which the tea was imported (Fig. 3). Sometimes they were engraved with pseudo-Chinese characters and planking.

By the end of the eighteenth century tea caddies were no longer made with separate cases; instead they carried their own locks. By this time they were generally oval with straight sides and domed covers and were decorated with bright-cut engraving (Fig. 4).

American caddies are rare; only a handful from the early 1700s and a few from the last years of the eighteenth century survive. Their scarcity may be due in part to the influx of the far less costly Chinese Export porcelain caddies in the latter period.

By the middle of the nineteenth century caddies had become unnecessary, as tea leaves, no longer a luxury, were relegated to the kitchen.

THUMBPIECE—The opening device for this George II tea caddy, made in London, appears from one side as a hat-adorned mask. The features of the mask are Oriental, obviously in reference to the origin of the contents. From the opposite angle, the thumbpiece appears to be two overlapping shells, and the mask is hidden from view.

COVER—The lid slides horizontally to reveal the contents of the caddy, The workmanship is so fine in this particular piece that the aperture is scarcely detectable when the cover is closed.

SHOULDERS—Here eagles surrounded by scrolls and sprays of flowers are chased in low and high relief on a matted ground.

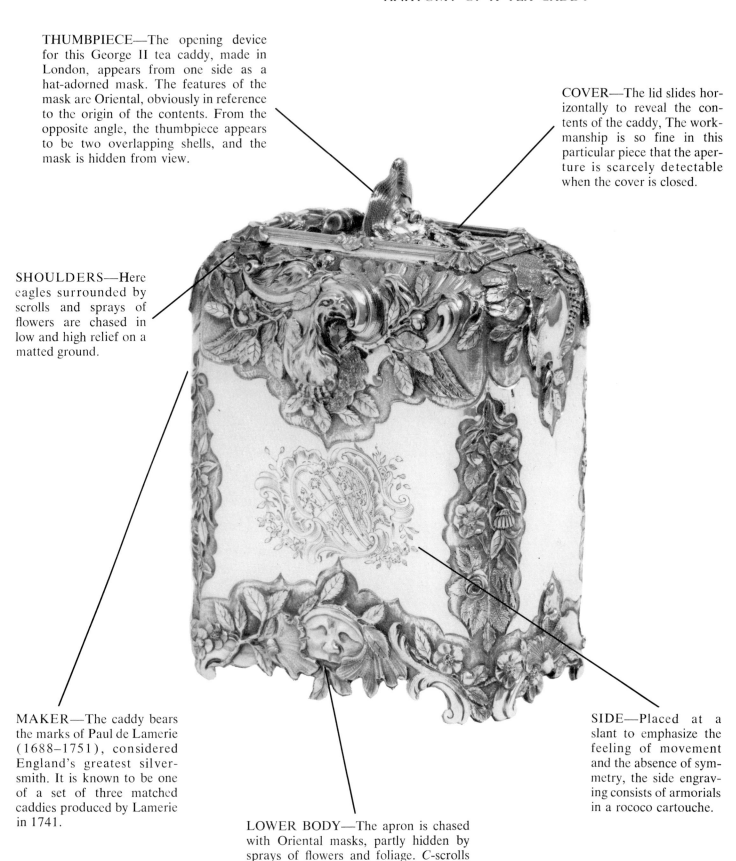

MAKER—The caddy bears the marks of Paul de Lamerie (1688–1751), considered England's greatest silversmith. It is known to be one of a set of three matched caddies produced by Lamerie in 1741.

SIDE—Placed at a slant to emphasize the feeling of movement and the absence of symmetry, the side engraving consists of armorials in a rococo cartouche.

LOWER BODY—The apron is chased with Oriental masks, partly hidden by sprays of flowers and foliage. C-scrolls emerge from the foliage and continue on to form the supports.

CHOCOLATE POTS AND COFFEEPOTS

Fig. 1

Fig. 2

Fig. 3

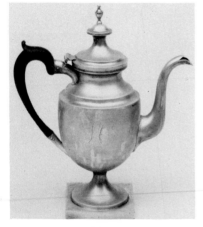

Fig. 4

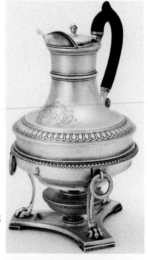

Fig. 5

Chocolate and coffee were introduced into England about 1650. A coffeehouse was opened in London in 1652, and one in Boston in 1670. The earliest known coffeepot, aside from those of the Middle East, dates from 1681, and the earliest chocolate pot from 1685. A rare early form (Fig. 1), derived from Oriental ceramic vases and surmounted by a slip-on cap, is reminiscent of the early tea caddy.

By the turn of the century chocolate pots and coffeepots had become indistinguishable, except for the hinged finial of the former. The tapered cylindrical form was replaced in the middle of the eighteenth century by a baluster shape or pear shape, often decorated with the popular *chinoiserie* scenes of 1750 to 1765, as in the coffeepot by Thomas Whipham in Fig. 2. The fashion for *chinoiserie* was manifest in all the European decorative arts. Its exoticism was particularly suited to the rococo period; in this example a fanciful mandarin holds a parasol beside a pagoda. The handle issues from a boar's head, and the coffee is poured through a duck's head, below which is a female mask.

A simpler version of the rococo style prevailed in America. As in the pot by Joseph Richardson, Philadelphia, c. 1760 (Fig. 3), the surface was frequently left plain except for the engraving of the owner's initials, which were often in the form of a reversed cipher.

In the last quarter of the eighteenth century vase-shaped pots were introduced. Sometimes they were decorated with lightly engraved festoons, but often they were left plain. Philadelphia specialized in the production of very large pots of this type with spool-shaped necks and covers with urn or pineapple finials. Pots were often as high as 14 inches and might weigh more than 40 ounces (Fig. 4). Their generous capacity suggests an era of increasingly widespread wealth and hospitality.

In England the Regency period, inspired by the tastes of the Prince Regent (later George IV), introduced a new pot complete with its own lamp, which could be used either to heat water—in conjunction with a teapot—or to keep coffee hot. The finest examples of this type were made by Paul Storr (Fig. 5), with squat circular bodies and spool-shaped necks. The handles were often in the form of twin snakes, the stands designed with three slender hoof feet raised on triform bases with urn-shaped lamps in the center. They were frequently embellished with anthemion foliage and other Greco-Egyptian motifs popularized by archaeological excavations and Britain's campaigns in the Mediterranean.

In the nineteenth century coffeepots were usually found as part of tea and coffee sets, and the form either reverted to eighteenth-century styles or became an enlarged version of the teapot.

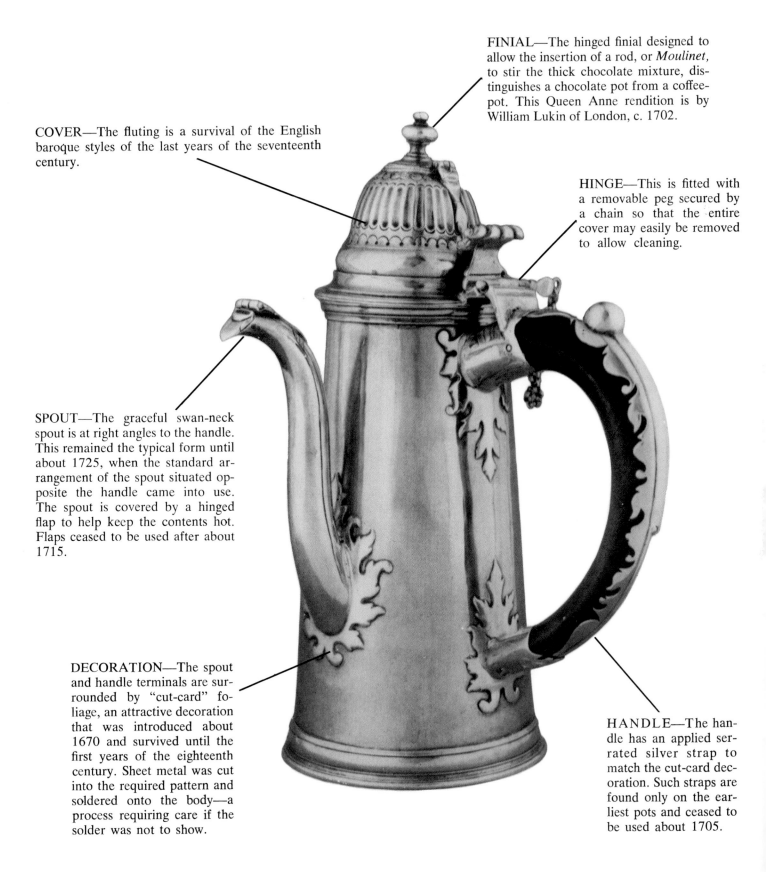

FINIAL—The hinged finial designed to allow the insertion of a rod, or *Moulinet,* to stir the thick chocolate mixture, distinguishes a chocolate pot from a coffeepot. This Queen Anne rendition is by William Lukin of London, c. 1702.

COVER—The fluting is a survival of the English baroque styles of the last years of the seventeenth century.

HINGE—This is fitted with a removable peg secured by a chain so that the entire cover may easily be removed to allow cleaning.

SPOUT—The graceful swan-neck spout is at right angles to the handle. This remained the typical form until about 1725, when the standard arrangement of the spout situated opposite the handle came into use. The spout is covered by a hinged flap to help keep the contents hot. Flaps ceased to be used after about 1715.

DECORATION—The spout and handle terminals are surrounded by "cut-card" foliage, an attractive decoration that was introduced about 1670 and survived until the first years of the eighteenth century. Sheet metal was cut into the required pattern and soldered onto the body—a process requiring care if the solder was not to show.

HANDLE—The handle has an applied serrated silver strap to match the cut-card decoration. Such straps are found only on the earliest pots and ceased to be used about 1705.

TANKARDS

Fig. 1

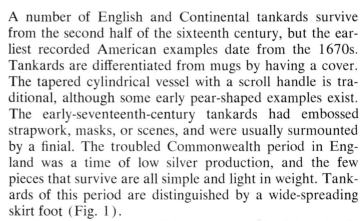

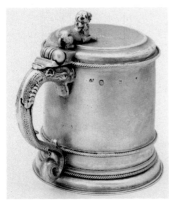

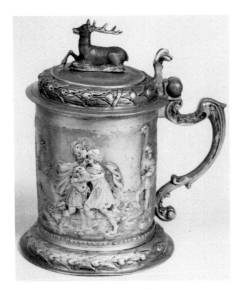

Fig. 2

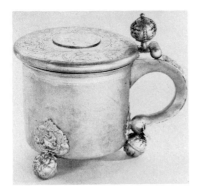

Fig. 3

Fig. 4

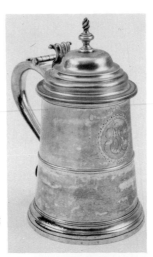

Fig. 5

A number of English and Continental tankards survive from the second half of the sixteenth century, but the earliest recorded American examples date from the 1670s. Tankards are differentiated from mugs by having a cover. The tapered cylindrical vessel with a scroll handle is traditional, although some early pear-shaped examples exist. The early-seventeenth-century tankards had embossed strapwork, masks, or scenes, and were usually surmounted by a finial. The troubled Commonwealth period in England was a time of low silver production, and the few pieces that survive are all simple and light in weight. Tankards of this period are distinguished by a wide-spreading skirt foot (Fig. 1).

After the restoration of the monarchy English tankards became heavy, sturdy vessels. They were more elaborate in decoration and had flat covers. In Fig. 2 the thumbpiece is formed as a lion couchant, and the handle as a dolphin with a scaly body. The latter form derived from German styles.

The popularity of tankards reached a peak in the late seventeenth century, when German examples were particularly exuberant. They were decorated in high relief with battle or Old Testament scenes and were sometimes fitted with carved ivory barrels. In Berlin they usually had an over-all design of inset coins.

Another tankard (Fig. 3), by Nathaniel Schlaubitz, is engraved with a scene depicting the reconciliation of Jacob and Esau. The finial, in the form of a stag, is possibly of heraldic significance. Unlike English and American examples, this tankard is gilded with typical German panache. The peg tankard occurs occasionally in English ware but is more usually associated with Scandinavian designs. A row of pegs, placed vertically inside the tankard, serves as a measure.

Among the most handsome specimens are the Swedish parcel-gilt tankards, also of the late seventeenth century. Usually these have a plain barrel, are raised on three ball feet topped by cartouches of foliage and fruit, and have a ball thumbpiece, as in the tankard by Ferdinand Sehl the Elder (Fig. 4). A coin is often inset on the flat covers of these tankards, which are usually engraved with a wide border of scrolling flowers and foliage. The popularity of Scandinavian designs spread to England in the third quarter of the sixteenth century, when tankards that could easily be mistaken for Scandinavian were actually made in York and Hull.

In the eighteenth century English and American tankards featured domed covers, and New England examples, such as those by Benjamin Burt of Boston (Fig. 5), are distinguished by finials. Though tankards continued to be made in the nineteenth century, they were generally replaced by the more practical pitchers, and, unfortunately, many early tankards were converted to this form by means of an added spout.

FORM—The flat cover with shaped front, the tapered cylindrical barrel and corkscrew thumbpiece are all typical of English and American tankards of the late seventeenth and early eighteenth centuries. This one was made in New York, c. 1710. It is 6⅝ inches in height and weighs 25 ounces, 8 pennyweight.

INSCRIPTION—The owner's coat of arms, in this case a butterfly above a scorpion (which may be fanciful rather than legitimate), is engraved in an elaborate cartouche of scrolling foliage terminating in ribbon-tied swags of fruit.

HANDLE—The handle has an applied lion passant at the top and a female mask at the base, both features of American tankards not found on English counterparts.

BASE—The serrated leaves and wriggle-work band, typical of the more elaborate New York tankards of the early eighteenth century, are derived more from Continental than from English sources.

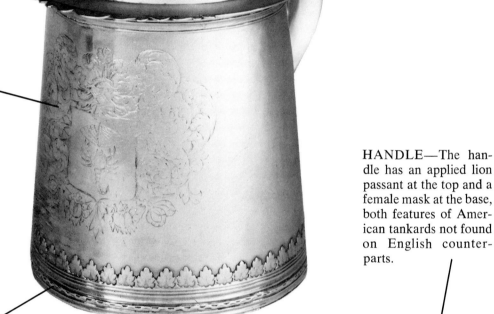

MARKINGS—The maker's mark "C. K." (Cornelius Kierstede), in a rectangle, is struck once on both sides of the handle near the rim. London examples usually have a row of four hallmarks to the right of the handle, all of which are repeated on the cover.

SALVERS

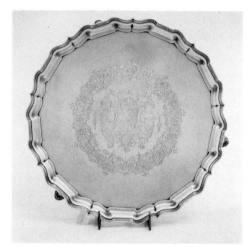

Fig. 1

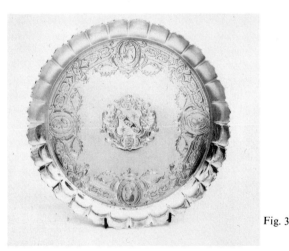

Fig. 2

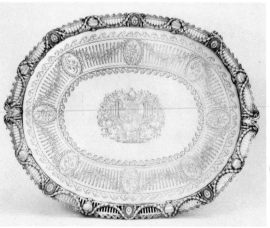

Fig. 3

The word "salver" is probably derived from the Spanish word *salvar,* meaning to preserve. Originally salvers were designed for the presentation of food at the table, and at first they were mounted on a single, central foot, as that in Fig. 1, made by Nathaniel Lock in 1708. About 1715, designs with three or four feet appeared.

Salvers are among the most difficult articles for a silversmith to make, since the shaping of a large flat sheet of even-gauge metal requires considerable time and skill. A number of eighteenth-century makers, including John Tuite, Edward Capper, Robert Abercrombie, and John Carter, specialized in this form.

The expansive flat surface of the salver provided a perfect vehicle for the engraver. Perhaps the finest engraved example is the Walpole Salver made by Paul de Lamerie in 1727, which carries a representation of the Exchequer Seal of King George I. The engraving is attributed to William Hogarth.

A large circular George II salver by Augustine Coutauld and a smaller one with a scalloped rim by Paul de Lamerie (Figs. 2 and 3) show the conventional engraved ornament of the 1720s, interlaced strapwork enclosing masks and husks.

A later example (Fig. 4), attributed to John Carter, is of exceptional size (31½″ in diameter), and a tour de force of engraving. The pierced borders (first introduced about 1745), with festoons hanging from urns and paterae, show the influence of Robert Adam.

A John S. Hunt Victorian salver (Fig. 5) is decorated with chased, rather than engraved, flower sprays. In engraving the metal is removed by a sharp tool, whereas in chasing it is pushed into position in low relief, leaving a reverse impression on the underside. The chased flower sprays spreading from a matching border decorated with scrolls and flowers reflect the Victorian taste for romantic naturalism—the antithesis of the symmetry found in earlier pieces.

Fig. 4

Fig. 5

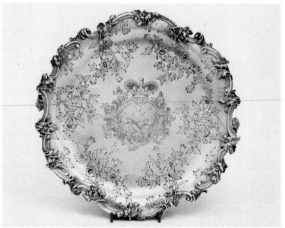

BORDER—The simple molded border and bold outline of this salver by John Bignell of London, 1725, are typical of George I silver, which relied for effect upon vigorous geometric form rather than ornamentation.

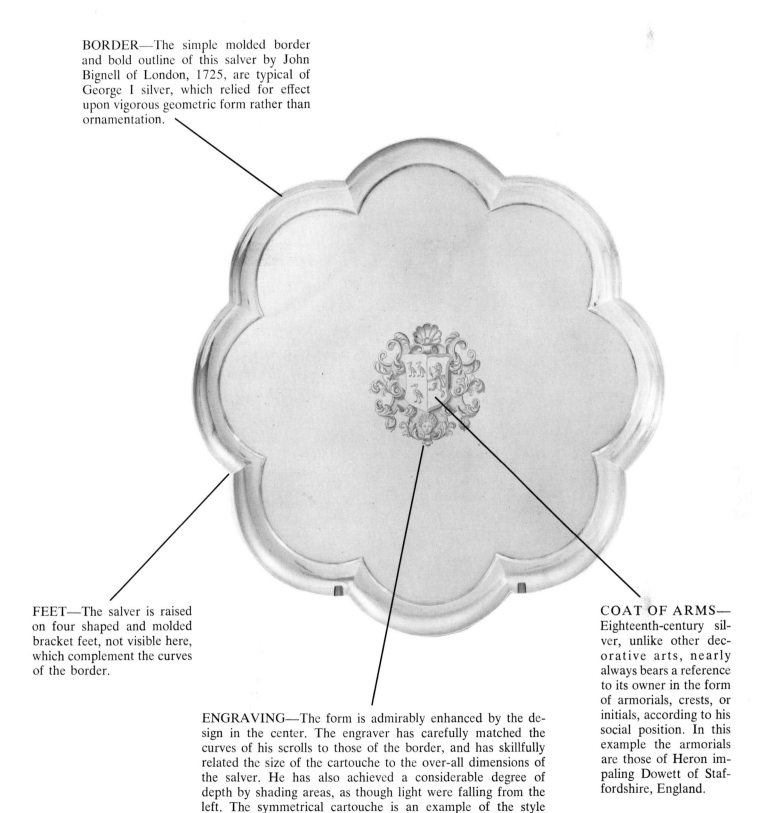

FEET—The salver is raised on four shaped and molded bracket feet, not visible here, which complement the curves of the border.

COAT OF ARMS— Eighteenth-century silver, unlike other decorative arts, nearly always bears a reference to its owner in the form of armorials, crests, or initials, according to his social position. In this example the armorials are those of Heron impaling Dowett of Staffordshire, England.

ENGRAVING—The form is admirably enhanced by the design in the center. The engraver has carefully matched the curves of his scrolls to those of the border, and has skillfully related the size of the cartouche to the over-all dimensions of the salver. He has also achieved a considerable degree of depth by shading areas, as though light were falling from the left. The symmetrical cartouche is an example of the style prevalent between 1690 and 1735. It is baroque in its most controlled form.

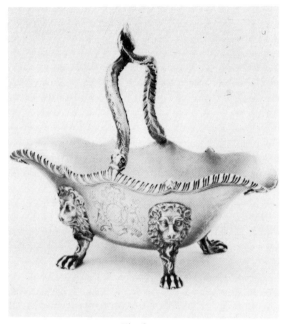

Fig. 1

Sauceboats made their first appearance about 1720. Early examples, such as the one by Nathaniel Gulliver illustrated in Fig. 1, are double lipped, with double-scroll handles on either side, and molded oval bases.

By 1730 a single lip had become general, with a scroll handle at the opposite end. From about 1735 sauceboats were designed with three and occasionally four feet. However, the double-lip variety continued to be made, as in Fig. 2. In this English example by Peter Archambo the handle is in the form of two eels with entwined tails meeting overhead.

Sauceboats were generally made in pairs, although small versions, usually called cream boats, were sold singly. In the late eighteenth century the sauce tureen with cover was introduced. This was usually a diminutive form of soup tureen and was often sold in pairs together with the larger vessel, the three forming a set. Although the covered tureen form had the advantage of keeping the liquid hot, it did not completely replace the sauceboat.

In the nineteenth century a number of sauceboats were made with handles formed as or surmounted by animal or human figures. This was a revival of a fashion originating in the 1750s. The figures were often heraldic and, as in Fig. 3, related to the coat of arms of the owner. The horse in this Mortimer & Hunt example may well represent the coat of arms of Hanover. The decoration, typical of the second quarter of the nineteenth century, shows a return to the rococo chasing popular a hundred years earlier.

American sauceboats were rare in the eighteenth century and remained so even in the nineteenth. The example in Fig. 4 by Marquand & Company of New York is similar to English designs of the 1760s except for the stand, which probably owes its inspiration to France.

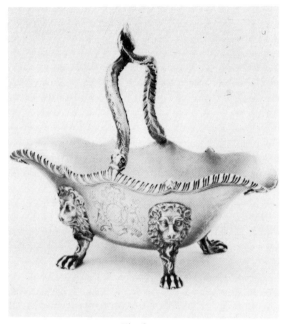

Fig. 2

Fig. 4

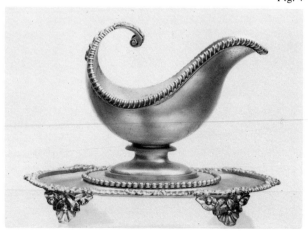

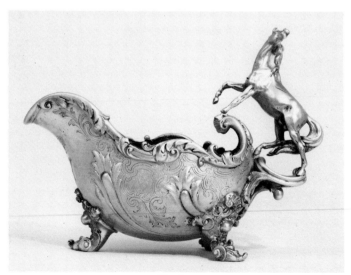

Fig. 3

66

HANDLE—This sauceboat by Paul Revere, Jr. (c. 1770), is distinguished by the applied *putto* mask at the top of the handle, a feature not found in English silver and usually associated with the handle terminals of American tankards.

FORM—The wide lip, for easy pouring, the waved rim and high double-scroll handle capped by a leaf are typical of mid-eighteenth-century English design.

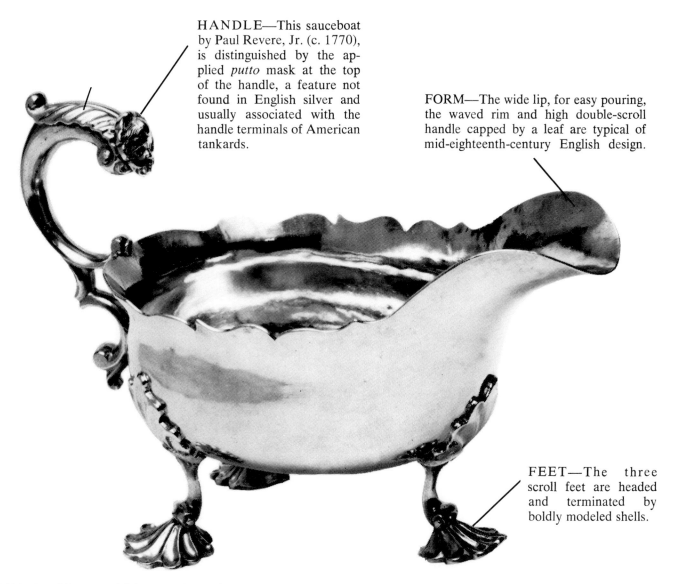

FEET—The three scroll feet are headed and terminated by boldly modeled shells.

MARKINGS—In addition to Revere's own mark, the piece is engraved with the initials "F I M," for Francis Johonnot, a Boston distiller, and his wife, Mary. Many Revere pieces can be traced to the original orders recorded in Paul Revere's day books, preserved in the Massachusetts Historical Society. This not only helps to establish authenticity but provides much information about the life and work of an eighteenth-century silversmith and his clients. Unlike English and European silver, American silver usually carries only a maker's mark. An example of this is shown at left. Paul Revere used several versions of both his full surname and his initials in italic script. Here the surname is struck in the base.

SOUP TUREENS

Fig. 1

Soup tureens were not found in England before the 1720s, but soon thereafter they became, with the epergne, one of the most prominent single articles of domestic plate.

By the middle of the eighteenth century tureens were often lavishly decorated with rococo motifs. In the tureen by Archambo and Meure illustrated in Fig. 1, the scroll feet are headed by masks representing the four seasons, the handles are shells, and the cover is surmounted by a large artichoke, surrounded by other vegetables. This style, derived from French silver, was often even more ornate. Vegetables and crustaceans, eagles and their prey, or hounds and deer might be piled on the cover in lavish arrangements.

At the end of the eighteenth century the trend was toward simplicity, and the boat-shaped tureen, such as that by Richard Cooke in Fig. 2, became popular. Instead of being raised on the four feet associated with rococo examples, tureens of this period generally had an oval pedestal base. Also typical were loop handles, and urn or ring finials.

Following the Regency period (a tureen of this era is exemplified on the opposite page), the use of formal ornament gradually gave way to naturalism. In a transitional tureen, such as the Emes & Barnard example in Fig. 3, massiveness is emphasized with a bold use of hairy-paw feet, lion masks, and acanthus foliage.

By the middle of the nineteenth century most tureens had become copies of eighteenth-century designs, often with classical and rococo themes combined in one piece. By this time their pre-eminent position in the dining room had been taken by ornate tea and coffee services.

Fig. 2

Fig. 3

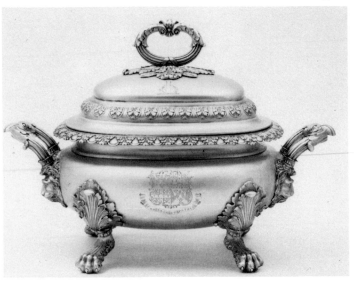

HANDLES—Designed in 1806 by Digby Scott and Benjamin Smith of London, this piece has handles in the form of the head of a helmeted Minerva. Encircling these helmeted heads are snakes wrapped in leaves, a design derived from French Empire silver.

FINIAL—At this date finials were often heraldic. The fashion for featuring the owner's crest or coronet spoiled the design of many such pieces. In this example, however, the finial complements the cast decoration of the body.

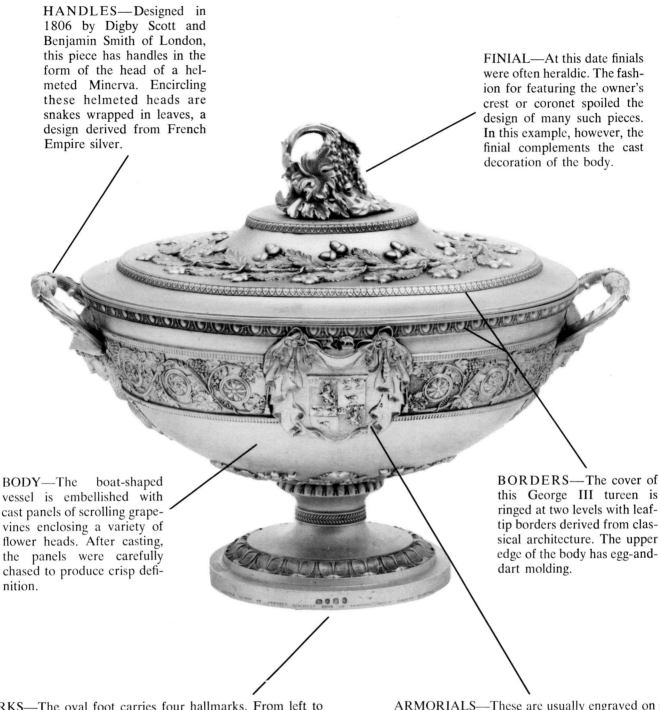

BODY—The boat-shaped vessel is embellished with cast panels of scrolling grapevines enclosing a variety of flower heads. After casting, the panels were carefully chased to produce crisp definition.

BORDERS—The cover of this George III tureen is ringed at two levels with leaf-tip borders derived from classical architecture. The upper edge of the body has egg-and-dart molding.

MARKS—The oval foot carries four hallmarks. From left to right they are: (1) a lion passant, to certify that the piece meets the sterling standard; (2) the crowned leopard's head to indicate London as the place of manufacture; (3) the letter L for the year 1806; and (4) the king's head in profile to show that duty has been paid. The latter mark was in use only from 1784 to 1890. The maker's mark, not visible here, is normally struck beside the other marks. Below the marks is the Latin signature of Rundell, Bridge & Rundell, the royal goldsmiths during the Regency period.

ARMORIALS—These are usually engraved on silver, but for an important commission, as in this case, they could be cast, complete with a drapery mantle tied by tasseled cords. The arms are those of Richard Fountayne Wilson of Melton, Yorkshire.

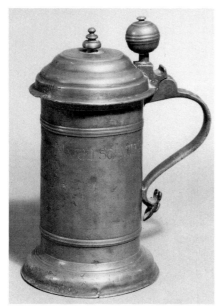

Fig. 1

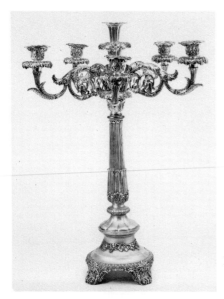

Fig. 3

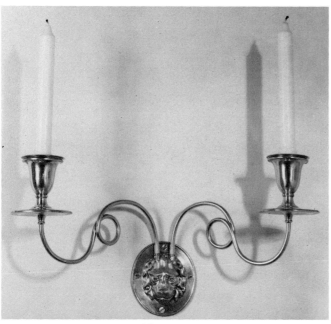

Fig. 4

Although silver was used extensively over the centuries for a variety of domestic, ecclesiastical, and ceremonial wares, there was always a demand for a substitute that was less costly. Pewter and, later, Sheffield plate were practical for everyday use and for those who could not afford silver.

From medieval times at least, pewter chalices, plates, pots, and tankards enjoyed widespread use. Pewter is an alloy of tin and lead. Its malleability and dull sheen made it very popular initially, and it remains so today.

Pewter's susceptibility to damage is evident in the tankard shown in Fig. 1. This German piece, made c. 1730–1735, has a molded dome lid and a spherical thumbpiece on an *S*-curved handle molded with floral devices. The maker's mark, "*MMK* 20," is impressed on the inside of the lid. In Fig. 2 are an American pewter platter, plate, and sugar bowl dating from the late eighteenth to the mid-nineteenth centuries.

Silver plate, introduced in England in the 1750s, was a very welcome addition to the means by which an emergent middle-class family could display its wealth and enjoy some

Fig. 2

of the luxury of silver without the expense of the genuine article. In Sheffield, long a metal-working center in England, a cutler named Thomas Boulsover accidentally discovered that silver would adhere to copper when fused under heat. This was about 1742. Within a comparatively short time great technical and artistic strides were made at Sheffield in the manufacture of silver on copper plate, to the point where London silversmiths became concerned about the threat to their own businesses and reputations.

The illustration opposite shows some of the grace and distinction found in a fine Sheffield plate article. Another graceful piece is shown in Fig. 3, a wall sconce with its two arms springing from a lion mask. This motif, very much in vogue during the latter half of the eighteenth century, is also found in architecture and furniture as well as in silver and other forms of decoration.

The heavier hand of the nineteenth-century designer is evident in the six-light candelabra with its somewhat mechanical decorative detail, shown in Fig. 4. In 1850, when the even cheaper process of electroplating was discovered, the era of Sheffield plate came to an end.

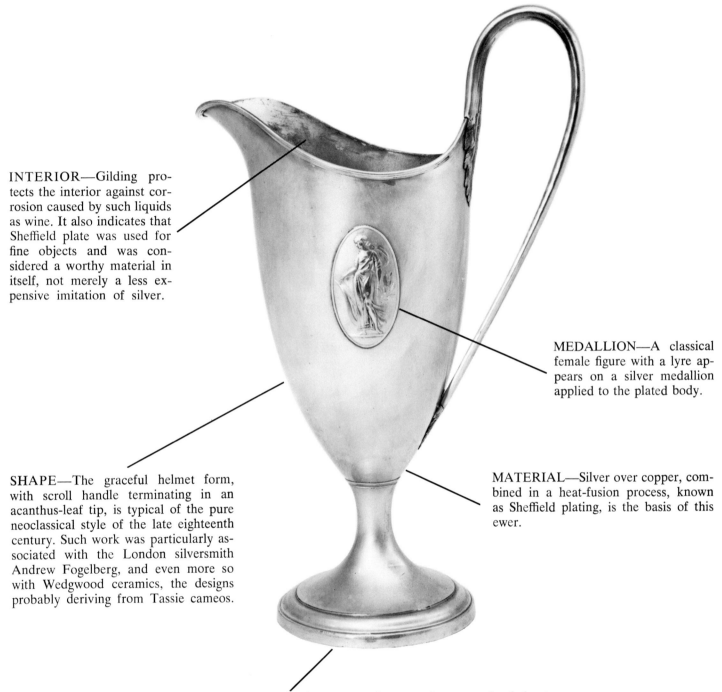

INTERIOR—Gilding protects the interior against corrosion caused by such liquids as wine. It also indicates that Sheffield plate was used for fine objects and was considered a worthy material in itself, not merely a less expensive imitation of silver.

MEDALLION—A classical female figure with a lyre appears on a silver medallion applied to the plated body.

SHAPE—The graceful helmet form, with scroll handle terminating in an acanthus-leaf tip, is typical of the pure neoclassical style of the late eighteenth century. Such work was particularly associated with the London silversmith Andrew Fogelberg, and even more so with Wedgwood ceramics, the designs probably deriving from Tassie cameos.

MATERIAL—Silver over copper, combined in a heat-fusion process, known as Sheffield plating, is the basis of this ewer.

BASE—The simple trumpet form conforms to the helmet shape above. The base is unmarked. Most Sheffield Plate was unmarked, particularly between 1773 and 1784, a period when the London silversmiths were worrying about competition. They were successful in obtaining an injunction against the Sheffield platers which prevented them from applying marks that might lead the public to believe that a Sheffield-plated object was silver. In 1784 marks were again allowed, but these had to display the name of the maker and a symbol or mark that would not be confused with the London hallmark.

CERAMICS AND GLASS

Pottery shards found in prehistoric tombs attest to the fact that clay—so accessible and so easily manipulated—has been used for making vessels since the dawn of time. Yet, except for the vases of classical Greece, most of the large ceramic wares of the West held little aesthetic appeal until the introduction into Europe of Islamic pottery in the twelfth century and the wares of the Orient in about the fifteenth century.

In Italy during the Renaissance all art forms came into focus, and pottery was no exception. Majolica was produced in several centers, the finely decorated ware being intended for display rather than use. In France too, during the reigns of Henry II and Francis I, very elaborate pottery was created, chiefly by the inventive Bernard Palissy.

But this and other fine pottery was a substitute for true porcelain, which was available only from China and at great cost. Many early attempts were made to produce porcelain in Europe. In the second half of the sixteenth century a "Medici ware" was produced in Tuscany, but this proved so costly that the experiment was abandoned. Finally in 1709 the secret of true porcelain was discovered at Meissen, Germany, and a factory opened there was soon in substantial production. Within the next fifty years other porcelain factories sprang up in Germany, and still others in France, Italy, Holland, and England.

Superb wares were produced at Meissen and at Sèvres in France, commanding vast sums then, as today. Less expensive but charming porcelain was made at such smaller factories as Wedgwood in Staffordshire and Hannong at Strasbourg.

Throughout the eighteenth century fine pottery was made in conjunction with porcelain. Although less "refined" than porcelain, among pottery or faïence pieces there are many that are extraordinarily elaborate and impressive.

Glass does not offer the variety of porcelain, but it is of interest for both its beauty and its rarity. Early examples are particularly scarce. The glass industry was mainly centered in Venice in the sixteenth century, but later workmen and formulas migrated to other capitals, particularly Germany, Ireland, and England, where fine tableware was produced in substantial quantity. By the end of the eighteenth century a nascent glass industry had appeared in America and was well established during the following century, culminating in the extraordinary productions of Louis Comfort Tiffany.

Fig. 1

Fig. 2

Fig. 3

Fig. 5

Fig. 4

MEDIEVAL ISLAMIC POTTERY

The chief characteristic of medieval Islamic pottery was its use of a true glaze. The technique of glazing is believed to have originated in ancient Egypt and to have spread eastward into Mesopotamia and Syria during the Roman period.

During the Sassanian period (third to seventh century A.D.) glazed pottery took second place to other materials. The craft was revived early in the Islamic period, and from the ninth century to the twelfth, Islamic potters devised new methods of decorating glazed wares. The techniques varied from region to region.

The bowl from Mesopotamia shown in Fig. 1 is an early example of luster painting. A metallic pigment, ranging in color from deep copper to golden yellow, was painted over the fired glaze. The vessel was then refired, and the lustrous metallic elements adhered closely to the glaze. The decorative lion is in the bold and naïve style typical of early luster pottery.

In the slip-painted bowl of Samarkand type (Fig. 2) the style is similar but the technique is different. Green, brown, and tomato-red pigments were painted directly on the bowl, which then received a protective colorless glaze and was fired. A clay slip was mixed with the colors to prevent them from running when the glaze was applied.

In the Kashan bowl (Fig. 3) the glaze itself gives the vessel its color. The water-weed motif was painted in black, then the entire bowl was covered with a transparent turquoise glaze which allowed the black design to show through.

Molded or incised ornament was also popular. The Rayy jar (Fig. 4) has a molded frieze of dancing figures beneath a glaze of deep lapis-lazuli blue. On the small bowl in Fig. 5 a haphazard spiral design was incised on a bright yellow ground; the pooling of the glaze in the incisions darkened the line. Chinese influence, always strong in Islamic pottery, shows in the green splashes around the rim, which imitate T'ang mottled wares.

Despite the many techniques employed by these craftsmen, the pottery as a whole has a fundamental unity. Unlike the ceramics of Greece and China, medieval Islamic wares are rarely beautiful in form, nor is there the refinement of surface decoration characteristic of later European porcelain. Instead the Islamic potter strove for vivid color and luminous glaze, which complemented the spontaneity of his designs.

SUBJECT—The painters of *minai* wares frequently used figural subjects. Sometimes historical scenes and episodes from the *Shah Nameh* (Book of Kings) were depicted. Here the two horsemen are purely decorative; like the tree and the ring of richly plumaged birds, both are spontaneously but delicately executed.

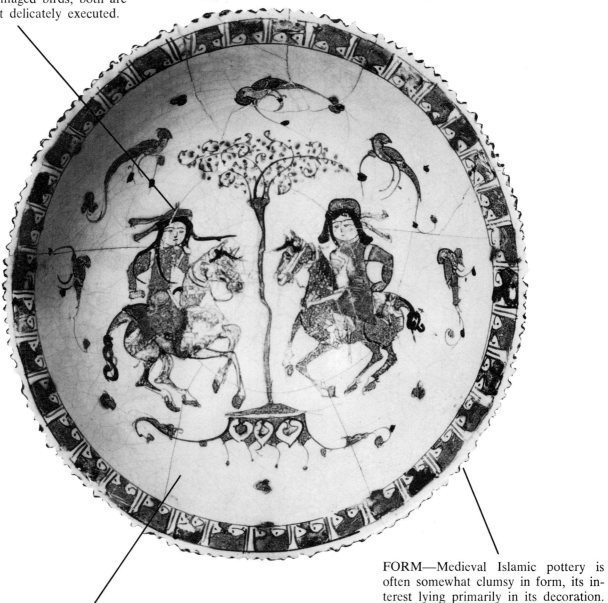

TECHNIQUE—Pottery of this type is called *minai,* a term referring to the manner in which it is decorated. With this technique, among the most complex in Islamic pottery, the potter achieved a broad range of colors. This bowl, created in the late twelfth or early thirteenth century A.D., was first covered with an ivory-white glaze. The design elements, in sea-green, aubergine, and pale blue, were then painted over the glaze. Next, the bowl was fired, after which supplementary black and gilt-leaf were added. The bowl was then fired again at a lower temperature. The second firing was necessary for the black and gilt, which could not withstand the high temperatures needed for the first glazes.

FORM—Medieval Islamic pottery is often somewhat clumsy in form, its interest lying primarily in its decoration. *Minai* pieces, however, are often exquisitely shaped and in the delicacy of their potting they resemble porcelain. This deep bowl rests on a high foot. Its profile is gently rounded, with a slight outward flare at the rim.

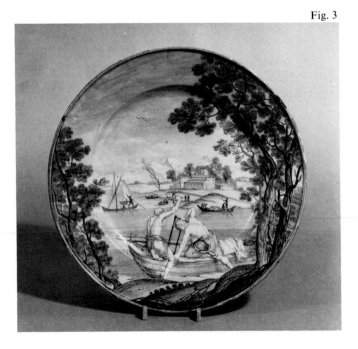

Fig. 1

The recent revival of interest in majolica has resulted in outstanding examples commanding the highest prices since the 1920s, when collectors, particularly in America, filled their houses with Renaissance treasures.

This form of earthenware, glazed with a white enamel mixture containing tin, derives its name from the island of Majorca, where the type was wrongly supposed to have originated. It is correct, however, to say that the earliest examples were made by the Moors. Italian majolica reached its zenith in central and northern Italy between the late fifteenth century and the end of the sixteenth.

The styles of majolica painting differed at the various centers of manufacture. At Deruta, for instance, the style was bold and simple; the artists displayed a strong sense of draftsmanship and a predilection for vivid borders. Charming subject matter, as in the dish opposite, was also characteristic.

The artists at Urbino and at Castel Durante displayed a more painterly approach. This can be observed in the dish representing Isaac blessing Jacob (Fig. 1), signed and dated by Francesco Xanto in 1536, and in the unusual Castel Durante vase (Fig. 2), signed and dated by Antoni Patanazzi in 1580.

Although the greatest period of Italian majolica painting belonged to the Renaissance, a major revival occurred in the eighteenth century, particularly at Castelli. Castelli ware usually features genre subjects (Fig. 3) rather than the mythological and Biblical themes favored in the fifteenth and sixteenth centuries.

Fig. 3

Fig. 2

SUBJECT—This vignette of a young man intently embracing a courtesan, who slyly reaches for his purse, is most unusual. Most plates were decorated with portraits or a Biblical or mythological scene.

DESIGN—Bold, relatively simple patterns surround figures in linear outline. The style was influenced by contemporary prints, Spanish pottery, and Oriental porcelain.

GLAZE—A white enamel, made opaque by the inclusion of tin in its composition, provided the ground for a second layer of colored decoration.

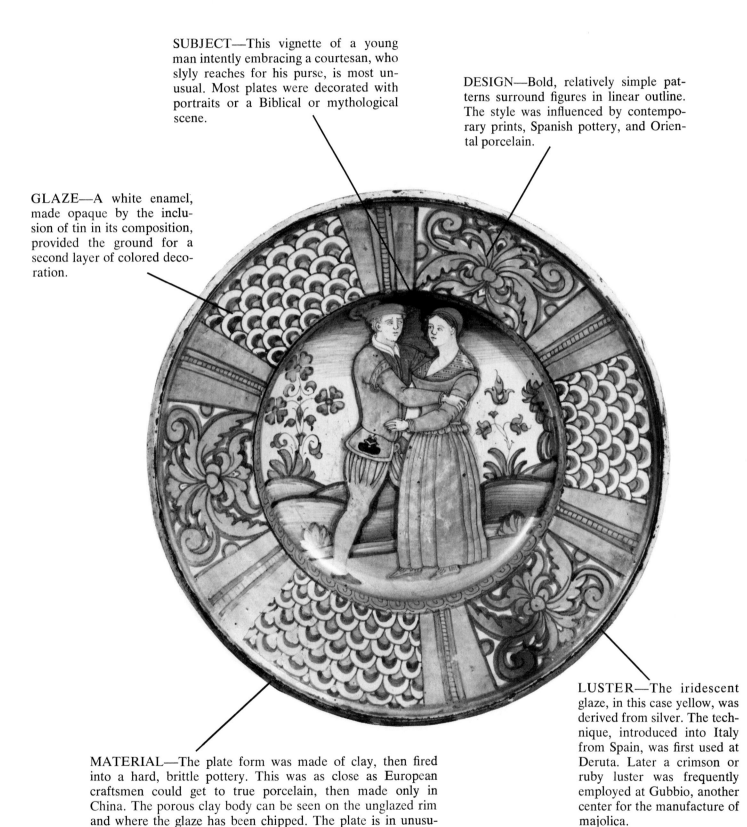

MATERIAL—The plate form was made of clay, then fired into a hard, brittle pottery. This was as close as European craftsmen could get to true porcelain, then made only in China. The porous clay body can be seen on the unglazed rim and where the glaze has been chipped. The plate is in unusually good condition; many examples of this age have been repaired and repainted.

LUSTER—The iridescent glaze, in this case yellow, was derived from silver. The technique, introduced into Italy from Spain, was first used at Deruta. Later a crimson or ruby luster was frequently employed at Gubbio, another center for the manufacture of majolica.

Fig. 1

During the first half of the seventeenth century Chinese porcelain was imported into Europe. Its cost was prohibitive for most families, and in response to the need for a less expensive substitute, local potteries arose. Particularly notable was the establishment about 1650 of potteries at Delft, which became the foremost ceramic center in Holland and one of the greatest in the West.

The earliest products from this area were usually naïve copies of the dinnerware and tea sets the Chinese made for European export in the Wan Li period. Most delftware was decorated in blue and white, although by the eighteenth century multicolored enamels and gilding were used.

Most Dutch delftware was intended for utilitarian purposes. Superb examples, such as the tulip vase seen on the opposite page, were extremely rare and were costly. More typical in form is the blue-and-white barber's bowl (Fig. 1), the cutout rim of which was designed to fit the neck.

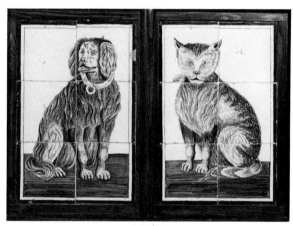

Fig. 2

Fig. 3

As Europe prospered, so did the potters of Delft. Their wares spread all over the Continent, and many of them found their way to the New World. Usefulness was still important, but many plates and chargers were esteemed as decoration. As a result, enterprising Delft potters began making more elaborate pieces, such as covered dishes in the form of fish, figures of peasants and cows, and pictures composed of matching tiles (Fig. 2). With few exceptions, Dutch earthenware was not made in sets; thus single items frequently served only as display pieces.

The success of Dutch delftware profoundly affected pottery making in the rest of Europe, particularly in Britain, where potteries had sprung up in London, Bristol, Liverpool, and Dublin by the end of the seventeenth century. Like Dutch pottery, much English delftware (Fig. 3) was actually produced by Delft potters who came to England at the time of William of Orange. The English pieces, however, were almost never marked, and it requires considerable expertise to tell the difference between English and Dutch delftware.

DECORATION—The design suggests the dual influence of Chinese porcelain in the floral sprays and of European prints in the continuous scene around the base. These two sources were the major inspiration for all Dutch Delft decoration.

BODY—The vase is of buff-colored pottery that has been covered with an opaque white tin glaze. This tin-glaze technique was used on almost all European pottery during the seventeenth and eighteenth centuries.

FORM—Designed to contain tulips in each aperture, the original inspiration for this vase may have been the classical obelisks of Egyptian antiquity; the supporting lions are doubtless adaptations of fifteenth-century German bronze figures. Essentially functional, the form was conceived to show off the brilliantly colored tulips that had only recently become the rage among the Dutch.

MARK—On the underside of the base is the mark of the De Pennis family of potters, who worked from 1750 to 1789. Although many potters in the Delft area signed their work, others did not, and many of the marks—which often are fanciful variations of Chinese characters—have yet to be deciphered.

Fig. 1

Fig. 2

CHINESE EXPORT PORCELAIN

Porcelain of Chinese manufacture was first exported during the Sung period (A.D. 960–1279), mainly to other Asian countries. It had been introduced into Europe by the fifteenth century, but it was not until the middle of the seventeenth century that it appeared there in large quantities.

The first exported pieces usually were decorated in blue and white, although late Ming polychrome and K'ang Hsi *famille verte* (predominantly green) wares also found their way onto the market. One of the many European ports to which they were shipped from China was Lowestoft in Suffolk, England. To this day many people refer incorrectly to Oriental export porcelain as "Lowestoft."

By the eighteenth century more and more porcelain was made solely for export. Particularly popular were large services decorated with the coats of arms of prospective buyers in the West (Fig. 1). These decorations were derived from sketches or bookplates sent to China to be copied. The service illustrated was made for Thomas Snodgrass of the East India Company.

Another popular style of decoration, originally ordered by Jesuit missionaries in China, was derived from contemporary European engravings of religious, mythological, and genre subjects. Painted in black and gold, these pieces are known as Jesuit ware (Fig. 2). The amusing mug in Fig. 3 is an example of this type. Of course, not all export porcelain was elaborately decorated; many pieces were simply painted with scattered flowers and standard Oriental scenes.

Since the eighteenth century enterprising Chinese factories have made porcelain for export in vast quantities. Millions of pieces have found their way to Europe and America, but collectors seek out the more distinctive examples, which have a special charm.

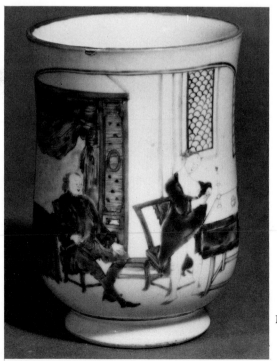

Fig. 3

INTERIOR BORDER—This is a very common type in Chinese Export and is found on many different wares of the period. It is described as a spearhead border. Often a scene related to that on the outside is painted on the interior of such bowls.

SUBJECT—A European hunting scene is depicted. It was copied from contemporary European engravings by Canot and Walker after four paintings by James Seymour, an English artist.

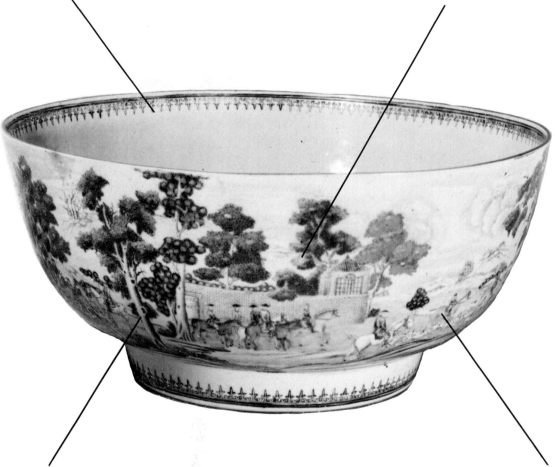

COLORING—The color is in *famille rose* enamels. This means that the colors include pink, a tone that was not developed in China until the beginning of the second quarter of the eighteenth century.

"RING"—Like all unrepaired porcelain bowls, a punch bowl should have a distinctly audible "ring" when lightly hit with the finger. This sonorous quality was revered by the Chinese as unique to porcelain.

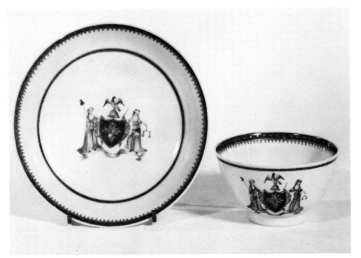

Fig. 1

Chinese Export porcelain enjoyed widespread popularity in America at the end of the eighteenth century. It was relatively inexpensive, since trade between China and the Colonies was extensive. It also filled a demand that could not be met domestically, as there were no porcelain factories in the New World at this time.

There was only one difference between Chinese ceramics for the American and for the European markets—and that was in the patterns. As a result, our knowledge of this field is derived largely from original sales records and the study of the armorial devices that were used. A tea bowl and saucer decorated with a variation of the coat of arms of the State of New York was obviously intended for the American market (Fig. 1).

The value of Export porcelain of this type is determined for the most part by the rarity of its pattern and by the historical importance of the individual or organization for whom the piece was made. This explains the extremely high value placed on the George Washington platter illustrated on the opposite page.

Probably the Export pattern most popular in this country as well as in England was the so-called Fitzhugh. Executed in blue, green, orange, brown, and, more rarely, in lilac and yellow, Fitzhugh is said to have been designed for Thomas Fitzhugh, president of the Canton Company and the captain of a British ship. There were many variations, but the green platter (Fig. 2) is in the standard pattern. A blue Fitzhugh platter from a service made for the Perkins family of Boston is shown in Fig 3.

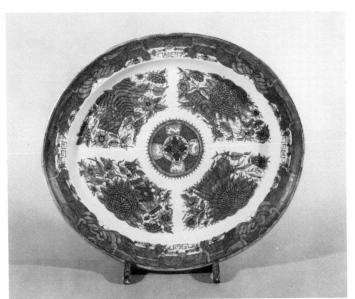

Fig. 2

Fig. 3

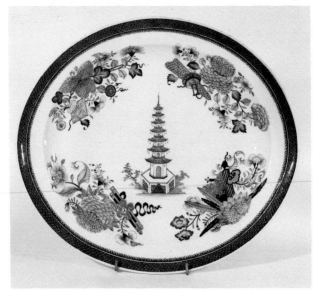

DECORATION—The flying angel, emblematic of Fame, is combined here with the badge of the American Order of the Cincinnati, an organization of men who had served as officers in the Continental Army under General George Washington. The historical interest of this piece serves to differentiate it from the thousands of similar examples made for export to the West, and accounts for the extremely high demand for pieces in this pattern.

BODY—The basic material of this platter, taken from a service ordered by George Washington in 1786, is hard-paste porcelain. This is true of almost all Chinese examples.

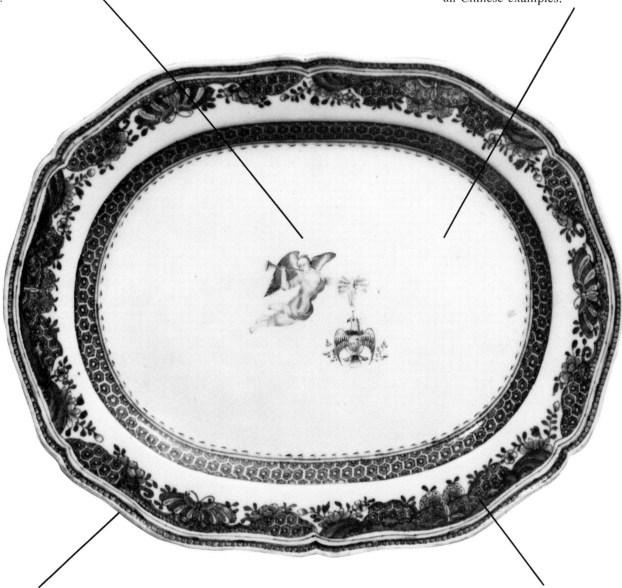

SHAPE—The outline of this platter is probably derived from an English silver shape of the eighteenth century. Not only were decorative details copied from European models; the essential look was often adapted as well, sometimes with rather awkward results.

BORDER—A typical Chinese Export treatment of an insect and flower theme, the border is painted in underglaze blue. It is one of literally thousands of pattern variants of this theme.

THE IMARI PATTERN

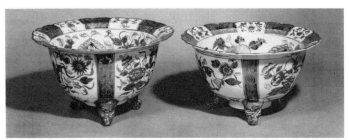

Fig. 1

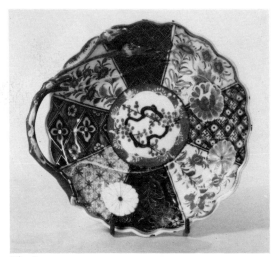

Fig. 2

Fig. 3

When China closed her ports to foreigners for a short period in the late seventeenth century, Japan stepped in as the principal supplier of porcelain to the West. Most of the Japanese pieces produced for export were decorated in a close floral pattern of iron-red, blue, and gold known as Imari. This pattern proved popular in Europe and continued to be so much in demand that it was later copied by German and English factories and even by the Chinese.

The fashionable acceptance of Imari is reflected in the enormous quantity collected by Augustus the Strong, Elector of Saxony. So extensive were his holdings that a special mark was devised in 1721 for the pieces in the royal inventory. Augustus later went so far as to have a Japanese palace erected just to contain his collection. The plate illustrated in Fig. 1 is a Chinese plate in an Imari pattern belonging to the Elector. The Meissen factory popularized the taste for Imari wares, and this led to imitative competition from other European factories.

The two bowls in Fig. 2 are particularly interesting in that they were products of the Vienna factory while it was under the directorship of Claude du Paquier. Note that they are not only decorated in Imari colors—they also owe their form to Japanese prototypes.

Later in the eighteenth century Japanese patterns were used by various English factories, notably Worcester. The sweetmeat dish in Fig. 3 is a particularly unusual example. This form was rarely decorated in the Imari fashion.

The taste for Japanese decoration continued into the nineteenth century, and the Coalport service in Fig. 4 was just one of a vast number made by various factories during this period and even later. The Imari pattern remains popular today.

Fig. 4

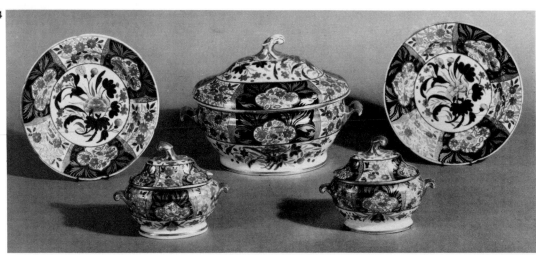

STYLE—The plate is in the Imari pattern, but this is a distinctly European version, dating from about 1730, of the popular Japanese decorative style developed at Arita. It can be identified not only by the design elements but by the traditional Imari colors—iron-red, blue, and gold.

DECORATION—Composed of various Oriental motifs, the design incorporates the popular Oriental lotus, among other flowers. The blue decoration was applied under the glaze. The red and gold layers were applied later and the plate was then refired at each stage at the lower temperature which these more sensitive colors required.

MARK—Crossed swords and the letter *K* appear on the reverse center. The sword emblem is the Meissen mark, while the *K* is believed to stand for Kretschmar, the man responsible for the underglaze-blue painting.

Fig. 1

Fig. 2

Fig. 3

MEISSEN PORCELAIN

True hard-paste porcelain, comparable in quality to Chinese porcelain, was first developed in Europe in 1709 by an alchemist, Johann Friedrich Böttger, who worked for Augustus the Strong in Dresden. Böttger's first products appeared in a hard red-brown stoneware, and his white porcelain was not perfected until about 1713.

The earliest products of the Meissen factory, which was just outside the city of Dresden, were largely utilitarian, and the forms were derived from Chinese imports of the same period. Very shortly, however, the factory turned to shapes of contemporary German silver, which were European in style.

Enamel color was not used as decoration on Meissen wares until about 1720. But by the end of that decade superb painting in fanciful Chinese and Japanese styles had been developed. The teapot illustrated on the opposite page is a fine example of *chinoiserie* painting, decorated under the direction of Johann Gregor Horoldt, the factory manager. A romanticized depiction of the fabled Orient as seen through Western eyes is what is meant by the term *chinoiserie,* in contrast to real Chinese decoration.

The tea bowl and saucer in Fig. 1 are painted in a sparse Japanese style—Kakiemon—named for its inventor, a famous potter from Arita. This piece is particularly attractive because of the turquoise ground surrounding the painted panels. Other ground colors, including yellow, green, powder blue, lilac, and coral, were also used and are considered very desirable.

As the eighteenth century progressed, various new forms of decoration came into fashion. The painting on the snuffbox in Fig. 2 is derived from an episode in *Don Quixote,* although most pieces of this middle period of the factory were decorated with Watteau subjects or scenes from daily life.

Interesting, too, are the wares with floral decoration executed between 1745 and 1755 (Fig. 3). They are among the last of what is generally considered the best period, and by 1763 the so-called Dot Period (characterized by a dot below the crossed-swords mark) was under way, ending the "Golden Age of Meissen."

The Meissen factory is still in existence and has skillfully reproduced many of these early wares, often from the original molds, but these copies lack the spontaneity of the originals.

FORM—An extremely exotic example, the shape is derived from an Augsburg silver teapot of the same period. During the infancy of the porcelain industry in Europe, the products of the more experienced silversmiths were widely used as models.

BORDER—Painted in iron-red, purple, lilac luster, and gold, the border is baroque in feeling; it resembles those found on metalwork and architectural devices of the period. This example was made about 1724.

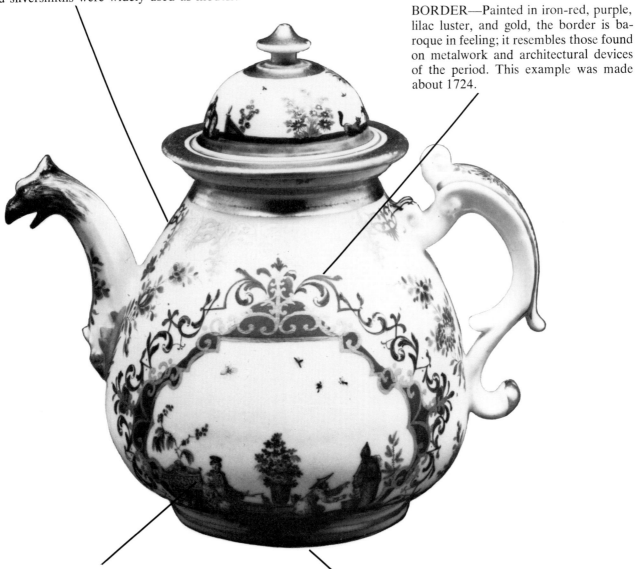

DECORATION—In the fashionable *chinoiserie* style, the decoration reflects the fascination of Europeans with the East. The feeling is distinctly European, although the subject is not.

MARK—The mark shows crossed swords in blue enamel, *"K.P.M."* in underglaze blue, and the numeral 63 in gilding. The letters "K.P.M." stand for Königliche Porzellan Manufaktur and signify pieces made for the private use of Augustus the Strong. The numeral refers to the gilder, whose cipher also appears on the cover. The crossed-swords mark is still in use at the Meissen factory; it varies slightly, depending on the period.

Fig. 1

Eighteenth-century banquets at the courts of the numerous princes of Germany often featured tables elaborately decorated with figures molded of sugar or wax. The Meissen factory, under the patronage of that great host, Augustus the Strong, and his equally genial factory manager, Count Brühl, produced porcelain figures which were to compete with and eventually replace these impermanent decorations.

At first small stoneware figures were turned out. However, the charming examples modeled between 1740 and 1760 are more representative of the factory's work. These figures fall into several distinct categories: animals, birds, Italian Comedy figures, peasants, children, soldiers, Chinese figures, saints, and even workmen from the Saxon salt mines.

Fig. 2

Fig. 3

The chief modeler at the factory was Johann Joachim Kaendler, and the Italian Comedy group of Scaramouche and Columbine (Fig. 1) was completed by him in 1741. His elegant style and superb sculpting are reflected in this fine example.

Another popular series of figures modeled by Kaendler between 1750 and 1755, with the assistance of Peter Reinicke, is the so-called Cris de Paris set, one of which is shown in Fig. 2. These figures representing street venders are taken from engravings by the Comte de Caylus after Bouchardon. Highly regarded in the eighteenth century but now rather out of fashion is the series of children and Cupid, again often modeled by Kaendler. The hairdressing group (Fig. 3) illustrates this variety.

The quality of Meissen figures remained consistently high until the death of Kaendler in 1775. After this date most figures are in the neoclassical style, made under the *Modellmeister* Michel-Victor Acier. These later figures lack the vitality of the earlier examples and mark the decline of the factory from its position of pre-eminence.

SUBJECT—The figure is a character from the Italian Comedy (*Commedia del' Arte*), a form of slapstick theatrical that had spread from Italy to all of the Continent. This figure represents Pedrolino. Like the other characters, he is recognizable by his distinctive costume.

MODEL—This particular form was orignally executed by Peter Reinicke for the Duke of Weissenfels, c. 1743–1744. It was a very popular series, and a relatively large number of sets is known. They are smaller than the better-known figures modeled by Kaendler and were often used as table decorations for aristocratic entertainment.

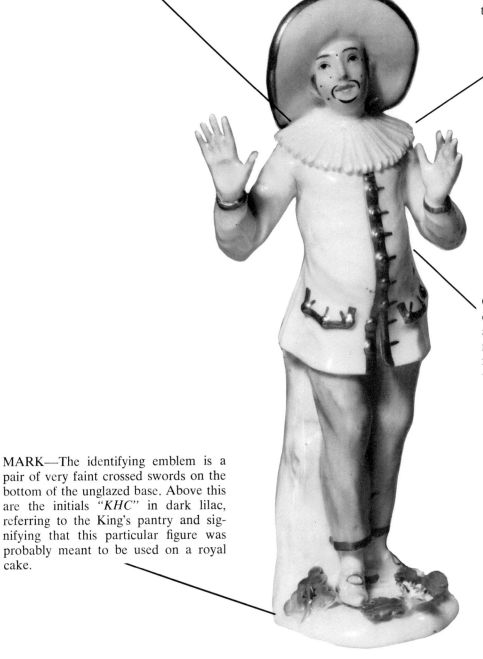

COLORING—On Meissen figures decoration varies greatly from one figure to another. Here the painting displays a rather limited palette. Collectors tend to favor the Harlequin or card-playing figures, where the range of tones is broader.

MARK—The identifying emblem is a pair of very faint crossed swords on the bottom of the unglazed base. Above this are the initials *"KHC"* in dark lilac, referring to the King's pantry and signifying that this particular figure was probably meant to be used on a royal cake.

Fig. 1

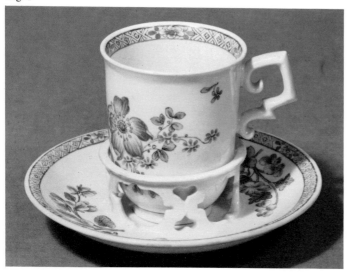

The Vienna factory was the second porcelain factory in Europe and in its earliest period produced some of the finest wares ever made. The factory was established in 1719 under Claude Innocentius du Paquier, from Holland, and the early wares are extremely close in their composition to those made from Böttger's formula at Meissen. This is not surprising, as the secret of porcelain manufacturing was brought to Vienna by two workmen from Meissen, C. K. Hunger and Samuel Stölzel.

The shapes of the Du Paquier wares are almost entirely derived from silver forms and are distinctly baroque in

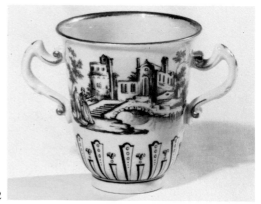

Fig. 2

Fig. 3

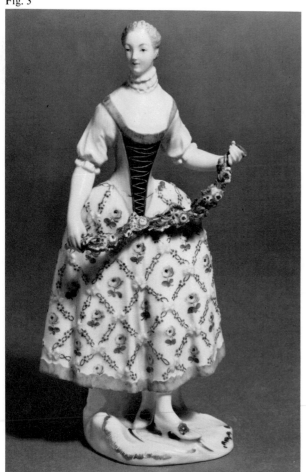

feeling. The decoration is varied, but four major categories exist: Oriental, German floral (*deutsche Blumen*), *chinoiserie* and *Schwarzlot* (black monochrome).

The sauceboat illustrated opposite is an example of one type of Oriental decoration. Other patterns in Kakiemon and Imari styles were also popular. The *"trembleuse"* cup and saucer (Fig. 1) is a form often found in Viennese porcelain of the Du Paquier period, and the painting is of the finest quality. This model is called a *trembleuse* because the saucer has a gallery into which the cup fits securely so that it will not topple if held by a trembling hand.

The beaker (Fig. 2) is an example of *Schwarzlot* decoration. Although the continuous landscape around the rim could date from any period, the gadrooned border at the base is typical of the early eighteenth century, when it was a popular motif in baroque silver as well as in porcelain.

The figures of the Du Paquier period (Fig. 3) are extremely rare. Although they are in many ways naïve in feeling, the coloring is very fine and the motifs of the decoration are consistent with comparable wares.

In 1744 the factory was taken over by the government; it continued in production until 1864. The later products are often of superb quality technically, sometimes at the expense of the vitality apparent in the earlier pieces.

DECORATION—The design is copied directly from a Chinese *famille verte* piece. The exotic bird in the center is a phoenix, a particularly popular device of the period.

SHAPE—Directly copied from a double-lipped silver sauceboat, this porcelain piece closely resembles a number of French, German, and English silver forms of the first quarter of the eighteenth century.

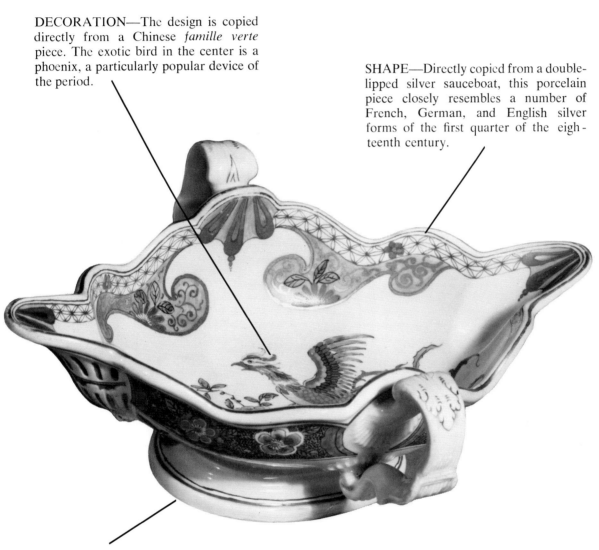

FACTORY—The base of this piece is unmarked, which is the case with all Vienna porcelain of the Du Paquier period. In 1744 the shield, or "beehive," mark was adopted, and it continued to be used on all later pieces. The erroneous term "beehive" is widely used because the Vienna shield when viewed upside down resembles a beehive. This mark is usually found in underglaze blue but is more rarely impressed.

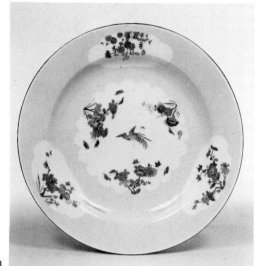

Fig. 1

The craze for porcelain in Europe during the eighteenth century is exemplified by the lavish services made for the ruling monarchs of the day.

It is not surprising that the first royal services made in Europe were for Augustus the Strong. One of these plates decorated on a yellow ground with Japanese Kakiemon flowers is illustrated in Fig. 1; it was part of Augustus's hunting service. The Imari-style butter tub in Fig. 2 is from a service made for his palace in Warsaw.

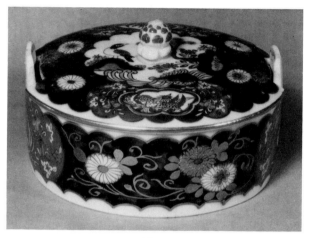

Fig. 2

The wealthiest figures close to the courts also commissioned porcelain for their tables. The plates shown here are Sèvres. The plate in Fig. 3 was made for the Cardinal Prince de Rohan (the Austrian Ambassador) and that in Fig. 4 for Madame du Barry.

Famous among royal porcelains is the set made at Meissen for Catherine the Great; the Russian Empress spread the payments over ten years. Queen Juliana Maria of Denmark possessed a Chinese Export service (Fig. 5).

Collectors today look for pieces from these royal services because the workmanship and decoration is of the finest quality and the romantic association with historical figures increases the interest and value.

Fig. 3

Fig. 4

Fig. 5

DECORATION—This piece is particularly lavish in its rich use of gold, which the king had decreed could be used only on the products of Sèvres, his own factory. The charm of the gilding and the enamel colors results from the way they appear to float over the surface on the soft-paste body.

MONOGRAM—The emblem is that of Catherine II, "The Great" (in the Russian alphabet *Ekatepiha*). This service was made to her order.

CAMEO MEDALLIONS—These reflect the neoclassical fashion of the day by simulating the carved gems of antiquity.

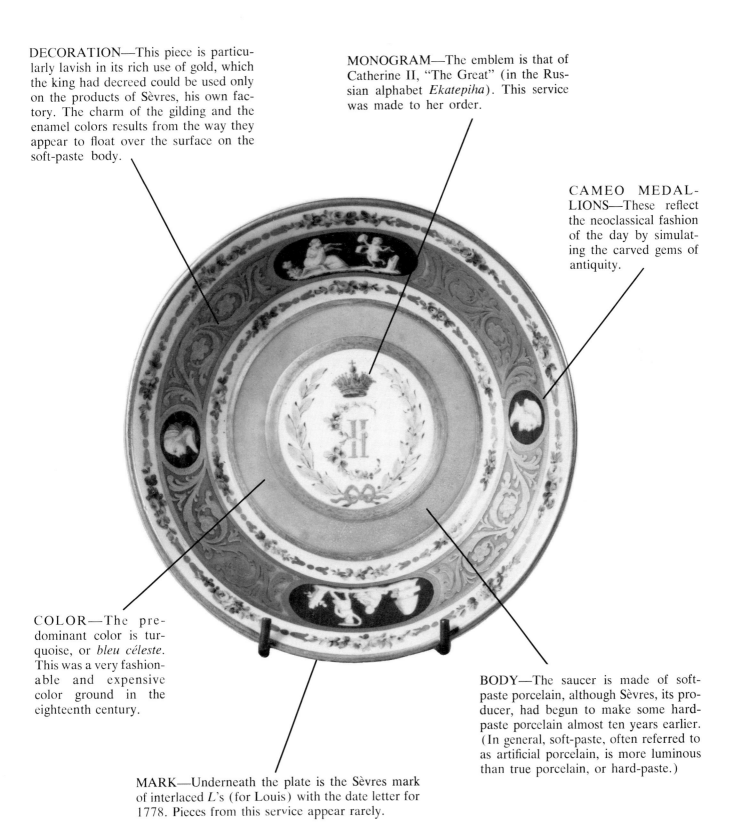

COLOR—The predominant color is turquoise, or *bleu céleste*. This was a very fashionable and expensive color ground in the eighteenth century.

BODY—The saucer is made of soft-paste porcelain, although Sèvres, its producer, had begun to make some hard-paste porcelain almost ten years earlier. (In general, soft-paste, often referred to as artificial porcelain, is more luminous than true porcelain, or hard-paste.)

MARK—Underneath the plate is the Sèvres mark of interlaced *L*'s (for Louis) with the date letter for 1778. Pieces from this service appear rarely.

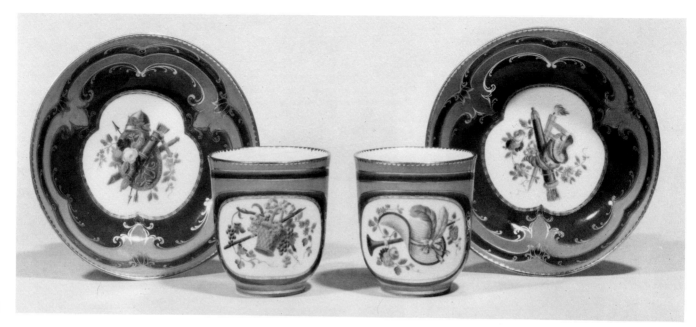

Fig. 1

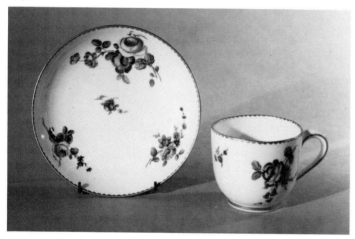

Fig. 2

Fig. 3

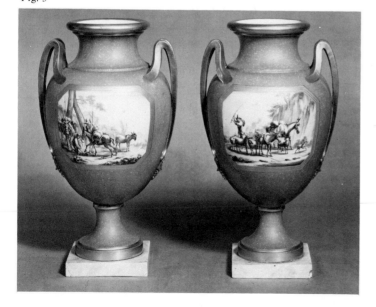

SÈVRES PORCELAIN

The exact origin of the Sèvres factory remains somewhat mysterious to students of European porcelain. Although it is thought to have been founded c. 1738 at Vincennes, the earliest recorded pieces date from the last years of the 1740s.

From its beginning the Sèvres factory enjoyed royal patronage, and no other major French enterprise was allowed to compete with it. The factory actually was bought by Louis XV in 1760 and remained in the possession of the royal family until the French Revolution.

The milk jug shown opposite is of this early period, while the pair of cups and saucers (Fig. 1) is slightly later. The demand for and value of eighteenth-century Sèvres are directly proportional to the richness of the decoration and the rarity of the colored ground. These cups are in apple-green and pink (*rose Pompadour*), which is one of the most desirable combinations. Also popular are turquoise (*bleu céleste*), dark blue (*gros bleu* or *bleu lapis*), the later purple-blue (*bleu de roi*), and the rarer yellow (*jaune jonquille*).

Not all Sèvres, however, is expensive today. The modest value of the charming cup and saucer (Fig. 2) reflects only a lack of interest among collectors; the piece is of high quality.

Other reasonably priced Sèvres pieces include those made at the factory after 1793, when the company was taken over by the Revolutionary government. The extremely attractive vases in Fig. 3 date from about 1795 and illustrate the way in which the factory adapted its output to the neoclassical taste of its new clientele.

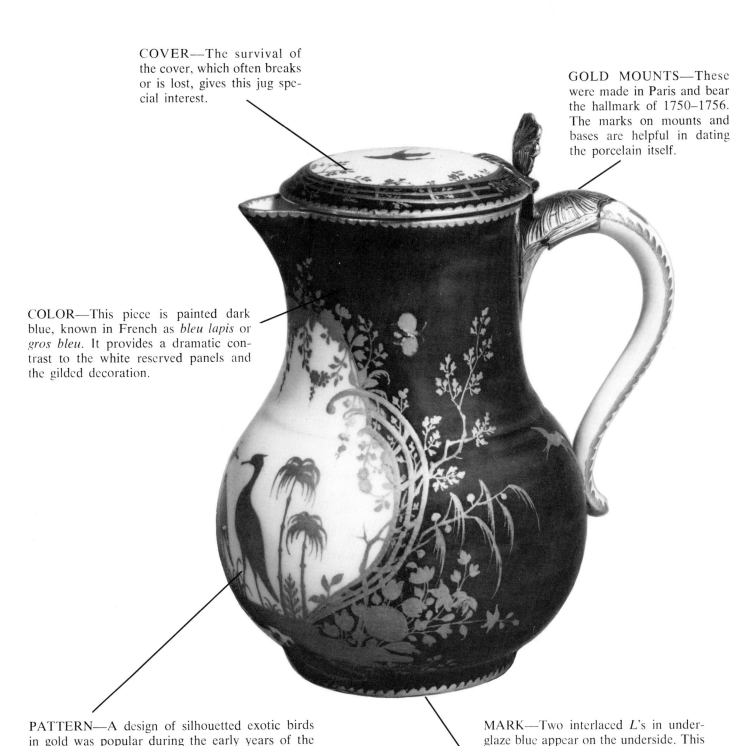

COVER—The survival of the cover, which often breaks or is lost, gives this jug special interest.

GOLD MOUNTS—These were made in Paris and bear the hallmark of 1750–1756. The marks on mounts and bases are helpful in dating the porcelain itself.

COLOR—This piece is painted dark blue, known in French as *bleu lapis* or *gros bleu*. It provides a dramatic contrast to the white reserved panels and the gilded decoration.

PATTERN—A design of silhouetted exotic birds in gold was popular during the early years of the Sèvres factory, so much so that it was copied by the Chelsea factory in England during the Gold Anchor Period (1758–1770). The delicately gilded and tooled borders attest to the high level of workmanship at the Sèvres factory, as well as to the wealth of its royal patronage.

MARK—Two interlaced *L*'s in underglaze blue appear on the underside. This mark is also found in blue enamel, and from 1753 onward surrounded a letter of the alphabet, referring to the date of manufacture. This piece, made before date letters were used, is of the Vincennes period, prior to the factory's removal to Sèvres in 1756.

Fig. 1

Fig. 2

VIEUX
PARIS PORCELAIN

The waning interest of Louis XVI in the royally subsidized factory at Sèvres resulted in the rise in importance of other porcelain factories in Paris during the last quarter of the eighteenth century. Until 1787 Sèvres had a royal monopoly. However, in that year four factories—Rue Thiroux, Clignancourt, Rue de Bondy, and Faubourg Saint-Denis (under the protection of the Queen, the King's brother, the Duc d'Angoulême and the Comte d'Artois, respectively) were granted concessions to produce wares hitherto reserved exclusively for the Sèvres factory.

Paris porcelain is largely repetitive, and it is very difficult to differentiate among pieces from the numerous factories. By the end of the eighteenth century, moreover, scores of independent operators were producing wares in very much the same styles.

The plate illustrated in Fig. 1 was executed at the Rue de Bondy factory c. 1790 and reflects the Louis XVI neoclassical style. The quality of the painting is superb, and the plate's relatively low price makes it a good purchase for modest collectors.

The Louis XVI style was replaced in the early nineteenth century by the more pretentious Empire style of Napoleon's reign. This later period again derived most of its inspiration from neoclassical and Egyptian forms, but vases and other pieces are often heavy and pompous (Fig. 2).

Another example of Paris porcelain is the cup and saucer, c. 1810, in Fig. 3.

A rare and extremely interesting plate with the American presidential seal is also illustrated (Fig. 4). It was made as a sample, showing several variations of borders for selection by an American client, and reflects the international clientele of this important center.

Fig. 3

Fig. 4

COLOR—This example is predominantly gold. The surface is covered in burnished gilding, a popular technique on Paris porcelain.

FORM—Of neoclassical inspiration, the design is in keeping with the taste of the early nineteenth century. However, it bears little resemblance to any authentic classical piece.

MATERIAL—Like almost all Paris porcelain, this piece is of true hard-paste porcelain, white and of fine texture.

DECORATION—The decoration varies widely from one piece of Paris porcelain to another. Landscapes, neoclassical scenes, *chinoiserie* figures, and, as here, portraits were particularly popular. A veritable army of porcelain painters was kept busy filling orders from innumerable domestic and foreign customers. The quality of the painting ranges from ordinary to extremely fine.

MAKER—This particular example is unmarked, although many pieces bear impressed or painted marks of one sort or another. Only further research will enable us to attribute pieces to the various factories known to have been in operation. Of course some examples fully marked with the name of their factory assist in classifying unmarked specimens.

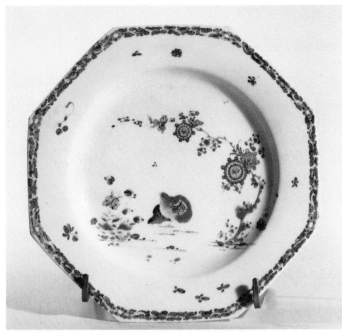

Fig. 1

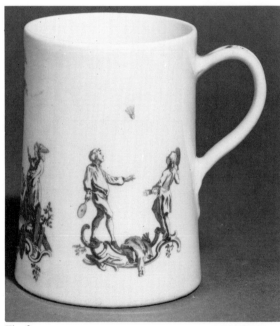

Fig. 2

BOW PORCELAIN

The porcelain factory at Bow, in East London, is thought to have preceded the Chelsea factory by one year. The first recorded reference to the Bow China Works is a patent taken out in 1744 by Thomas Frye and Edward Heylyn for the manufacture of porcelain.

The earliest products were plain white, imitating *blanc-de-chine* ware. They were decorated with typical Oriental motifs, especially prunus blossoms, molded in relief. It is interesting to note that these forms were also widely used at the French factories of Mennecy and St. Cloud during this same time.

By 1775 Bow was producing colorful utilitarian wares in various patterns, including some in Japanese Kakiemon style (Fig. 1). Other pieces were decorated with flowers in Meissen style or in *famille rose* colors after Chinese Export examples. The tankard in Fig. 2 shows another and distinctively English method of decoration—transfer printing, the process by which an etching is "transferred" to a porcelain surface in color. This particular print is by Robert Hancock and is executed in iron-red. This transfer print color is rarely found on any English porcelain products other than those made at the Bow factory.

Among the most desirable types made at Bow are the naturalistic wares, such as the leaf-form cream boat (Fig. 3). Naturalistic wares are much appreciated today.

A wide variety of figures also was produced at the Bow factory. Although derived chiefly from Meissen models, the Bow examples have a naïve charm of their own. The earliest examples have flat mound bases, while those dating from after 1760 are often supported on scroll feet. With rare exceptions, Bow figures are not considered expensive by today's collectors and may prove to be good investments in the years ahead.

The factory ceased production about 1775, when the molds and models were removed to Derby.

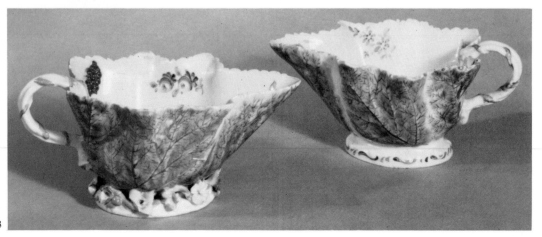

Fig. 3

98

MODEL—The figure was inspired by a Meissen prototype. Bow, like most English factories of this period, copied this fashionable and expensive German porcelain. This example dates from 1755–1760.

COLORING—Rather harsh in general, the colors include a hue which is distinctive of the Bow factory—a pale blue found here on a flower.

MARK—This particular piece bears an anchor and a dagger mark in iron-red. Many Bow examples are unmarked, but a characteristic feature is the brownish color of the unglazed surfaces, revealing phosphatic traces in the clay.

REVERSE—There is a square aperture on the reverse above the base, designed so that these figures could be fitted easily with metal candlearms. Bow is the only English factory that commonly used this device.

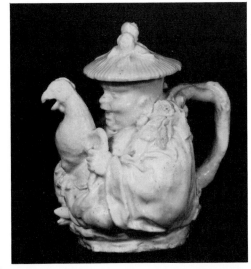

Fig. 1

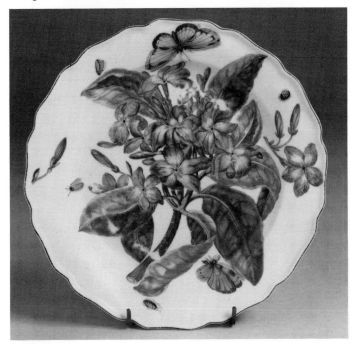

Fig. 2

Fig. 3

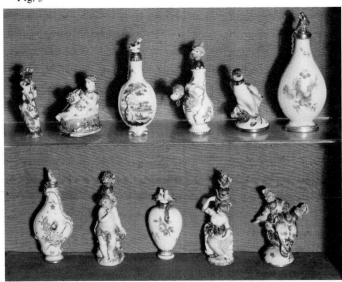

CHELSEA PORCELAIN

Chelsea, perhaps the most important English factory, produced a wide variety of wares and figures from 1745 to 1784. The styles of decoration, the shapes, and the "paste" itself changed markedly during these decades. Consequently today's scholars separate the products into categories relating to the known marked specimens as follows: Triangle Period, 1745–1749; Raised Anchor Period, 1750–1753; Red Anchor Period, 1753–1758; Gold Anchor Period, 1758–1770; and Chelsea-Derby Period, 1770–1784.

The earliest examples, of the Triangle Period, are derived mainly from silver shapes and are usually undecorated. Among the most famous products of this time are the "goat and bee" jugs, the well-known crayfish salts, and a teapot in the form of a seated Chinese man with a parrot (Fig. 1).

The decoration of Chelsea porcelain was often inspired by contemporary Japanese porcelain with Imari or Kakiemon patterns. Another particularly popular type of decoration was derived from prints of botanical flowers in Sir Hans Sloane's Chelsea Physic Gardens, copied from English drawings by Philip Miller (Fig. 2).

Among the most desirable products of the Red Anchor Period are toys and scent bottles (Fig. 3). These are difficult, however, to classify, as many of the molds used were also employed at the neighboring and still mysterious "Girl in a Swing" factory. They continued to be produced into the Chelsea Gold Anchor Period.

From 1756 to 1758 the factory appears to have been closed, but when it reopened the new wares were obviously influenced by Sèvres porcelain. The paste and glaze had changed noticeably, too, the paste being modified by the use of bone-ash, the glaze becoming much more glassy and thick, often falling into pools that resemble cracked ice. The coloring is garish compared to that of the earlier, more restrained products, but the objects themselves are often original in form, reflecting the rococo spirit of the day. The figures are more ambitious and theatrical in feeling, and again are more richly decorated than the Red Anchor pieces.

In 1769 Nicholas Sprimont, a silversmith from Liège, who had managed operations since the early years, sold the factory, and in 1770 it was taken over by William Duesbury and John Heath of Derby. The ensuing products were much closer to those of the Derby factory than to Chelsea porcelain in style and tradition, and these are therefore generally classified with Derby's products.

GLAZE—The glaze on Chelsea Gold Anchor porcelain is unmistakable: it is extremely glossy and often falls into "pools" at the natural terminals, such as handles, foot rims, and interiors.

FORM—A monument to the spirit of the rococo movement, this piece is similar in feeling to other Chelsea pieces of the late Gold Anchor Period. This vase was designed to contain potpourri.

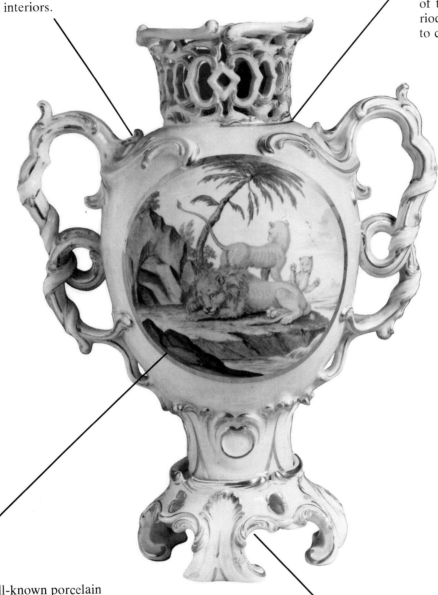

PAINTING—The well-known porcelain painter Jefferyes Hamett O'Neale, who worked on Chelsea, Worcester, and Chinese Export porcelain, executed the painting on this piece. Exotic birds or figural subjects after Watteau, Boucher, or Teniers are more typical decoration on Gold Anchor wares.

MARK—The anchor is almost invariably of small size and should not be confused with the larger anchor mark, usually in red, found on Cozzi Venice porcelain. Depending on the period, the Chelsea mark may be found in either red, brown, gold, but rarely in underglaze blue or puce. This piece bears a gold anchor mark, but it should be noted that this mark is also often found on the forgeries of Samson, a French manufacturer of hard-paste porcelain who specialized in copying the work of various porcelain factories.

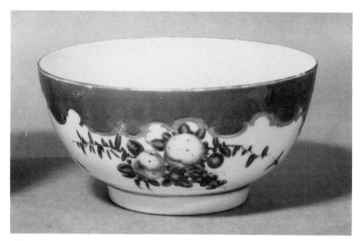

Fig. 1

Worcester was the largest and most productive English porcelain factory of the eighteenth century. It was founded in 1751 and absorbed the Lowdin's Bristol factory the following year. The most important products of Worcester were made during the First Period, which ended in 1783. Although the early products were not ambitious and were mainly utilitarian, they stand out because of their subtle painting. The cream boat in Fig. 1 is an especially pleasing example of this early period.

As the factory progressed, various ground colors were perfected, inspired by styles developed at Sèvres. Apple green, claret, yellow, and turquoise—colors of the bowl in Fig. 2—were the most popular.

Other European ceramic factories also influenced the production of Worcester. For example, the blue "scale" technique, also done in yellow and pink, was borrowed from Meissen and Berlin.

Loyal Worcester collectors tend to try to have an example of each of the many types of decoration the factory produced. Rare patterns such as that on the sucrier and cover (Fig. 3), from a service specially commissioned by Lord Henry Thynne, are particularly sought after.

In addition to imitating other factories, Worcester also made extensive use of the technique of transfer-printing—England's main contribution to the decoration of eighteenth-century porcelain. The spoon tray in Fig. 4 is transfer-printed in lilac and then hand-colored. Most prints, however, are found in either plain black or underglaze blue.

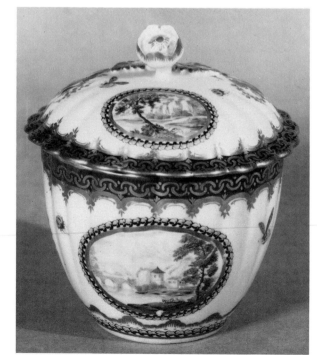

Fig. 2

Fig. 4

Fig. 3

PAINTING—On this particular example the painting was done outside the factory, at the workshop of James Giles, in London. Most Worcester pieces, however, were decorated at the factory. The subject is a brightly plumed bird reflecting the English gentry's interest in nature.

FORM—Exotic but basically utilitarian, this piece was designed to hold chestnuts or sweetmeats.

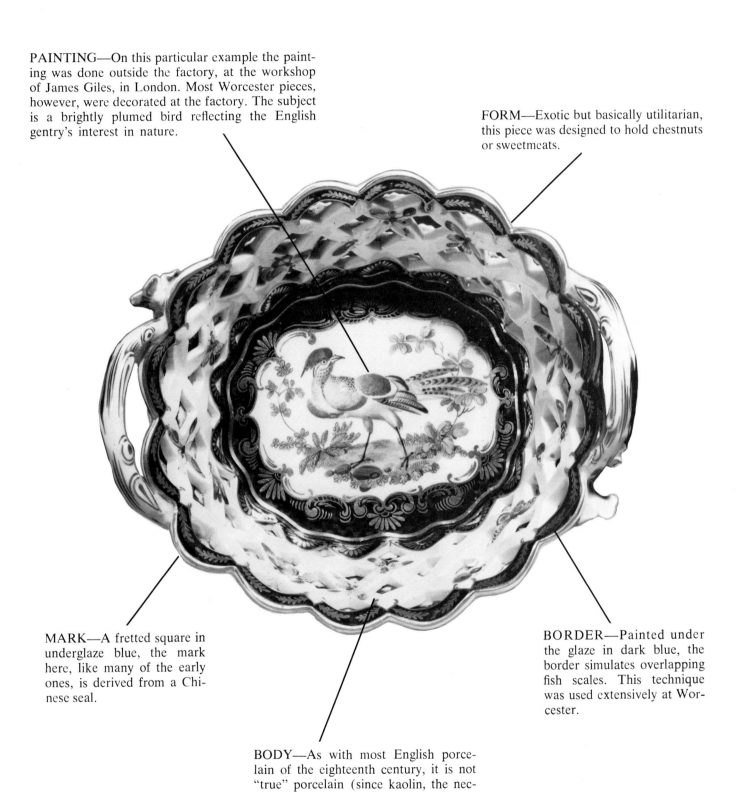

MARK—A fretted square in underglaze blue, the mark here, like many of the early ones, is derived from a Chinese seal.

BORDER—Painted under the glaze in dark blue, the border simulates overlapping fish scales. This technique was used extensively at Worcester.

BODY—As with most English porcelain of the eighteenth century, it is not "true" porcelain (since kaolin, the necessary ingredient, was unobtainable) but soft-paste porcelain. This example is dated c.1765.

WEDGWOOD PORCELAIN

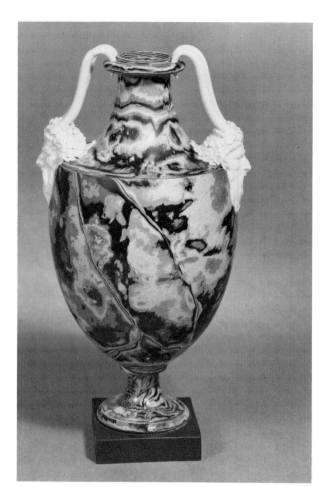

Fig. 1

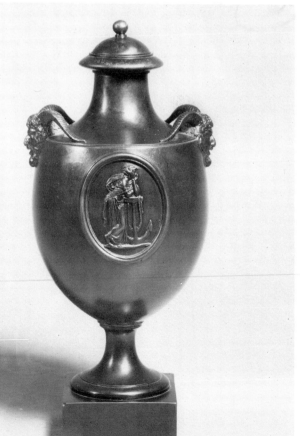

Fig. 2

Josiah Wedgwood (1730–1795) revolutionized the English pottery industry in the eighteenth century. A member of a large family of Burslem potters, Josiah started the Wedgwood factory at Etruria, Staffordshire, in 1768. The first period, still regarded as producing the most desirable wares, lasted from 1769 to 1780, the years during which Wedgwood's partner was Thomas Bentley.

The Wedgwood factory, during this early period, improved many old styles of decoration and developed new materials as well. Among their most popular types are the marbleized wares or "agatewares" (Fig. 1), formed by a mixture of different colored clays, which were developed from similar pottery made while Wedgwood's partner was Thomas Whieldon (1754–1759).

Wedgwood's first original effort was to develop a hard, solid black stoneware capable of being polished on a lapidary's wheel. After much experimentation this was achieved and the name "black basaltes" given to it. The piece illustrated in Fig. 2 is a fine example of the Wedgwood and Bentley period and obviously derives its inspiration from classical art.

The best known of Wedgwood products is jasperware. There are two varieties: solid jasper and jasper dip. In solid jasper the clay is colored throughout. In jasper dip only the surface is colored in the desired tone. Jasperware occurs in white, green, blue, lilac, yellow, black, and brown. Pieces with unusual color combinations are rare.

Creamware, or Queen's ware, is the third of Wedgwood's most successful and best-known products. Less well known but still very representative are rosso antico wares and caneware. The caneware figure of a seated sphinx (Fig. 3) is inspired by ancient Egyptian sculpture, although the adaptation is distinctly Wedgwood and neoclassical in feeling.

From this strong and original beginning, the Wedgwood factory has prospered and remains today a dominant force in the field of ceramic production. Many of the early forms were employed over and over again through the years. Late nineteenth- and twentieth-century examples have the word *England* impressed after the Wedgwood mark. This stamping of the country of origin (begun in response to the American tariff law of 1891) was not done on the earliest productions.

Fig. 3

FORM—Derived from a Greek krater (urn), the form reflects Josiah Wedgwood's reliance on classical shapes for inspiration.

BODY—The composition is hard white stoneware dipped in a wash of pale blue jasper, both made from the clays of England's Staffordshire region.

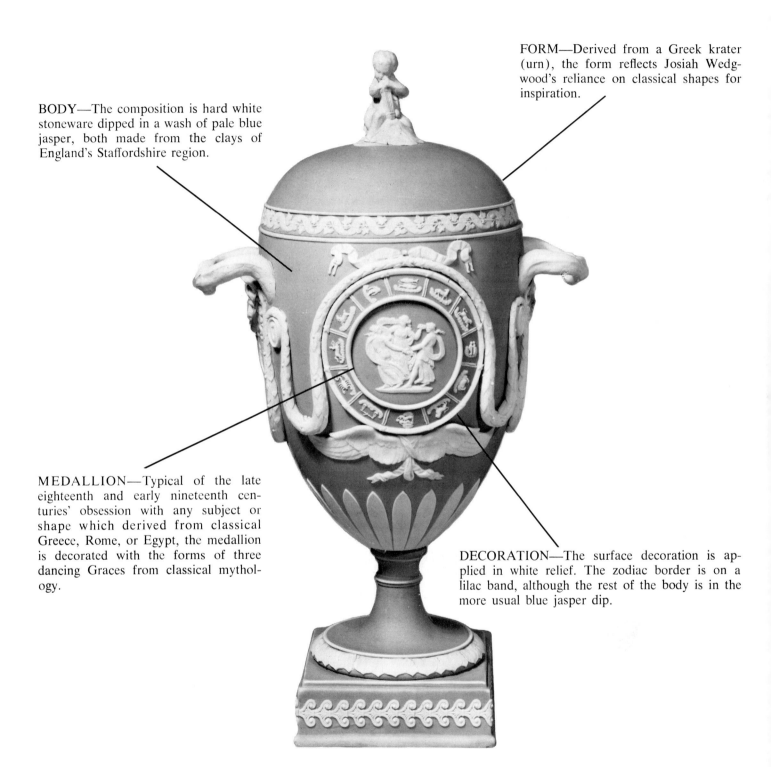

MEDALLION—Typical of the late eighteenth and early nineteenth centuries' obsession with any subject or shape which derived from classical Greece, Rome, or Egypt, the medallion is decorated with the forms of three dancing Graces from classical mythology.

DECORATION—The surface decoration is applied in white relief. The zodiac border is on a lilac band, although the rest of the body is in the more usual blue jasper dip.

Fig. 1

Fig. 2

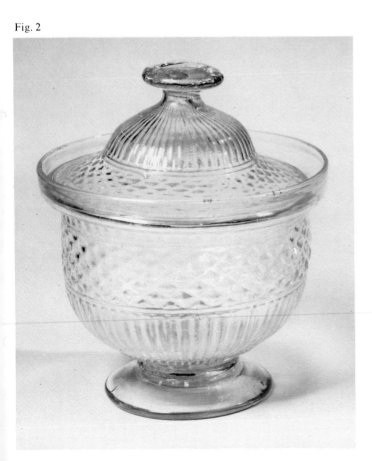

AMERICAN GLASS

Despite the critical need for windowpanes and bottles, by the time the Massachusetts Bay Colony was settled, two commercial glassmaking attempts at Jamestown had already failed. For nearly a hundred years to follow, no colonial glasshouse realized more than a brief or partial success. With all its many early setbacks, however, glassmaking was to reach unimaginable heights in this country after the 1820s, when Americans perfected the mechanical pressing machine. This was the most significant development in the manufacture of glass in 2000 years—since the blowpipe was first used somewhere in the Roman empire. In the decades between, German immigrants had attempted to fill the burgeoning country's need for glass products, chiefly windowpanes and bottles. Among the more notable were Caspar Wistar, who opened his works in Salem County, New Jersey, in 1739; Henry William Stiegel, who started three factories in Pennsylvania between 1763 and 1774; and John Frederick Amelung, who was working in Maryland in 1784. Amelung thought he was assured of success from the start, as he arrived with letters of introduction from Benjamin Franklin and John Adams, whom he had met in Europe, plus money from backers and, not the least, sixty-eight experienced German workmen. However, like Stiegel, he was to be disappointed: Stiegel was in debtors' prison by 1774, and Amelung went bankrupt in 1795.

. In the 1800s glassmaking became important in the Midwest, and one Benjamin Bakewell of Pittsburgh was credited with such a quality output of clear glass that it created a mild sensation both here and abroad.

The sugar bowl, opposite, is of Midwestern origin and is one of only eight or nine known examples. Shown also is a plain blown-glass specimen (Fig. 1) and a blown-three-mold example (Fig. 2). Both sugar bowls are believed to have been produced by the Boston and Sandwich Glass Company.

106

LID—The domed top was formed from a molten gather of glass placed in a sixteen-rib mold, then manipulated by hand to its final shape. While the lid was being formed, it was attached to a pontil rod for ease in manipulation. The mark left by this tool is visible on the flattened surface at the swirled knob.

RIM—Known as a "galleried" rim, this feature distinguishes nineteenth-century covered bowls from those of the eighteenth. The earlier covers have a flange that fits inside the bowl.

BOWL—The surface has been ornamented with diamond diapering and vertical grooves. Three faint lines on the body of the piece are evidence that it was blown in a hinged mold. This is a technique dating back to the glasshouses of ancient Rome; it permitted greater production of tablewares and more elaborate designs than could be achieved with standard blown glass.

ORIGIN—This is a rare example of an early amethyst sugar bowl from the American Midwest. It is believed to have been made between 1810 and 1830 in either Ohio or Michigan.

FOOT—The base piece was formed of a separate gather of glass from the same batch and then applied to the bowl. A pontil mark is visible on the underside.

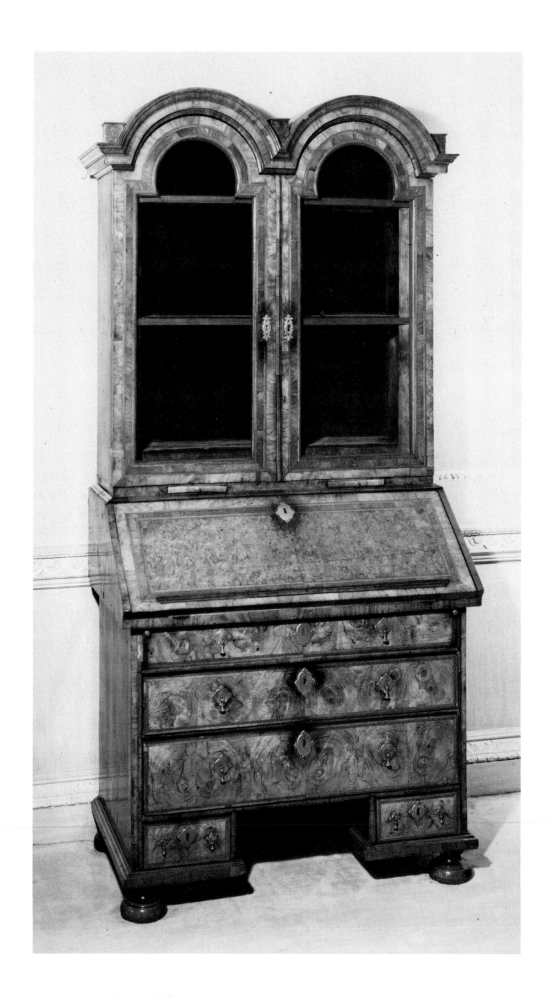

FURNITURE

Nowhere is the happy coincidence of wealth and artistic prowess, so characteristic of the eighteenth century, better demonstrated than in the furniture produced throughout the continent of Europe from the late baroque period to the neoclassical period.

Previous generations had been forced to content themselves with the bare necessities: plank tables, storage chests, settles, and uncomfortable chairs. But when kings, and lesser nobility and wealthy merchants as well, began to build luxurious, unfortified houses in the towns and out in the country, the demand for new furniture—pleasing to the eye as well as comfortable and convenient—gave designers, joiners, carvers, gilders, and upholsterers an opportunity to create beautiful things in quantity.

From the dazzling fancies of inlay and gilding made for Louis XV, to the sturdy yet simple, graceful yet functional, New England country pieces, the varying needs and tastes of the time were met. Today collectors are able to avail themselves of a remarkably large residue of these furnishings. For even after wars, floods, fires, and continued use, great quantities of antique furniture have survived, with lines, proportions, and workmanship that contribute to its desirability in modern times.

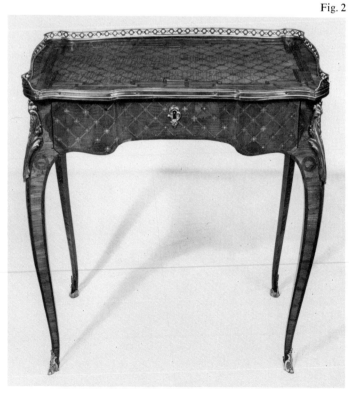

Fig. 1

France was the center of fashion and taste in the eighteenth century. All the courts of Europe copied Versailles in etiquette, dress, and, especially, decoration. In the working districts of Paris some of the finest furniture was created. These workshops were under the control of guilds which from their original foundation in the late Middle Ages set up programs of long apprenticeship, training the most skilled cabinetmakers, gilders, and bronze casters on the Continent.

These guildsmen (or *maîtres*) catered to the courtiers' increasing desire for luxurious comfort and convenience and created multiple-purpose pieces of furniture, often fitted with elaborate locks and mechanisms.

One *maître,* Jean François Oeben, specialized in such pieces, and in spite of guild regulations which forbade a craftsman to practice two activities at the same time, Oeben was both a mechanician and a cabinetmaker. This was possible in Oeben's case only because he enjoyed royal protection (he was appointed cabinetmaker to the King in 1754 and was known to have enjoyed the patronage of Madame de Pompadour).

Oeben is credited with the creation of the complicated, multipurpose mechanical table illustrated opposite. He was noted for making the most luxurious and elaborate tables of this type, although other craftsmen produced variations of the same model.

Another table (Fig. 1) is comparatively small. The frieze pulls out like a drawer and reveals a hinged leather writing surface and several small compartments for writing implements. The end-cut wood floral marquetry, the shaping of the top, and the graceful line of the legs exemplify the Louis XV taste.

Another useful writing table of the late Louis XV period (Fig. 2), by Leonard Boudin, is somewhat comparable to the Oeben table illustrated opposite, although it is considerably less elaborate. The frieze opens in conjunction with the sliding top and reveals a hinged writing surface and fitted compartments. This table was probably made at the beginning of the transitional period between the reigns of Louis XV and Louis XVI. Although the general design remains rococo in character, the trellis parquetry inlaid with stylized quatrefoils at the intersections is in the Louis XVI taste, particularly on the top, where it is surrounded by interlacing rectilinear borders.

Fig. 2

110

TOP—The shaped, ormolu-rimmed top slides back in conjunction with the frieze drawer and is inlaid with a particularly fine and elaborate panel executed in numerous stained and natural-color etched exotic woods on a mahogany ground. It incorporates allegorical symbols of horticulture and the arts and sciences, a reference to the varied interests of its original owner, Madame de Pompadour.

MARQUETRY—In addition to the elaborate inlaid top, the table is veneered all over with flowers and foliage, and the piece is decorated on all four sides, suggesting that it was intended for a prominent position in the middle of a room. Marquetry originated in Germany but reached new heights of refinement and beauty under the influence of French taste. Originally all the various woods would have been colorfully stained, so that the finished inlaid panel would appear to be a painting

MOUNTS—The ormolu mounts are all of rococo foliate form. The capitals of the legs are fitted with mounts incorporating the main charge, a tower, from the coat of arms of Madame de Pompadour. Under guild regulations, the mounts were ordered by the cabinetmakers from the entirely separate workshop of a *fondeur-ciseleur*, who specialized in making gilded metal fittings for furniture.

FRIEZE—The frieze pulls out and contains a shallow drawer released by a secret catch. The frieze is also fitted with a reading stand lined with silk on one side and a lacquer panel on the other and flanked by a hinged compartment at either side.

LEGS—One highly unusual refinement found on this table is the piercing of the cabriole legs, which are fitted with ormolu bandings. This piercing adds to the grace and elegance of the table without sacrificing its strength.

MAKER—This table bears the stamp of both Jean François Oeben and Roger Vandercruse (Oeben's brother-in-law). This is a most unusual feature and may indicate that Vandercruse completed work on the table. In its design, intricate mechanical features, and superb marquetry, this Louis XV table is one of the finest examples of French cabinetwork produced in the eighteenth century.

Several distinct stages of development may be distinguished in the evolution of the French desk or bureau. Its origin can be traced to an early type made during the seventeenth century (Fig. 1) which was formed of a writing surface placed above a number of drawers surrounding a kneehole and topped by an arrangement of smaller drawers.

This form disappeared during the last quarter of the seventeenth century, but was revived during the Louis XV period (1723–1774) when a hinged, sloping fall front was added. This arrangement permitted papers left inside to be kept secret. Known as *bureau en pente,* it originated c. 1730–1735 and was intended especially for a lady's chamber. It ceased to be fashionable and practically disappeared after about 1750.

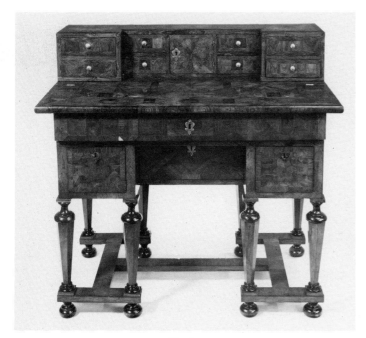

Fig. 1

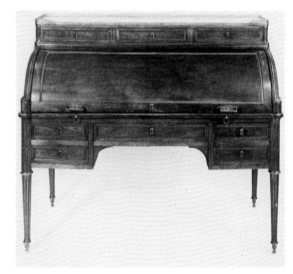

Fig. 3

Fig. 2

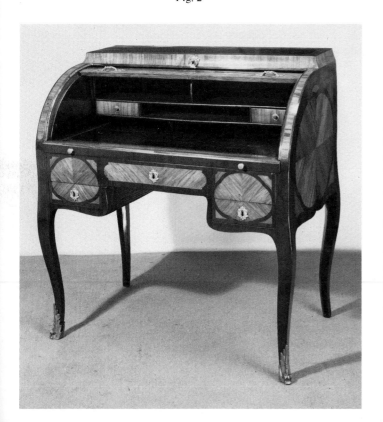

The rolltop desk (*bureau à cylindre*) evolved from the *bureau en pente.* The flat fall front was replaced by a quarter cylinder that slid into the body. Often the rolltop opened in conjunction with the frieze, which slid forward to form an extended writing surface. The interior of the *bureau* in Fig. 2, which is also of the Louis XV period and signed L. Boudin, was fitted with an arrangement of shelves and drawers similar to those of the *bureau en pente.*

The third example (Fig. 3) is a desk in the Louis XVI taste. Its shape is rectilinear, and it is veneered with plain panels of mahogany. In addition to the usual features it contains three drawers between the cylinder and the brass-galleried marble top. The rolltop desk, which appeared c. 1760, remained popular throughout the 1800s.

INTERIOR—The inside of the desk is lacquered in red and fitted with shelves, drawers, and a secret compartment.

MOUNTS—Originally mounts were intended to protect the angles of a piece of furniture from the swords worn by seventeenth-century cavaliers. The mounts were of gilded bronze (ormolu) and survived as a purely decorative feature. This *bureau* is, in addition, completely outlined by a slender ormolu rim, which accents its graceful contour.

FALL FRONT—The distinguishing feature of this desk known as a *bureau en pente* is its fall front. It is sloping (*en pente*), hinged, and, when open, rests horizontally on sliding supports, forming a flat writing surface.

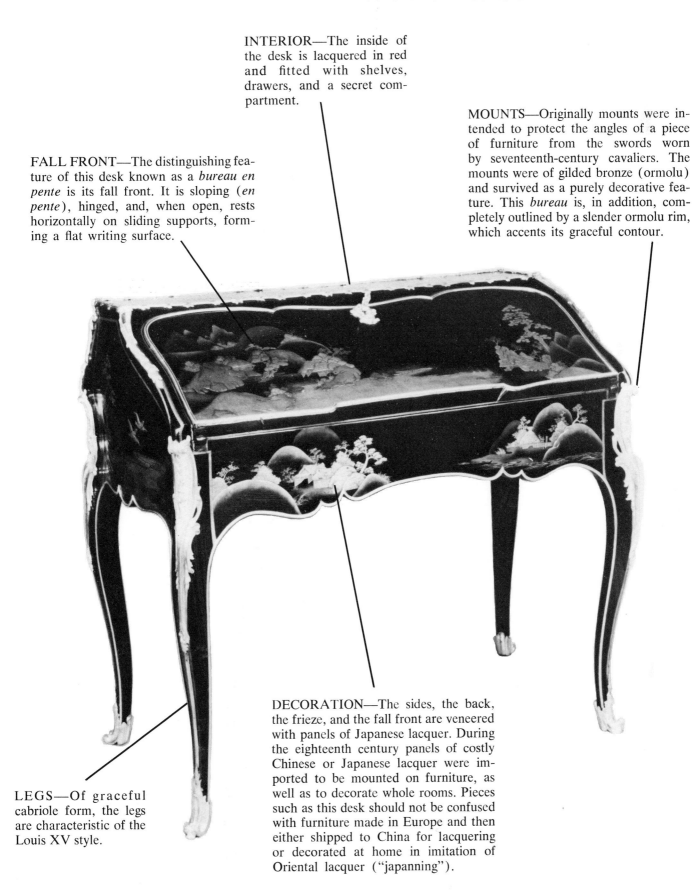

LEGS—Of graceful cabriole form, the legs are characteristic of the Louis XV style.

DECORATION—The sides, the back, the frieze, and the fall front are veneered with panels of Japanese lacquer. During the eighteenth century panels of costly Chinese or Japanese lacquer were imported to be mounted on furniture, as well as to decorate whole rooms. Pieces such as this desk should not be confused with furniture made in Europe and then either shipped to China for lacquering or decorated at home in imitation of Oriental lacquer ("japanning").

113

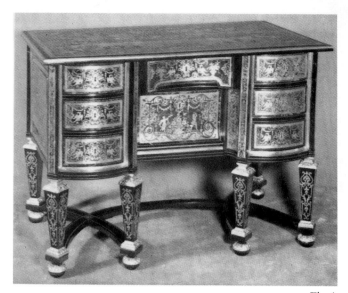

Fig. 1

The precursor of the typical *bureau plat* may be found in the Boulle *bureau mazarin* of the Louis XIV period (Fig. 1). It has a rectangular top and could have been used either as a writing table or a dressing table. The body of the *bureau* contains seven drawers and a cupboard at the kneehole recess and is raised on six legs joined by a curved stretcher.

The *bureau plat* evolved into its final form during the late Louis XIV and the *Régence* periods, when the number of legs was reduced to four, the stretcher disappeared, and the drawers were confined to the frieze.

The *Régence bureau plat* in Fig. 2 retains the rectangular top, but the frieze is shaped and fitted with three drawers, the middle one inset and shallower than the side drawers. The frieze is also decorated with finely chiseled ormolu female heads and foliate handles and escutcheons. The legs have become cabriole in shape, although the full development of curved supports did not occur until about 1740, during the Louis XV period.

Under the influence of the rococo the *bureau plat* became more graceful (Fig. 3). The top was given a shaped outline and placed on full cabriole legs. The ormolu mounts were made totally asymmetrical in form and contrasted with the quartered kingwood veneer, banded with purplewood. An added refinement on this *bureau plat* is the ormolu rim that decorates the base line of the frieze and continues down the cabriole legs to the ormolu-mounted feet.

During the latter part of the eighteenth century the form of the *bureau plat* changed from the curved lines of the Louis XV period to more simple neoclassical lines. The Riesener *bureau plat* opposite is a fine example of this more restrained style, which at its best, as here, has a feeling of elegance but avoids rigidity.

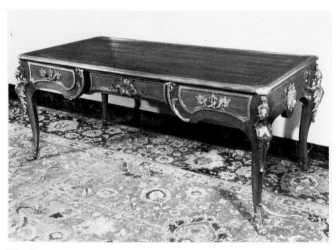

Fig. 2

Fig. 3

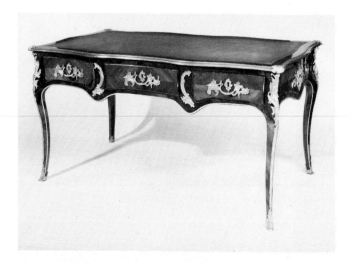

READING SLIDE—A Louis XVI *bureau plat* was often fitted with pull-out reading slides. This example has a hinged reading stand that can be pulled out of the frieze.

DECORATION—Surface decoration is very sparse; the successful design of this piece rests entirely on the simple uncluttered line, the use of finely grained mahogany, and the ormolu bandings chiseled with leaf tips and rope-twist pattern.

TOP—The top is rectangular and covered with a gold-tooled leather writing surface. The coverings were usually leather—occasionally velvet was also employed. However, the pierced brass gallery on this desk was probably added in England in the nineteenth century for convenience. French *bureaux* did not usually have this feature.

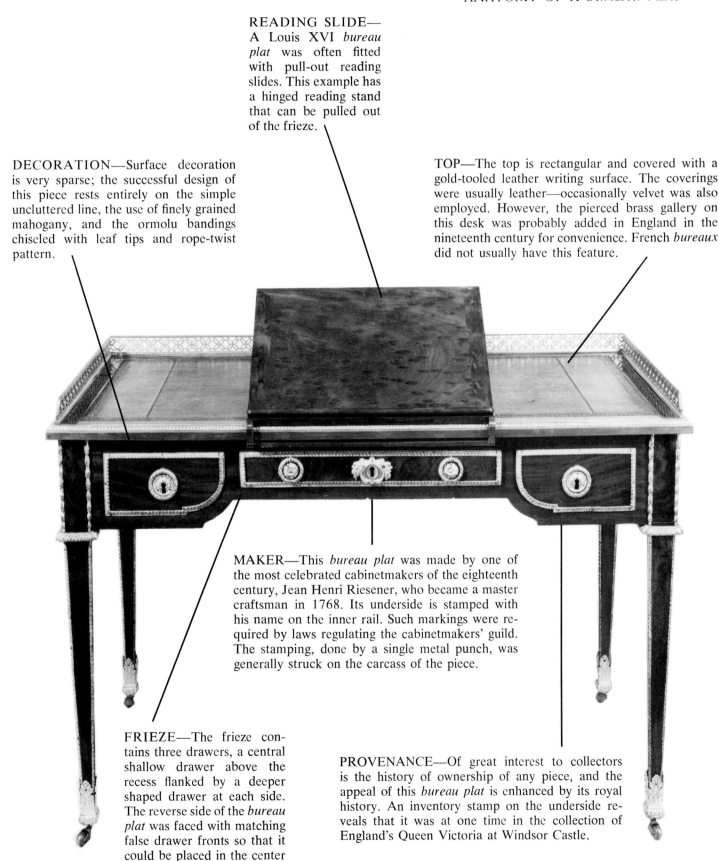

MAKER—This *bureau plat* was made by one of the most celebrated cabinetmakers of the eighteenth century, Jean Henri Riesener, who became a master craftsman in 1768. Its underside is stamped with his name on the inner rail. Such markings were required by laws regulating the cabinetmakers' guild. The stamping, done by a single metal punch, was generally struck on the carcass of the piece.

FRIEZE—The frieze contains three drawers, a central shallow drawer above the recess flanked by a deeper shaped drawer at each side. The reverse side of the *bureau plat* was faced with matching false drawer fronts so that it could be placed in the center of a salon.

PROVENANCE—Of great interest to collectors is the history of ownership of any piece, and the appeal of this *bureau plat* is enhanced by its royal history. An inventory stamp on the underside reveals that it was at one time in the collection of England's Queen Victoria at Windsor Castle.

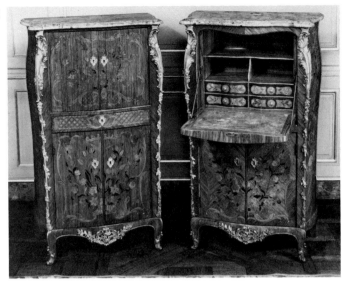

Fig. 1

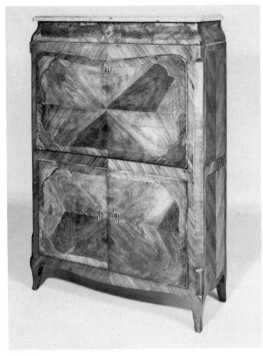

Fig. 2

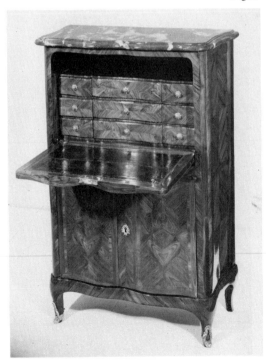

Fig. 3

SECRÉTAIRES

The fall-front desk (*secrétaire à abattant*) is a piece of furniture intended to be used for writing and storage of papers and small objects. The distinguishing feature of the *secrétaire à abattant* is the fall front, which opens to form a writing surface and, when closed, conceals an arrangement of shelves and drawers. It also usually incorporates a drawer above and a cupboard beneath.

The *secrétaire à abattant* appeared in the middle of the eighteenth century and soon replaced the *bureau en pente*. Because it always stood against the wall, the back was left unfinished.

A rather elaborate type of fall-front *secrétaire* (Fig. 1) is of the Louis XV period. It is raised on short cabriole legs and is lavishly decorated with ormolu mounts which have chiseled leaf and shell motifs; the sides are veneered in a design of flowers and foliage to match the front. When open, the flap is supported by metal stays running into the carcass, and inside is the usual arrangement of shelves and drawers.

A simpler *secrétaire* (Fig. 2) dates from c. 1760–1770. The decoration is reduced to a plain veneer of elegantly shaped and quartered panels of tulipwood within cross-banded borders of the same wood. The shape is rectilinear, but the short cabriole legs indicate that this is a transitional piece in the Louis XV–XVI stylistic evolution.

Somewhat similar but smaller, the next desk (Fig. 3) does not incorporate a frieze drawer; greater importance has been given to the small drawers. This *secrétaire* was probably intended for use in a small room, such as a lady's boudoir.

116

FRIEZE—This narrow upper section under the top contains a long drawer fitted with a keyhole escutcheon and two handles in gilded bronze.

TOP—The removable marble top has a molded border that conforms to the general outline of the *secrétaire*. Underneath, the wood top was usually left unfinished and often bears the stamp of the maker.

VENEER—Each part of this *secrétaire* is veneered with plain panels of tulipwood, which was fashionable for surface decoration in the 1780s. The vertical and horizontal arrangement of the veneer creates an interesting contrast.

FALL FRONT—The fall front can be locked in its upright closed position. When open, it reveals a leather writing surface and an arrangement of shelves, pigeonholes, and small drawers for writing utensils.

CUPBOARD—The lower section usually consists of a cupboard with shelves, although it may contain two or more drawers and sometimes even a safe.

ORNAMENTS—The ornaments are all of gilded bronze. They are composed of foliate motifs symmetrically treated and classical in derivation (acanthus leaves, wave design). The main panels are outlined with beaded borders.

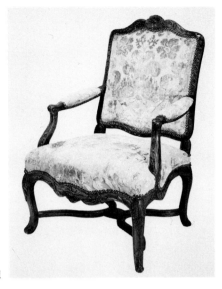

Fig. 1

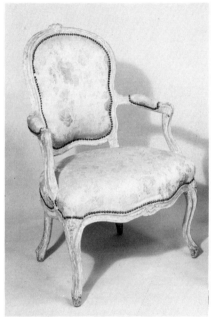

Fig. 2

The popular decorative styles during the eighteenth century in France can be illustrated by comparing the changing types of armchairs (*fauteuils*).

A chair dating from c. 1720, during the *Régence* period (Fig. 1), evolved from the grand and formal baroque style of the reign of Louis XIV. It retains a wide, flat, and almost rectangular backrest and an *X*-form stretcher, but the serpentine top rail, the similarly shaped seat rail, and the cabriole legs suggest the coming fashion of the rococo.

A pure rococo Louis XV armchair (Fig. 2), which dates from the mid-eighteenth century, shows a keen awareness of the beauty to be found in sinuous lines. The flatness and formality of earlier *fauteuils* have disappeared; even the backrest has been curved for the sake of both comfort and design. The size was greatly reduced to fit the intimate suites that had replaced the vast salons of earlier days. A neoclassical version of this form of armchair (Fig. 3) dates from c. 1770, in the Louis XVI period. The asymmetrical curves of the rococo period have been replaced by straight lines and symmetrical curves. This chair relies on simplicity of design with a minimum of carving, yet maintains the elegance of earlier French chairs.

The Louis XVI armchair of later neoclassical design (Fig. 4) is even more elaborate. The frame is gilded and carved with spiral fluting on the tapered legs and the baluster-shaped arm supports. It has entwined ribbon and leaf tips on the backrest and seat rail. This represents the final graceful design of a French chair. With the Revolution and the subsequent Empire period, furniture became heavy and pompous, and the unparalleled elegance of the eighteenth century disappeared.

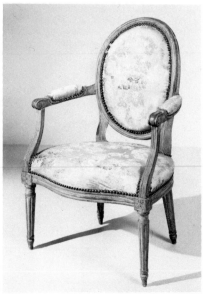

Fig. 3

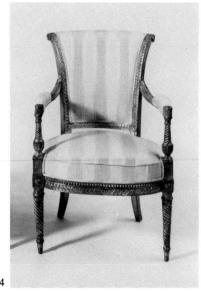

Fig. 4

TAPESTRY UPHOLSTERY—Although this chair is covered with eighteenth-century Beauvais tapestry, the more common upholstery fabrics of the period were silk, brocade, and lampas. Early chairs of this type were often caned and fitted with loose cushions.

TOP RAIL—The joining of the top rail to the uprights of the backrest is perpendicular to the plane of the floor. If the angle is horizontal, the chair is not of eighteenth-century origin or else it is an English chair in the "French taste."

FORM—The open armchair (*fauteuil*) became popular early in the eighteenth century, during the regency of the young Louis XV. Chairs in this graceful style were of more modest proportions than the monumental armchairs popular during the reign of the Sun King.

FRAME—The frame of this chair is of waxed beechwood. The use of natural wood was not uncommon, although originally most eighteenth-century French chairs were either painted or gilded. Surface decoration was preferred, so chair frames were not made of such fine woods as the mahogany prized by English chairmakers.

JOINTS—In eighteenth-century French chair construction wooden pegs, never nails or glue, were always used.

CARVING—The carving may seem to lack a certain crispness because the original coat of gesso and gilding has been removed and the chair has been stripped to its natural wood finish to appeal to today's taste for simpler finishes and exposed wood grain.

119

The *bergère* is a comfortable chair that originated in France early in the eighteenth century and has remained popular to the present day. *Bergères* differ from the usual French armchair (*fauteuils*) in that the area between the armrest and the lower seat rail is closed with upholstery.

The simplest type of *bergère* of the Louis XV period (Fig. 1) has a plain molded top rail which continues down to form the padded armrests. When the backrest of a *bergère* is curved, as in the present example, it is known as a *bergère en cabriolet*.

A *bergère* of the later Louis XVI period (Fig. 2) is rectilinear in form with straight uprights, a bow-fronted seat, and straight legs. The frame is simply molded and carved with flower heads. The shape of the back is called *chapeau de gendarme* because of its resemblance to the hats worn by constables.

Another *bergère* of the same period (Fig. 3) is characterized by more elaborate carving, using such typical neoclassical motifs as interlaced ribbons and Greek-key frets. This *bergère* was covered with gesso (a thin layer of white plaster), and then gold leaf was applied and burnished. Gilding tended to be the primary form of decoration on French chairs of the eighteenth century. However, some examples were painted, partially gilded, or simply of plain waxed wood.

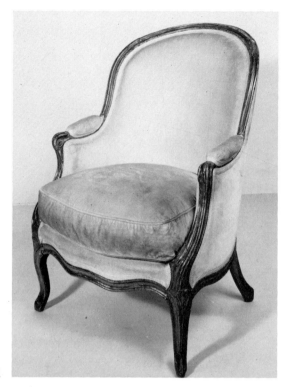

Fig. 1

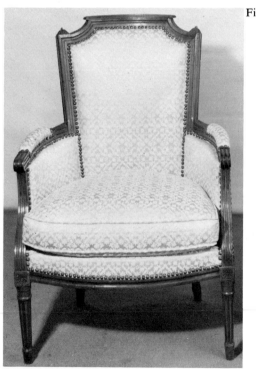

Fig. 2

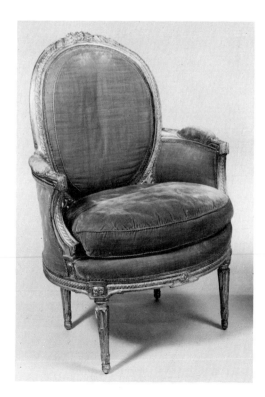

Fig. 3

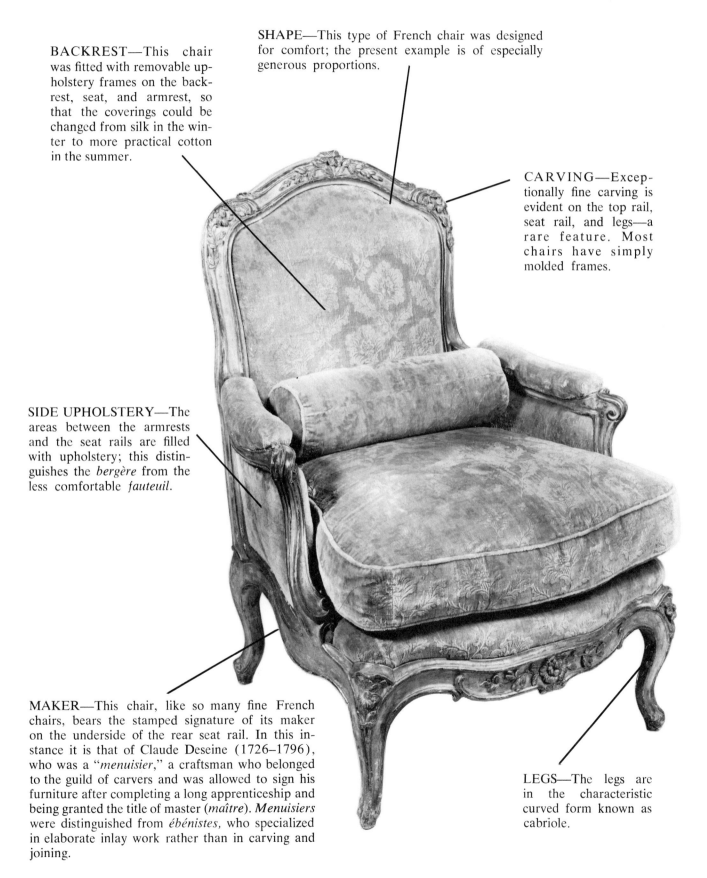

BACKREST—This chair was fitted with removable upholstery frames on the backrest, seat, and armrest, so that the coverings could be changed from silk in the winter to more practical cotton in the summer.

SHAPE—This type of French chair was designed for comfort; the present example is of especially generous proportions.

CARVING—Exceptionally fine carving is evident on the top rail, seat rail, and legs—a rare feature. Most chairs have simply molded frames.

SIDE UPHOLSTERY—The areas between the armrests and the seat rails are filled with upholstery; this distinguishes the *bergère* from the less comfortable *fauteuil*.

MAKER—This chair, like so many fine French chairs, bears the stamped signature of its maker on the underside of the rear seat rail. In this instance it is that of Claude Deseine (1726–1796), who was a "*menuisier*," a craftsman who belonged to the guild of carvers and was allowed to sign his furniture after completing a long apprenticeship and being granted the title of master (*maître*). *Menuisiers* were distinguished from *ébénistes*, who specialized in elaborate inlay work rather than in carving and joining.

LEGS—The legs are in the characteristic curved form known as cabriole.

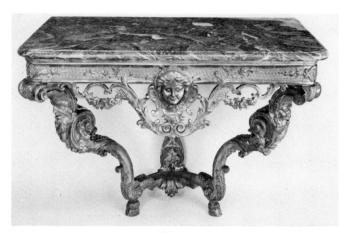

Fig. 1

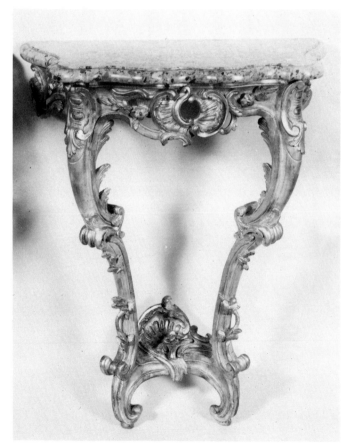

Fig. 2

The console is essentially a flat surface, often of stone or marble, supported by one or more legs. It was usually meant to stand beneath a mirror as an integral part of the over-all architectural design of a room.

As marble was very expensive in the seventeenth and eighteenth centuries, the top of a console was originally its most important and costliest part. However, throughout the eighteenth century the supports of the marble top became more and more elaborate.

The *Régence* console in Fig. 1 has a very broad marble top of typical thickness, and the supports are necessarily monumental. The effect, however, is relieved by delicately carved floral swags, human masks, *C*-scrolls, and foliage. Many of these motifs, notably the masks, were also used in bronze mounts for veneered pieces of furniture.

The small Louis XV console in Fig. 2 is lighter in feeling and is carved with delicate asymmetrical scrollwork. Like the *Régence* console, it was covered with a layer of gesso; then gold leaf, contrasting with the colorful, mottled marble top, was applied.

The console of the Louis XVI period in Fig. 3 is rectilinear in form and richly pierced and carved with bow-knotted floral swags, entwined ribbon, laurel leaves, and fluting. The center of the curved stretcher supports a carved neoclassical urn. This console is also covered with a layer of gesso, but it has been painted pale blue rather than gilded.

Fig. 3

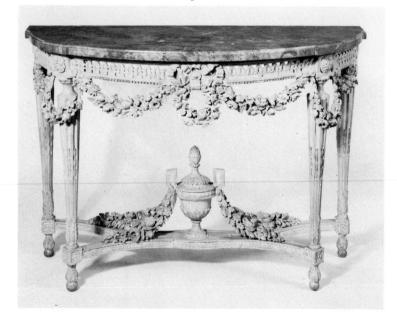

ANATOMY OF A FRENCH CONSOLE

(See Color Plate 13.)

TOP—The shallow *D*-shaped top is of dark red (*griotte d'Italie*) marble. The small size and narrow proportions of this console were practical in the smaller rooms installed at Versailles in the late eighteenth century.

MAKER—The name of Jean Henri Riesener (1734–1806), a renowned *ébéniste* of the Louis XVI era, is stamped twice beneath the marble on the wood top of the console. He made many fine pieces of furniture for Queen Marie Antoinette. This console is known to have been delivered to her apartments on September 14, 1781.

VENEER—Specially selected thin panels of mahogany and purplewood are veneered to the carcass. The restrained simplicity of the wood sets off the brilliance of the metalwork.

SHELF—This console is unusual in that it has a second shelf, also fitted with marble, forming a recessed compartment backed by a panel of plain mahogany.

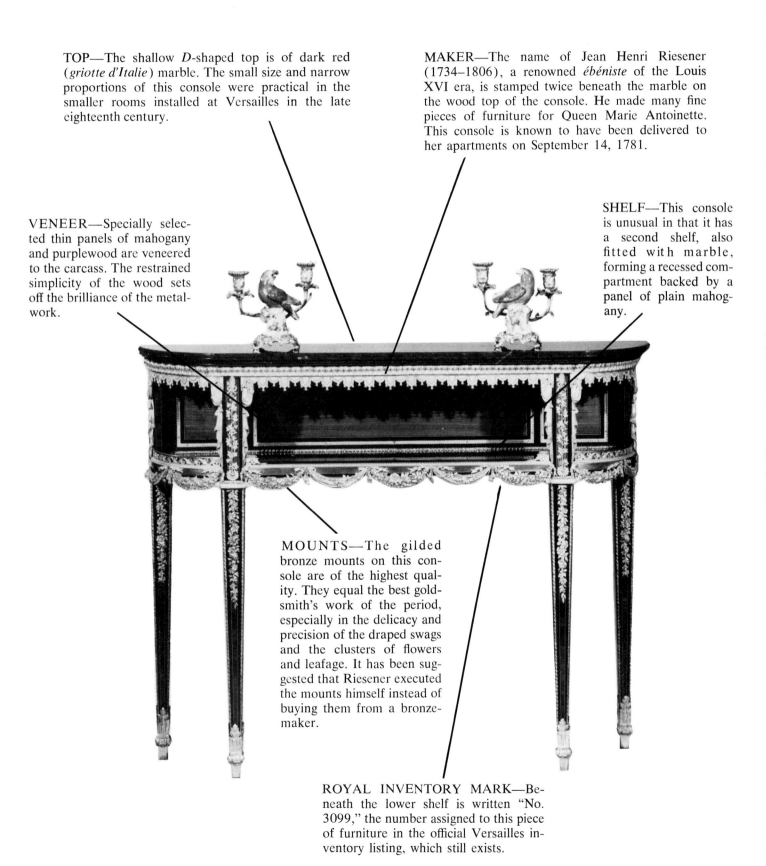

MOUNTS—The gilded bronze mounts on this console are of the highest quality. They equal the best goldsmith's work of the period, especially in the delicacy and precision of the draped swags and the clusters of flowers and leafage. It has been suggested that Riesener executed the mounts himself instead of buying them from a bronze-maker.

ROYAL INVENTORY MARK—Beneath the lower shelf is written "No. 3099," the number assigned to this piece of furniture in the official Versailles inventory listing, which still exists.

Fig. 1

During the eighteenth century small multipurpose tables were made and soon were found in almost every room of a well-furnished house. These tables were among the most useful pieces of furniture in a salon or boudoir of that era as most communication was done by notes carried by page or post, and courtiers were constantly sitting at tables to write political messages, social invitations, or *billets doux*.

The upper parts of the table had appropriate fittings, and the legs were often joined by platform stretchers on which books and papers could be placed. These tables could easily be moved about the house and were not considered an integral part of a room's design.

The top of the small worktable in Fig. 1 is inlaid with floral marquetry. With its ormolu-rimmed top, its asymmetrical marquetry, and its graceful cabriole legs, this

Fig. 3

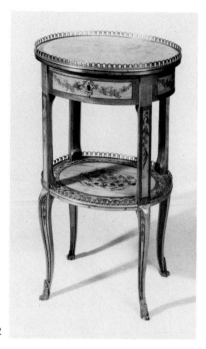

Fig. 2

table is a very good example of a worktable of the Louis XV period.

The design of another worktable (Fig. 2) indicates that it probably was made during the transitional period between the reigns of Louis XV and Louis XVI. The upper part is severe and the supports rectilinear, but the legs beneath are slightly curved.

The table in Fig. 3 is essentially of the same simplicity and shows how the general design remained consistent. Today collectors find these pieces just as convenient and attractive as did their original owners.

TOP—The top of this table is oval in shape; similar tables may have circular or, less frequently, rectangular tops. The top is surrounded by a high pierced ormolu gallery.

SIZE—This worktable is typically small and therefore could easily be moved about in the more intimate apartments of the mid-eighteenth century.

FRIEZE—The frieze contains a drawer fitted with a leather-lined, hinged writing surface and compartments for an inkwell and other writing implements.

DECORATION—This table is fully veneered with natural and stained holly wood, inlaid with single flowers enclosed within lozenges and surrounded by sycamore borders. The gilt-bronze mounts are in the neoclassical style.

STYLE—Although this table dates from the Louis XVI period, the cabriole legs are reminiscent of the rococo lines popular during the previous reign. Styles did not change suddenly; they slowly evolved. The neoclassical style now called Louis XVI actually started during the reign of Louis XV, and, as in this example, some neoclassical furniture retained rococo elements.

MAKER—This table is stamped "*RVLC JME.*" The first initials refer to Roger Vandercruse (1728–1799), a Flemish craftsman who worked in Paris and was known there as Roger Lacroix. The "*JME*" is the abbreviation for *Juré* (or *Jurande*) *des Menuisiers Ebénistes*, signifying that Lacroix had been officially sworn into the cabinetmakers' guild.

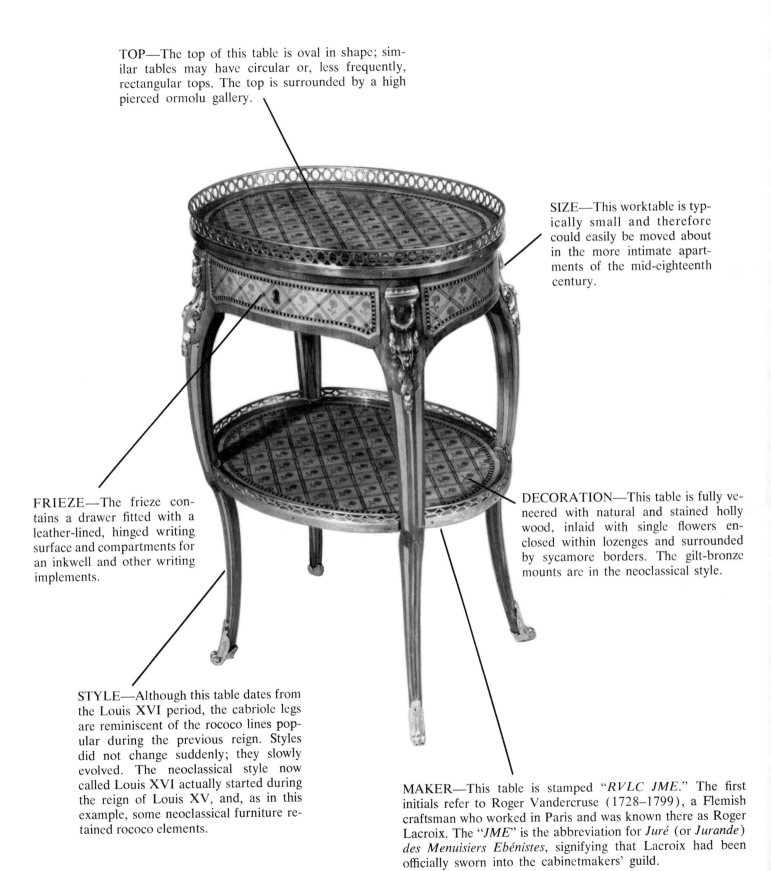

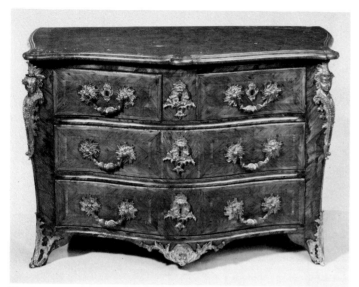

Fig. 1

The chest of drawers appeared in France about 1690 and was named "commode" because of its practicality. The body of a commode contains several drawers and is usually surmounted by a marble top. Its obvious use was for the storing of clothes and other effects. The first commodes had only two drawers and were raised on tall legs. But during the *Régence* period (1715–1723) a new type of commode was developed, normally containing a tier of three drawers.

A chest of drawers of this period, illustrated in Fig. 1, has two long and two short drawers. It is veneered with banded, cross-banded, and quartered kingwood to contrast with the broad, flat surfaces. It is also lavishly fitted with finely chiseled foliate mounts, handles, and escutcheons of ormolu. The corner mounts are of the type known as *espagnolettes* (female heads with Spanish features), a motif used by the painter Watteau and adopted by various bronzemakers of the *Régence* period. This motif fell into disuse during the Louis XV period, when it was replaced by scrolling foliate mounts such as those on the commode opposite.

Another commode (Fig. 2), dating from the transitional period between the reigns of Louis XV and Louis XVI, has cabriole legs that are reminiscent of the Louis XV style, but its general design is more rectilinear. The marquetry and the ormolu mounts are totally symmetrical. Also at this point, the frieze drawer makes its appearance as a further refinement in the form of the commode.

A late Louis XVI period commode (Fig. 3) is very restrained, almost severe, in design. Its top is a half-oval of white marble and it contains the usual three drawers. Each end is fitted with a cupboard door enclosing shelves. Commodes of this kind are known as *commodes à encoigneurs* (chests with corner compartments or shelves).

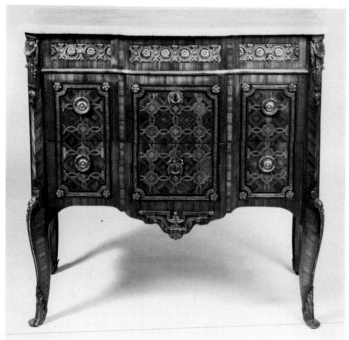

Fig. 2

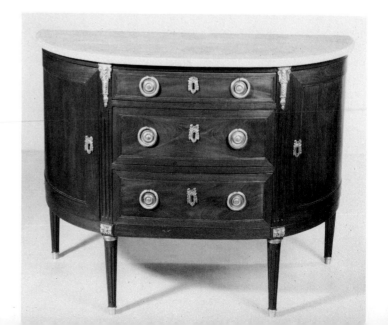

Fig. 3

TOP—The top of this commode is a polished slab of Brèche d'Alep marble which closely follows the outline of the commode itself. The marble tops for French commodes often were chosen to match marble mantelpieces in a particular room.

MARQUETRY—The sides and front of the commode were veneered and inlaid with flowers and scrolling foliage executed in various stained and natural exotic woods on a ground of tulipwood contrasted with dark borders of purplewood. Originally the woods were colorfully stained, but in most instances they have faded from years of exposure to sunlight.

SHAPE—The commode has a serpentine contour reflective of the rococo taste for undulating lines, and the front and sides are *bombé*—that is, slightly bulbous.

DRAWERS—The front of this commode contains two drawers without shelves or divisions between them (*sans traverse*). This allows the front of the piece to be treated as a single decorative unit. For the same reason, the central section of the apron is attached to the bottom drawer.

MOUNTS—The mounts are of gilt bronze and emphasize the sinuous lines of the commode, particularly in relation to the pattern of the floral marquetry.

127

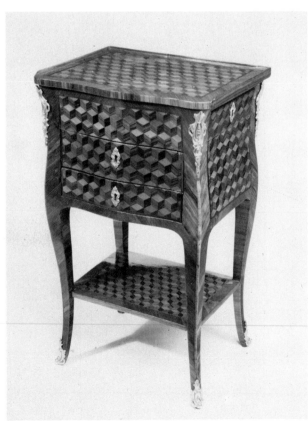

Fig. 1

A typical example of the small tables known as *petites commodes* (Fig. 1) has an upper drawer that opens from the side and contains a leather-lined writing slide and fitted compartments. The two other drawers are not fitted but were used for the storage of letters and books. This Louis XV table is gracefully shaped and attractively veneered with floral marquetry.

The small commode in Fig. 2 has basically the same structure as the previous example, but it has a platform stretcher joining the legs. The carcass is veneered with parquetry similar to that of the Louis XVI table shown opposite. By comparing these two tables, one can easily see how their contours were altered in accordance with changing tastes.

Fig. 3 represents an interesting variation of the small commode. The three drawers are veneered *sans traverse* and are enclosed by a tambour—a flexible, moving shutter made of splats of kingwood glued to a canvas backing. The side drawers open on swivel hinges and are decorated to match the tambour. This small commode is late Louis XV, the early transitional period, with an ormolu-rimmed, kidney-shaped top, a straight carcass, and cabriole legs.

Fig. 3

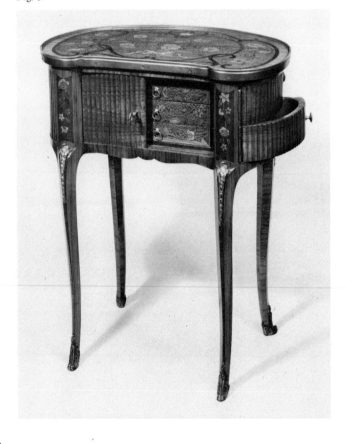

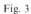

Fig. 2

TOP—Rectangular with slightly outset corners, the top is surrounded by an ormolu rim which encloses a central floral panel flanked by parquetry.

BODY—This small commode contains three drawers *sans traverse*. The upper drawer is fitted with a writing slide and compartments for writing implements.

MOUNTS—The mounts of this table are ormolu, executed in the neoclassical taste with bowknotted laurel escutcheons, laurel swag capital mounts, and human mask corner mounts, all typical of the Louis XVI period.

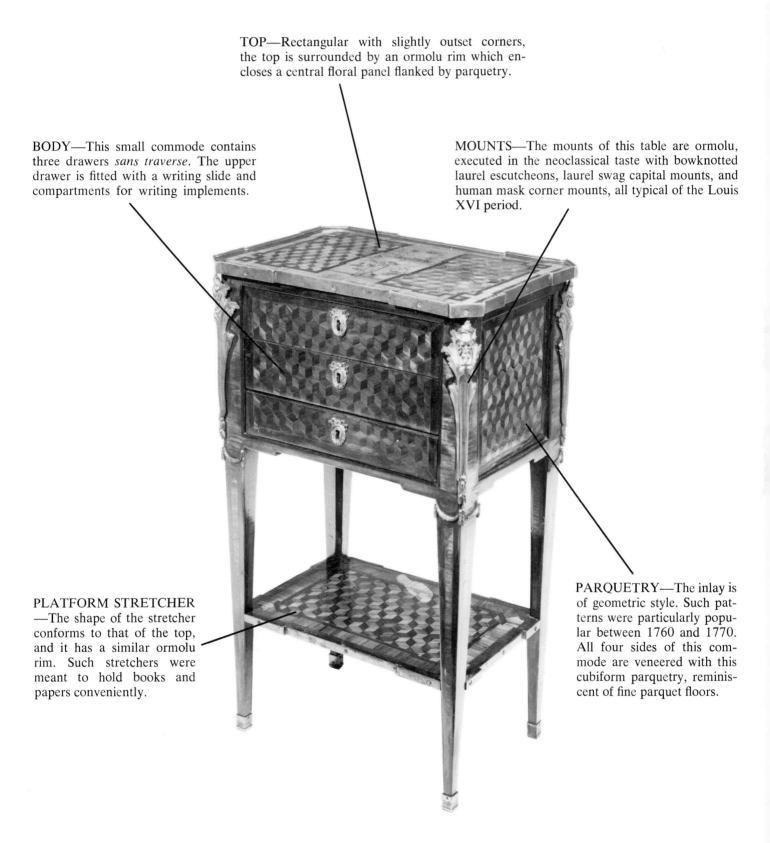

PLATFORM STRETCHER —The shape of the stretcher conforms to that of the top, and it has a similar ormolu rim. Such stretchers were meant to hold books and papers conveniently.

PARQUETRY—The inlay is of geometric style. Such patterns were particularly popular between 1760 and 1770. All four sides of this commode are veneered with this cubiform parquetry, reminiscent of fine parquet floors.

Fig. 1

Fig. 2

Fig. 3

ITALIAN CHAIRS

Italian furniture of the Renaissance and the seventeenth century greatly influenced furniture styles throughout Europe, particularly in France. Italian painters, sculptors, and craftsmen were employed at the courts of Europe, and Italian excellence in the use of wood marquetry, carved stone, and marble was much admired and imitated. However, by the eighteenth century Italian furniture production tended to be strongly influenced by French furniture styles, as Versailles set the fashion for all Europe.

The Italian side chair (Fig. 1) is basically Louis XV in design and of mid-eighteenth-century origin. Its upholstery is on detachable frames, a system that allowed chair coverings to be changed seasonally. Although this feature is found on many French chairs of the same period, it seems to have been more widely used in Italy, perhaps because of the warmer climate. The thickness of the seat rail and the legs gives this chair a somewhat heavy feeling—as do the shortness of the legs and the unusual width of the seat and the backrest. The chair lacks the graceful elegance of a French chair of the same basic design and period.

These same characteristics are to be found on another chair (Fig. 2), which was made in Italy some twenty years later. It is in the neoclassical style, although it has a sinuous open backrest with a pierced splat. The slip seat rests on thick molded rails raised on four strong legs carved with fluting.

The side chair in Fig. 3 is also of the neoclassical period, but it is much lighter in feeling than the previous example. The carving is richer and the design and proportions more elegant. It was probably made in a major metropolitan area rather than in the provinces and may also reflect the French incursions into northern Italy toward the end of the eighteenth century.

FORM—Although this chair is basically in the Louis XV style, the exaggerated curves of the arms and backrest are typically Italian and help to identify its country of origin. A French chair would be more restrained in feeling.

PAINTING—Although some Italian chairs are gilded, it is more usual to find them painted and then highlighted with floral decoration. The painted details are usually more important in Italian furniture than the carving.

SPLATS—The use of open backrests with pierced and shaped splats is characteristic of Italian chairs throughout the 1700s.

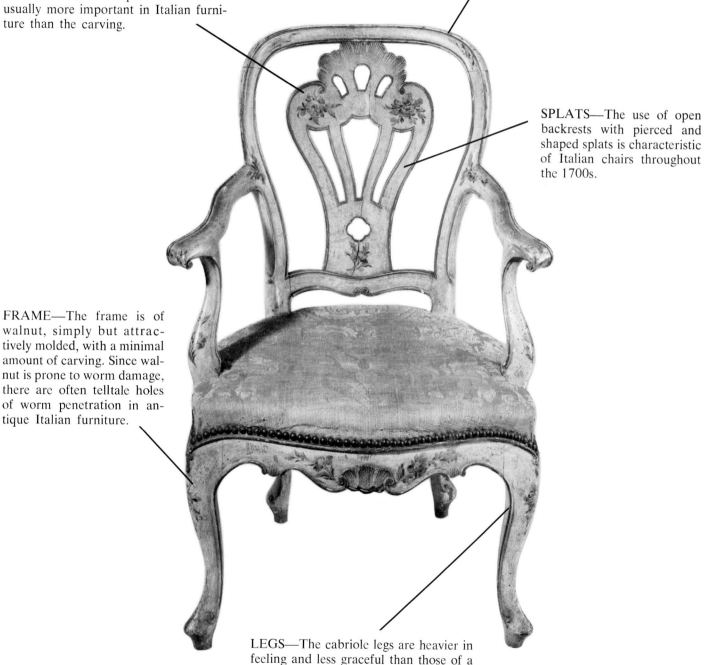

FRAME—The frame is of walnut, simply but attractively molded, with a minimal amount of carving. Since walnut is prone to worm damage, there are often telltale holes of worm penetration in antique Italian furniture.

LEGS—The cabriole legs are heavier in feeling and less graceful than those of a comparable French chair of the same period.

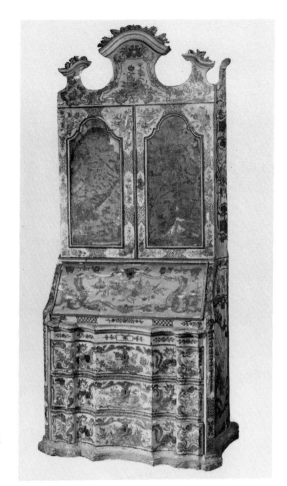

Fig. 1

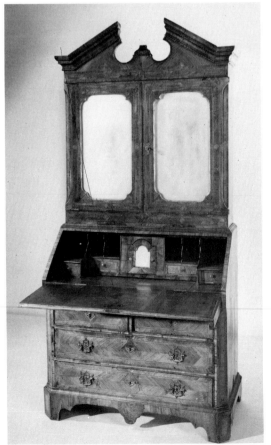

Fig. 2

ITALIAN
BUREAU BOOKCASES

A bureau bookcase is basically composed of three elements: a writing area or bureau, an enclosed series of shelves for books above, and a bank of drawers or cupboards beneath. The bureau bookcase can be found in countries other than Italy, particularly in England; however, Italian bureau bookcases have a distinctive construction and an unusual form of decoration.

The carcass of an Italian bureau bookcase is almost always made of pine, which is then either covered with painted gesso or veneered with walnut and other figured woods. As with most Italian case furniture, the interior construction is quite crude, greater emphasis always being placed on surface appearance.

The bureau bookcase opposite dates from the second quarter of the eighteenth century. Its probable prototype, an English piece of the same structural design, would have been made approximately twenty years earlier. This bureau bookcase is a very rare example of its type, due to the brilliance of its original red lacquer decoration.

In an example dating from the third quarter of the eighteenth century (Fig. 1), the decoration, the shaping of the sides, the fall front, and the lower chest of drawers reflect a strong rococo feeling. The high-arched cornice and the elaborate floral and geometric decoration indicate that this bureau bookcase is probably Sicilian in origin.

Of the bookcases illustrated here, the bureau bookcase made in the last part of the eighteenth century (Fig. 2) is closest in design to a standard English model; however, the carcass is pine and the construction is cruder than that of any such piece made in England at the time. This bureau bookcase is veneered with cross-banded and quarter-veneered walnut, is fitted with English-style brass handles, and is decorated with mirror panels on the cupboard doors.

ANATOMY OF AN ITALIAN BUREAU BOOKCASE

(See Color Plate 12.)

CORNICE—The top of this bureau bookcase is elaborately shaped, extensively molded, and fitted with attractive top-form finials.

DECORATION—The piece is lavishly painted and lacquered with pseudo-Chinese scenes in tones of gold and brown on a red lacquer ground. Although Oriental lacquer was sometimes used, furniture very often was made and decorated in Europe in the Chinese taste. Each European country managed to develop its own distinctive type of *chinoiserie*.

DOORS—The arched and paneled doors enclose an elaborately painted interior with a series of adjustable bookshelves.

FALL FRONT—This type of writing arrangement is a survival of the small traveling desks of the seventeenth century. The fall front opens to reveal a flat writing surface and an arrangement of small drawers and pigeonholes.

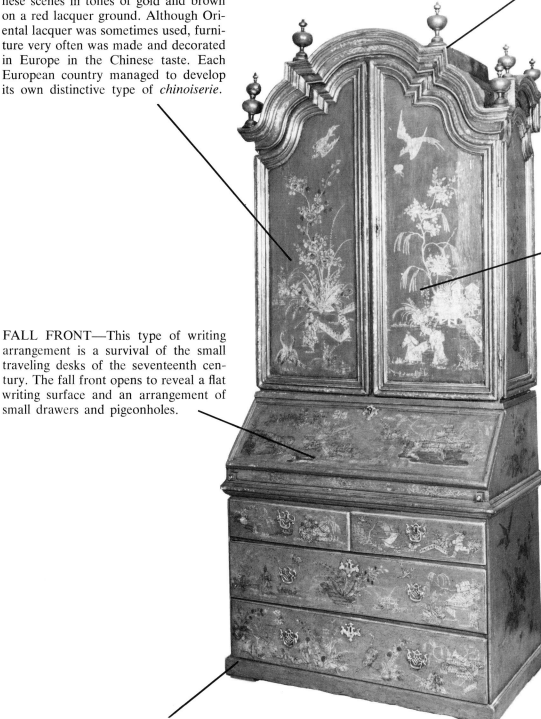

BASE—The lower part of this bureau bookcase contains two short and two long drawers, raised on a simple plinth and short bracket feet.

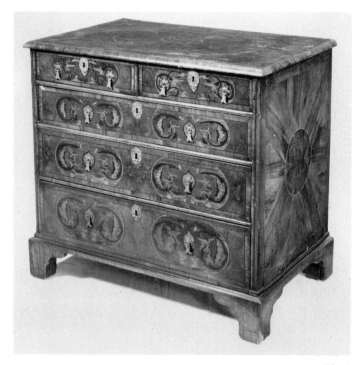

Fig. 1

The chest of drawers is an adaptation of the medieval coffer, or joined chest, and should be distinguished from the commode. The chest of drawers was primarily used in bedrooms or dressing rooms, while the commode was most often found in the drawing room. The chest does not figure in English inventories until after the mid-seventeenth century, and the earliest examples were nearly always made of oak.

The chest illustrated in Fig. 1 is veneered with walnut and has marquetry panels. It is typical of late-seventeenth-century examples that are close in feeling to Dutch furniture of the period, except for the bracket feet (these are often later replacements, the original bun feet having been destroyed by wood worms). Due to walnut's susceptibility to worm damage and because England's trade with the colonies brought in large quantities of mahogany, walnut's supremacy had ended by 1740.

Fig. 2 is a most common mahogany bow-front chest of the late eighteenth century. The value of the plainer varieties depends on such items as handles, cross-bandings, or other decorative details.

A variation on the plain chest is the more useful chest-on-chest (Fig. 3). Although providing greater storage space, its uppermost drawers are almost inaccessible. The better examples may have chamfered corners on the upper section, carved with either blind fretwork or fluting.

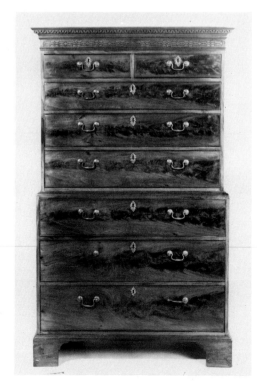

Fig. 3

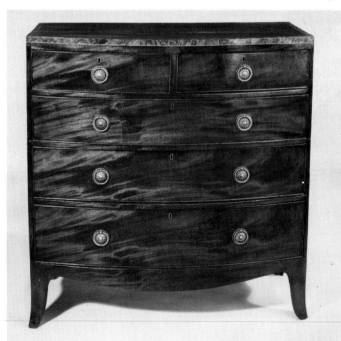

Fig. 2

TOP—The shaped top of this George II serpentine-front chest is accentuated by handsomely figured veneer. The compound molded edge and outset corners help to distinguish it from plainer examples, which exist in great number.

FRONT—The chest is fitted with graduated drawers enhanced by original handles and escutcheons of fine quality.

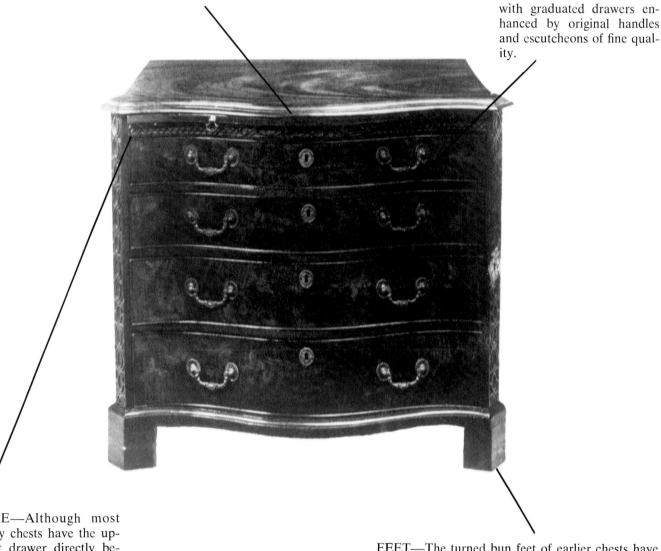

FRIEZE—Although most ordinary chests have the uppermost drawer directly below the top, the frieze of this chest contains both a slide and a band of blind-fret carving above the drawer.

FEET—The turned bun feet of earlier chests have given way here to plain conforming bracket feet. Also popular during this period (mid-eighteenth century) were ogee section bracket feet and, later, splayed bracket feet or short turned legs.

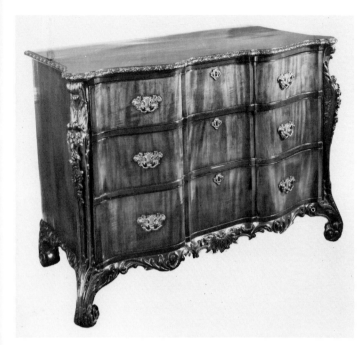

Fig. 1

The term "commode" comes from the French and describes a chest of drawers. The word first appeared in English trade journals during the second quarter of the eighteenth century, and early examples closely copied French models. French commodes became very fashionable, and great attention was given them by the most important cabinetmakers of London, including Thomas Chippendale and, especially, the King's own furniture maker, William Vile.

Nearly every fashionable drawing room contained a commode. The example shown in Fig. 1 is based on a design by Chippendale published in *The Gentleman and Cabinet Maker's Directory* of 1762, plate 26. It typically

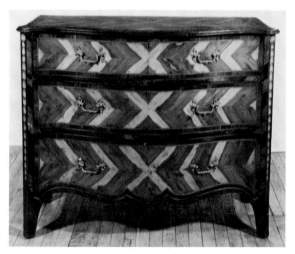

Fig. 2

uses carving as major ornamentation, the only gilt enrichments being the handles. The French prototype, instead of using carved decoration, would have employed elaborate gilded metal mounts.

Another commode (Fig. 2), slightly more ornate and later in date (c. 1770), uses a careful arrangement of olivewood veneer to accentuate the serpentine shape. The inlaid husks at the corners are typical of late eighteenth-century English marquetry.

The demilune satinwood commode in Fig. 3 of the late 1700s is characterized by a plain bowed outline, adorned with the finest of marquetry in the neoclassical taste. A commode of this shape often stood between windows in a drawing room, below a pier glass. It exemplifies the restrained elegance found in the designs of Robert Adam, the celebrated architect who designed interiors and the furniture for them.

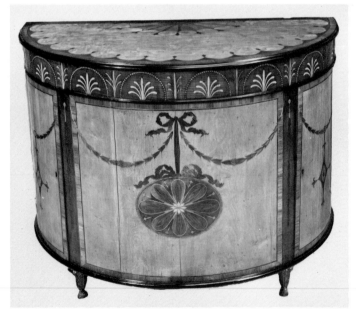

Fig. 3

136

DECORATION—Marquetry, which originated in Germany and the Low Countries, is one of the most effective means of decoration. This commode represents the ultimate in English marquetry craftsmanship and design. The flowers, originally brightly stained, have faded, but the fine engraving remains. Gilt-metal mounts emphasize the curvilinear outline and unify the design.

TOP—Shaped at both front and sides, the serpentine top dictates the contour of the rest of the piece. Gilt-metal borders are often found on commodes of this period (c. 1775).

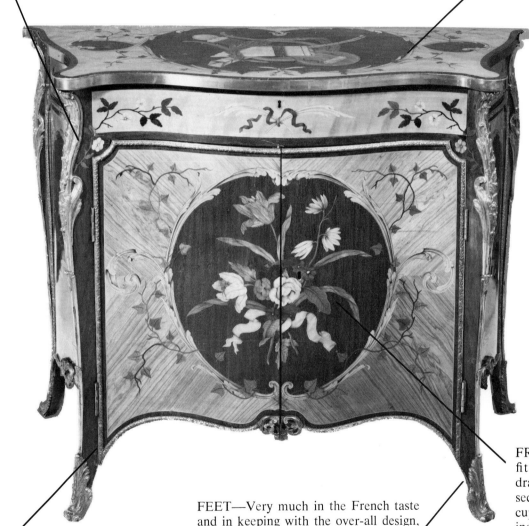

FORM—This ample storage piece was so beautifully designed that it was suitable for the finest drawing rooms in London. The debt owed to French designs of the Louis XV period is evidenced not only by the shape of this George III commode but also by the elaborate inlay and the gilded metal mounts on the stiles and feet.

FEET—Very much in the French taste and in keeping with the over-all design, the short, slightly outcurved feet are mounted with gilt-metal acanthus leaves.

FRONT—The frieze is fitted with a long drawer, and the lower section with a pair of cupboard doors enclosing drawers. This large expanse forms a perfect surface for marquetry, here of the highest quality.

ENGLISH SECRETARIES

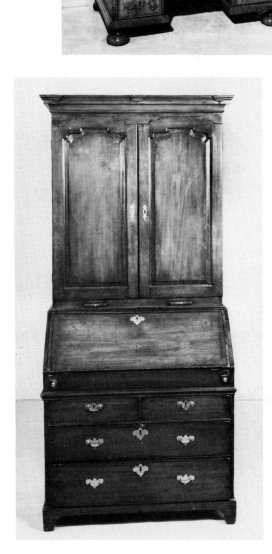

Fig. 1

Fig. 2

The convenience of having bookshelves, storage space, and a writing surface all in one piece of furniture is the reason for the long-standing popularity of the bureau bookcase, commonly known as *secrétaire* or secretary. What began as a portable fitted chest on a table developed into a highly functional and one of the most architectural furniture forms in Georgian England. The increased affluence and literate sociability of the upper classes in the eighteenth century have left us with a large number of examples, the earliest of which have slant-fronted desks beneath fairly simple glazed doors, such as the William and Mary *secrétaire* of walnut in Fig. 1 and the George II *secrétaire* of Scottish cedarwood in Fig. 2.

After the middle of the century, the slant-front arrangement gave way to a secretary-drawer arrangement with a hinged fall front opening to form a writing surface, but which when closed was uniform in appearance with the lower drawers, as shown in the George III mahogany example in Fig. 3.

An expansion of the bureau bookcase is the very large breakfront cabinet with secretary-drawer, often specially built to fit into a room and blend with its general architectural scheme.

Like many large pieces of eighteenth-century case furniture, secretaries were usually made in two detachable sections to afford ease of movement.

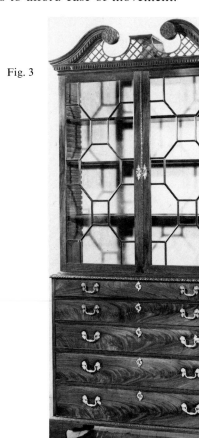

Fig. 3

CORNICE—Of restrained neo-Gothic architectural inspiration, this cornice is unusual in that it contains a clock. Earlier examples are often found with swanneck or plain molded cornices.

UPPER SECTION—This section affords the choice of either a bookcase or cabinet. There is an unusual arrangement of three glazed cupboard doors with astragals, again in the neo-Gothic taste. A more usual arrangement for earlier examples would be either two or four such doors.

SECRETARY DRAWER OR BUREAU—The hinged secretary drawer is veneered to give the appearance of two drawers and contains cupboard drawers and compartments for writing implements and stationery.

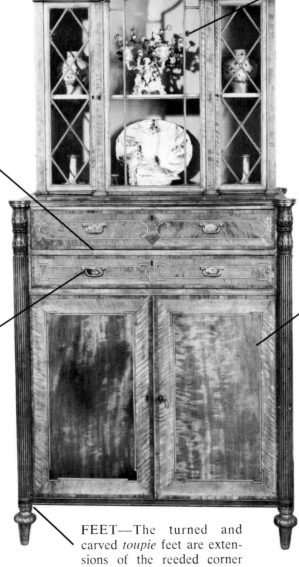

DECORATION—Here the decoration is achieved almost entirely through the use of beautifully grained light woods which contrast with the darker accents. An additional feature is the silver drawer handles.

LOWER SECTION—The lower section is enclosed by a pair of cupboard doors, with shelves inside. Earlier examples are found more often with arrangements of drawers in the lower section.

FEET—The turned and carved *toupie* feet are extensions of the reeded corner columns. They are typical of this period (c. 1800) and were used until the Victorian period.

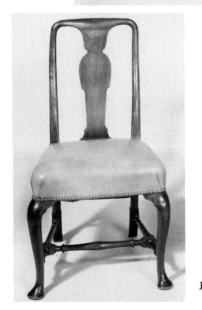

Fig. 1

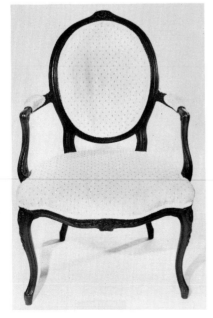

Fig. 2

Chairs were not common in England until the sixteenth century, and even then they were reserved for persons of rank. They probably did not come into general use until the middle of the seventeenth century.

One of the first chairs for commoners (Fig. 1) dates from the early seventeenth century. It was made of oak by a chair turner, a craftsman who specialized in lathe work.

A typical walnut side chair (Fig. 2) of the Queen Anne period (c. 1710) has cabriole legs and the turned and blocked stretcher popular at the time. Walnut was used almost exclusively during this period, and the style remained in fashion about thirty-five years.

In the third quarter of the eighteenth century all Europe looked to Versailles for inspiration, and chairs imitating French styles became popular. Thomas Chippendale's designs derived from the French *fauteuil;* he even imported chair frames from France. A chair such as the George III armchair (Fig. 3) is said to be "in the French taste."

Sheraton, Hepplewhite, and the Adam brothers popularized the neoclassical style in furniture toward the end of the century. This style was characterized by simplicity of line. The emphasis was not on carving but on inlays of exotic wood or on lacquer in an Oriental vein (Fig. 4).

A splendidly concise historical guide to the economy, artistry, and standards of comfort and fashion in British society can be found in the changing styles of English chairs.

Fig. 4

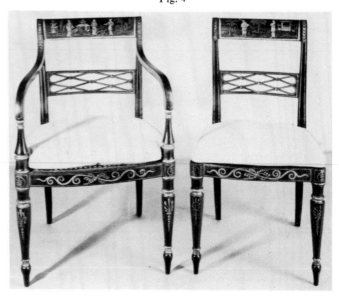

Fig. 3

SPLAT—The vase-shaped splat is of generous proportions and curved to conform to the shape of the human back. Note the accent of carving at the base.

TOP RAIL—Many variations can be found, but this down-curved and slightly molded rail is one of the most appealing. A carved rail also may be found on chairs of this period.

BACK UPRIGHTS—The front surfaces are flattened. An important feature of this chair is the conformity in outline between the outer edge of the splat and the inner edge of the upright.

ARMS—The so-called shepherd's-crook arm was peculiar to English chairs of this period (c. 1735).

SEAT—Of "balloon" shape, the drop-in (slip) seat made it easier to change upholstery. Earlier chairs were more likely to have caned or plain wooden seats with loose cushions, and later chairs generally had upholstered stationary seats.

LEGS—The cabriole leg was introduced into England by Huguenot cabinet-makers who fled France during the late seventeenth century. This particular example has a typical shell-carved knee and the claw-and-ball foot so often used by English craftsmen.

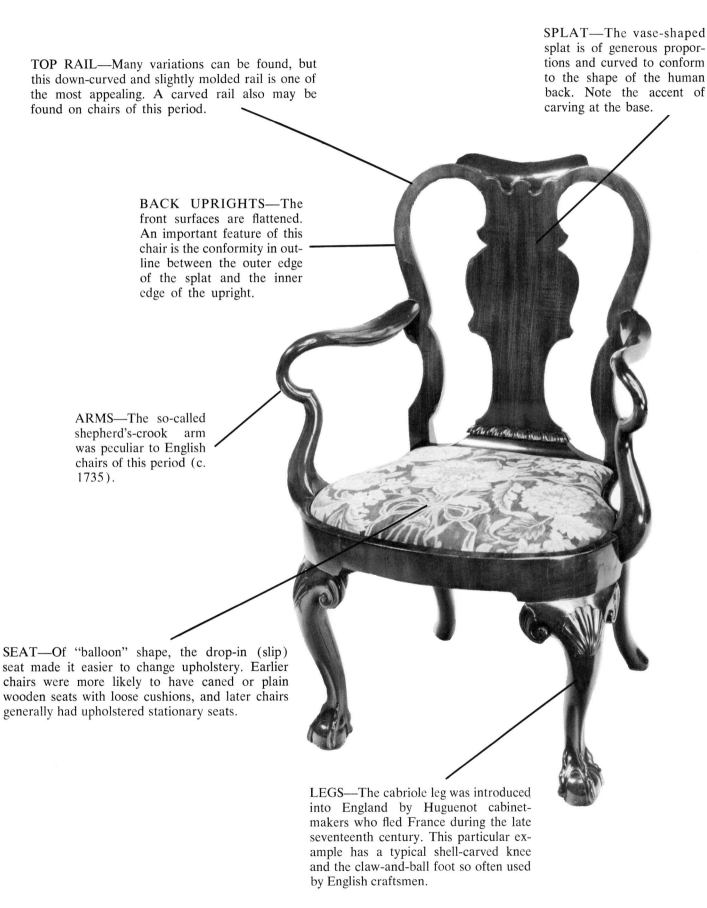

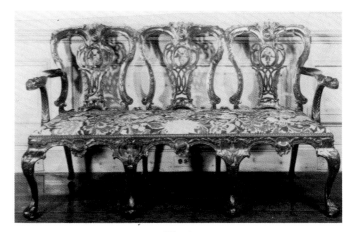

Fig. 1

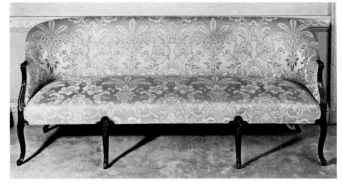

Fig. 2

The settee is an adaptation of the bench, fitted with a high back to ward off drafts. The earliest examples had plain rectangular seats with separate cushions and, later, sparse upholstery.

After the Restoration of Charles II to the throne in the mid-seventeenth century, the demand for more luxurious furniture led to a rapid development in the comfort and elegance of the settee. The backs of the earliest varieties were made by combining two or three chair backs. However, upholstered examples with tall backs and padded seats and arms soon replaced these "chairback settees." Even at this period settees were often made *en suite* with chairs and stools, and throughout the eighteenth century closely paralleled their development.

A finely carved mahogany settee dating from the second quarter of the eighteenth century is illustrated in Fig. 1. It is an early form, combining three chair backs with the limited comfort of an upholstered seat. It was probably intended to be placed in an entry or foyer. The carving and proportions are exceptional, and there is the added feature of contemporary needlework for the slip-in seat.

The settee of 1760–1770 (Fig. 2) is in the French taste. The molded cabriole legs were borrowed from a Louis XV design. However, the rear legs of this English settee have a pronounced outward rake, as opposed to the almost vertical French leg. The use of mahogany was also in keeping with English preference. The French settee would normally be painted and gilded.

The settee in Fig. 3 was part of a large suite of furniture designed by James Wyatt for Broome Park in Kent about 1780. The applied, raised, and gilded husk-and-leaf decoration is in *carton pierre,* a substance similar to papier-mâché, which simulated elaborate carving. Again we find an English adaptation of a French prototype—in this instance, the rectilinear Louis XVI design. The suite was undoubtedly made for an enormous salon and might well have consisted of at least three settees, fifteen armchairs, and four *torchères*.

Fig. 3

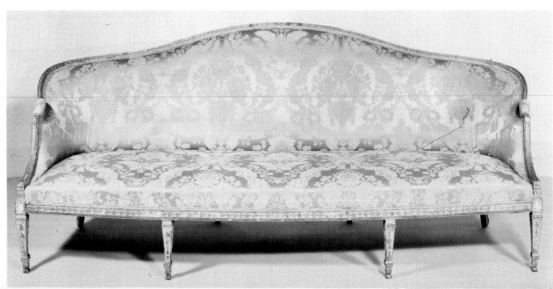

ANATOMY OF A GEORGIAN SETTEE

BACK—The upholstered back on this Georgian settee, dating from about 1735, retains the height associated with early examples. Later versions sacrificed the draft-preventing qualities of the extended back for greater aesthetic appeal.

ARMS—The contoured mahogany arms are enhanced by lion-mask terminals, design motifs which evolved from the architectural work of William Kent. Some settees of the period have upholstered arms.

LEGS—The best examples of this period have three front legs. Gone are the stretchers of twenty years earlier. The free-standing, slightly cabriole legs are enlivened with acanthus-leaf-carved knees and rococo cartouches in relief.

FEET—The claw-and-ball foot, which became popular at this time, was inspired by Chinese art, which often depicted a five-clawed dragon clutching a pearl.

ENGLISH WRITING TABLES

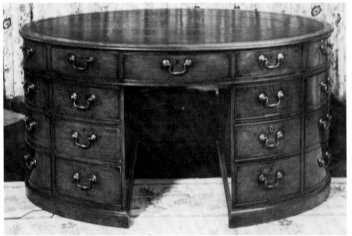

Fig. 1

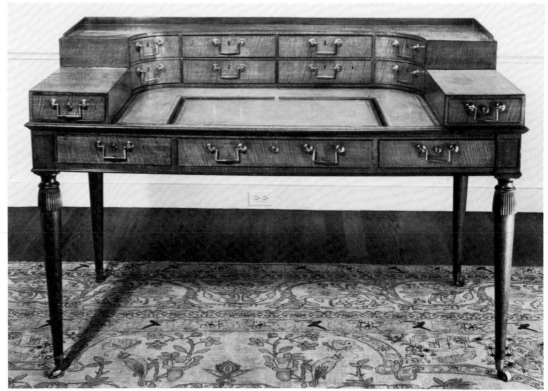

Fig. 2

While almost any table can be used as a desk or writing table, the form takes on a particular usefulness with the addition of drawers. In England writing tables as such did not appear until the late seventeenth century. These first examples usually were made of oak or walnut, and some had hinged tops that could be extended on a gateleg support.

Midway through the eighteenth century the pedestal table became popular in England, and it continues today as the most common and useful form of table for writing. The example illustrated in Fig. 1 is typical of the more ordinary mahogany tables made during the second half of the eighteenth century and throughout the nineteenth. The top was often inset with a leather panel, as here, and the reverse side of the pedestals sometimes contained cupboards.

Another example (Fig. 2) is a fine, faded mahogany table of unusual shape from the late eighteenth century. The ends, which contain cupboards with shelves, are veneered to simulate drawer fronts, thereby adding to the general continuity of the design. One of the most elegant of all writing tables is the type known as Carlton House (Fig. 3). The design appears together with the name in records of the Gillow cabinetmaking firm dating to about 1796. Though conclusive evidence does not exist, it is nevertheless believed that a table such as this was ordered for the Carlton House by the Prince of Wales.

Fig. 3

TOP—The top of this table, which is one of a pair, has an inset panel of leather. A pair of tables was often placed back to back and used as a large table in the center of a room.

DECORATION—Cabinetmakers relied on form, figured veneer, and carving as principal features of design during this period. This fine table combines all of these most successfully and is certainly the product of one of the best London craftsmen. The escutcheons add a flamboyant note to the otherwise plain drawer fronts.

FRIEZE—There are three drawers above the recessed area here, the usual arrangement for tables of this type. The central drawer was generally fitted with pen trays and inkwells.

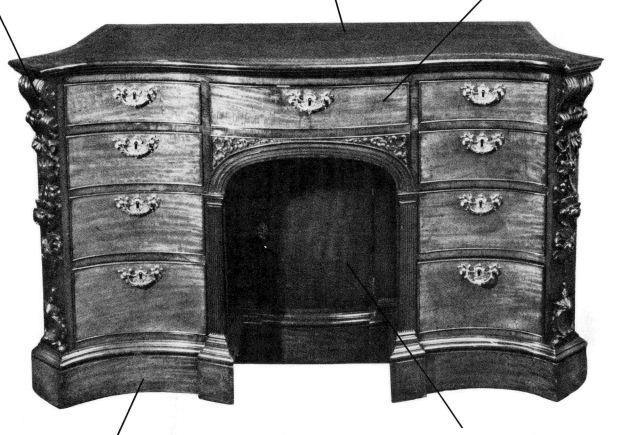

BASE—While a plain molded base like this is quite commonly found on tables of the period (c. 1765), other examples may have lion's-paw or short bracket feet.

FRONT—The knee recess contains a cupboard with shelves for paper. A pedestal writing table has an open recess for the knees, and usually three drawers in each pedestal.

ENGLISH
SIDE TABLES

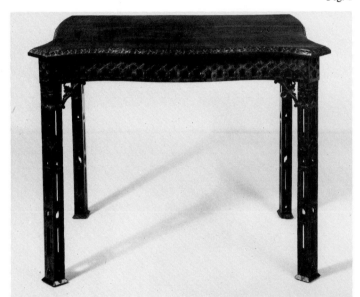

Fig. 1

Fig. 2

The general category of side tables includes consoles and pier tables. Both are designed to stand against a wall and are ornamented on only three sides. The console table is affixed to the wall with a bracket and has only front legs for support, while the pier table has four legs and is meant to stand between two windows, usually with a matching pier glass above it.

The table shown in Fig. 1 dates from the William and Mary period, c. 1685, and employs olivewood veneer and the spiral-turned legs typical of this date. An interesting feature is the end-cut veneer, sometimes called oyster veneer, produced by cutting thin slices from the ends of branches.

The example in Fig. 2 dates from the mid-eighteenth century. Typical of the best Chinese Chippendale taste, it exhibits a frieze of blind fretwork and square pierced-fret legs. A fine table in satinwood marquetry, dating from the last decade of the eighteenth century, is also illustrated (Fig. 3). The exceptional quality of its inlaid wood decoration is typical of the finest in cabinetmaking of the period, certainly on a par with documented examples from the workshop of Chippendale. In tables such as these we see the change from the heavier carved decoration of the mid-1700s to the lighter, more feminine inlaid styles of the closing decades of the eighteenth century.

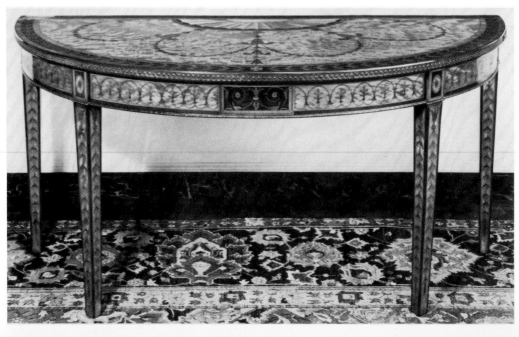

Fig. 3

FRIEZE—A well-figured central band is bordered at the top by egg-and-dart molding, an effective transition between the projecting marble and the recessed frieze. The lower edge is carved with a much more delicate flower-head and ribbon-twist molding. Both egg-and-dart and ribbon-twist moldings were widely employed by eighteenth-century furniture makers, following the strong architectural trend of the age.

TOP—The patterned green (*verde antico*) marble top complements the subtly rich color of the dark mahogany. The front corners are rounded in keeping with the outline of the legs. Marble was often used on tables destined for service in the dining room, because it was less liable to become damaged than plain wood.

DECORATION—Carved acanthus foliage of exceptional quality decorates the knees, ankles, and pad feet. Here, too, the use of a Greek architectural motif—the acanthus—shows the strong influence that architecture exerted on furnishings designed for the palatial dwellings of the period.

LEGS AND FEET—While quite sturdy, the turned (almost cabriole) legs are very much in proportion to the over-all generous dimensions of the table. The pad feet are also of appropriate size and are lightly carved, in contrast to the deeply carved claw-and-ball feet popular at a slightly later date.

ENGLISH
PEMBROKE TABLES

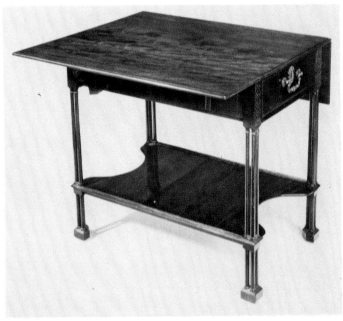

Fig. 1

The Pembroke table is traditionally thought to have been named for the Countess of Pembroke—the client who first ordered one. The tables were uncommon before the mid-eighteenth century. A design for a "breakfast table" of Pembroke form can be found in Chippendale's *Directory* of 1754, and in fact, according to contemporary accounts, such tables were used primarily for dining. Today, as side or end tables in living rooms, they are equally useful.

One of the earliest tables of this type (Fig. 1) was made about 1760. It incorporates design features in the "Gothic" taste, a style inspired by revived interest in medieval Gothic architecture.

A later table of plain cross-banded satinwood (Fig. 2) shows the graceful oval top that became popular at this period.

The sofa table in Fig. 3 is a later adaptation of the Pembroke. Designed to be placed behind a sofa in the center of a large drawing room, it was convenient for reading and writing. The refined designs of Hepplewhite and Sheraton lent themselves to the wealth of newly available materials, including such woods as calamander, rosewood, and zebrawood, all of which were used with imagination and skill in these multipurpose tables.

Fig. 2

Fig. 3

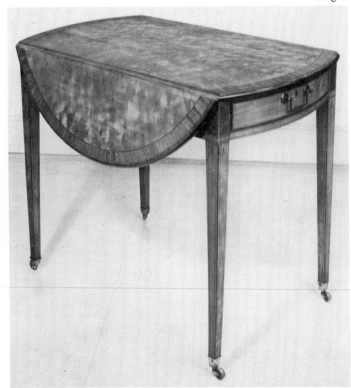

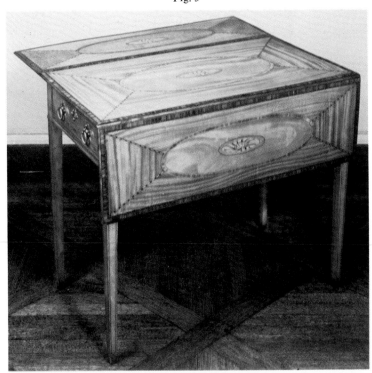

TOP—The satinwood veneer is cut to accentuate the fine musical-trophy inlay at the center. The *D*-shaped flaps are painted with garlands that not only form an integral part of the design when the flaps are raised, but are equally attractive as separate design elements in their lowered position.

DECORATION—Combined use of inlay and painted decoration point to the exceptional quality of this table. The darker walnut cross-banded borders heighten the importance of the finely painted trophy-and-garland decoration. Painted decoration came into its own during this period and was preferred to the inlay used by earlier cabinet-makers.

FRIEZE—The frieze contains one drawer; in some Pembroke tables one drawer at each end. Here decoration is kept to a minimum so as not to detract from the top.

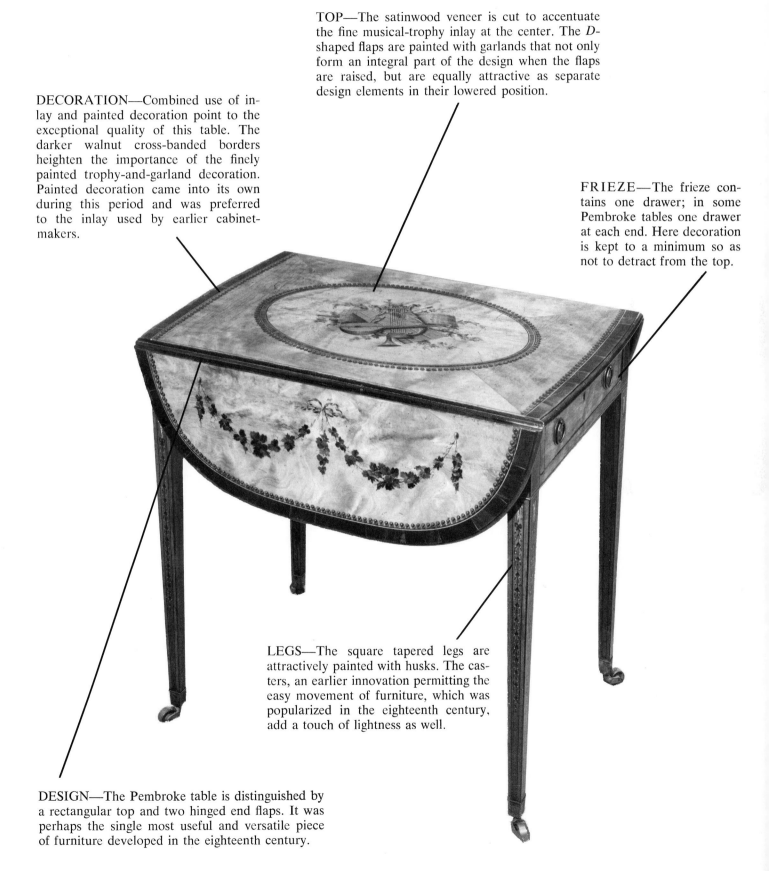

LEGS—The square tapered legs are attractively painted with husks. The casters, an earlier innovation permitting the easy movement of furniture, which was popularized in the eighteenth century, add a touch of lightness as well.

DESIGN—The Pembroke table is distinguished by a rectangular top and two hinged end flaps. It was perhaps the single most useful and versatile piece of furniture developed in the eighteenth century.

Fig. 1

Fig. 2

Fig. 3

ENGLISH
LONG-CASE CLOCKS

The long-case clock—also called tall case or grandfather—successfully solved the problem of concealing the weights and chains of the improved eight-day clock movements that had been developed in the seventeenth century.

Early examples were usually of simple architectural outline embellished with elaborate inlay, often the so-called seaweed marquetry popular during the reign of William and Mary (Fig. 1). The movement, considered more important than the case, was made by Joseph Windmills, a renowned clockmaker of the late-seventeenth and early-eighteenth centuries. An act of Parliament in 1698 required that the clockmaker's name appear on the dial.

The slightly later tall-case clock in Fig. 2 is of unusually stout proportions because it housed a movement of longer duration. However, it retains the flat top. This black lacquer example is signed Sam Baylis.

The red lacquer case of the clock in Fig. 3 is an unusual departure from marquetry decoration. Lacquer in Chinese designs was popular during the first half of the eighteenth century.

The long case remained popular during the English rococo period with the result that the top became elaborate, richly carved and ornate with swan-neck crestings. The clock itself grew more intricate too, and sometimes by means of elaborately painted dials told the month, the day of the week, and the phases of the moon.

A familiar feature of Georgian interiors, the long-case clock later lost its vogue, and by the early nineteenth century Sheraton could write that it was "almost obsolete in fashionable London."

HOOD—Designed as a protective cover for the movement, the hood can be removed by either lifting it or sliding it forward. It is always found with a hinged glazed door that opens to permit winding. The fret panel above the door is decorative and allows the sound of the striking movement to be heard more distinctly.

MOVEMENT—By far the most important part of an English clock, the movement is nearly always signed on the dial. The reputation of the maker and the elaborateness of the face are important factors in judging a clock and determining its value.

DECORATION—Here the oak case is veneered with ebony, a form of decoration most common in late-seventeenth- and early-eighteenth-century clocks. During this period marquetry and plain walnut cases were also used.

WAIST—The midsection always includes an access door for the weights and pendulum. The "bull's-eye" in the waist door allows one to see the moving pendulum without opening the door.

ENGLISH MIRRORS

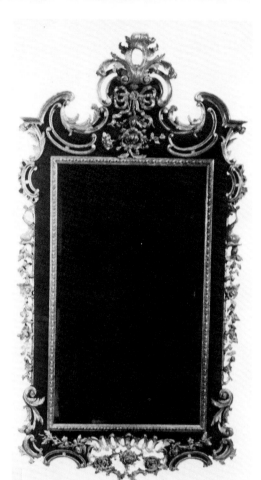

Fig. 1

Fig. 2

Fig. 3

The earliest mirror was a surface of polished metal, but mirrors of glass backed with various metals were made in Europe in the twelfth century. Venetian craftsmen perfected the mirror as we know it during the late Renaissance by applying mercury and silver to a glass panel.

Understandably, looking glasses were a great luxury item, and as long as Venice retained a monopoly on their manufacture they were prohibitively expensive. One of the great extravagances of that ultimate extravagance, Versailles, was its Hall of Mirrors, installed at huge expense by Louis XIV.

Eventually workmen from Venice migrated to other countries, bringing their skills with them. In England, by the late seventeenth century, they had centered in Vauxhall, near London, and were kept busy satisfying the huge demand for looking glasses among the newly prosperous of the day.

The plain surface of the glass itself encouraged ornamentation in the framework. In the late seventeenth century mirror frames were usually made of walnut or olivewood veneers or tortoiseshell. The cushion-framed marquetry and japanned mirrors of this period were often simple but pleasing. The mirror illustrated in Fig. 1 was probably designed c. 1735; the frame is veneered in burr walnut with carved and gilded highlights. Examples as fine as this are increasingly difficult to find.

A slightly earlier mirror, shown in Fig. 2, utilizes a different decorative technique: A thin plaster (gesso) ground was applied to the wood frame and deeper ornamentation was carved when the gesso dried. The entire frame was then gilded.

A late Georgian pier glass (Fig. 3) reflects the then-popular classical revival. It was intended to be hung between two windows and above a table or console of matching design.

The fine example illustrated opposite was probably carved about 1755 and is reminiscent of a design by Thomas Johnson.

FRAME—On English mirrors the frames of this period nearly always were of pine or limewood. Here we see the acme of the carver's art. The gilding is quite susceptible to the ravages of time, and many frames have been regilded.

CRESTING—Often a focal point of design in mid-eighteenth-century and later mirrors, the cresting conveys all the freedom and whimsy of the rococo taste. Mirrors always closely followed new styles in architecture and interior decoration and often exhibited them in a highly exaggerated manner.

STYLE—This Chippendale-type frame exemplifies the English eighteenth-century rococo style at its most exuberant. Carved details, such as the dogs, the figures in grottoes, and the waterfalls, reflect the English love of nature.

MIRROR PLATE—Because of the fragile nature of glass, comparatively few mirrors contain their original silvered plates. An original plate should show signs of deterioration of the mercurial silvering and may have a conforming beveled edge. Because of the difficulty of producing large glass plates, a tall pier glass was often composed of two or three separate pieces.

APRON—The apron, below the plate, is an area which often echoes the cresting, usually in less abundant detail. On pier mirrors the apron may incorporate part of the decoration of the table above which it was designed to be placed.

AMERICAN GAMING TABLES

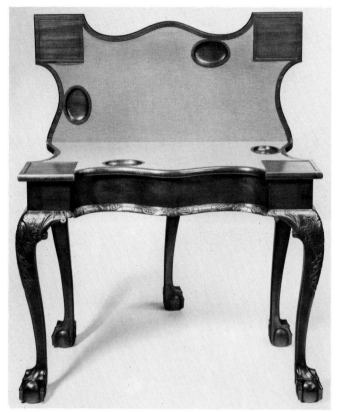

Fig. 1

During the Chippendale period in America, each of the major cabinetmaking centers excelled in the production of one form. The Boston area produced the great secretary-bookcases, Newport brought the block-and-shell design to perfection, Philadelphia made superb highboys and lowboys, and New York achieved distinction for its card tables.

In the eighteenth century New York was one of the most English cities in the colonies, and cabinetmakers copied English designs closely. New York chairs, for example, resemble English prototypes more than do the chairs of other American regions. The same is true of card tables. This may confuse collectors of American furniture. But a good indicator of the New York style is the "square" claw-and-ball foot. The fine five-leg gaming table in Fig. 1 has claw-and-ball feet with unarticulated rear talons—a feature of New York furniture.

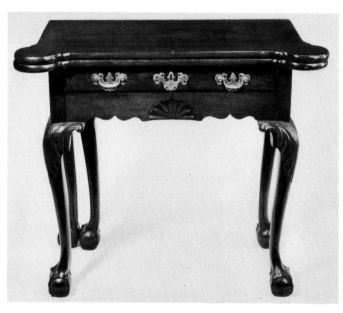

Fig. 2

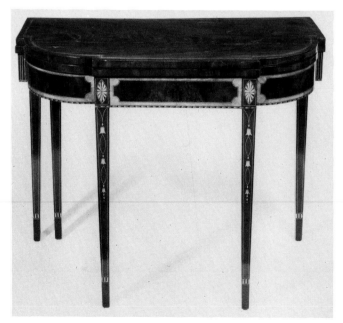

Fig. 3

Another New York card table, which has been attributed to Gilbert Ash, is shown in Fig. 2. It is more compact and smaller in scale than the others, but it remains an early and fine example of New York design. It has finely carved knees with the cross-hatching typical of many New York chairs. The legs end in well-carved feet. The frieze drawer is a rare feature—most New York Chippendale card tables have secret drawers.

An additional distinguishing feature of New York card tables is the presence of five legs. This persisted through the Chippendale and Federal periods, when a lighter, more restrained type of table appeared. The five-legged New York Federal gaming table in Fig. 3 is noteworthy for the effective play between curved and straight elements and light and dark inlays.

The card table seen opposite, a masterpiece of craftsmanship, which descended in the Van Vechten family, has vigorous curves, fine carving, and delicate legs.

TOP—The hinged top of this Chippendale carved mahogany gaming table has a serpentine contour that is bisymmetrical throughout: When opened, all four sides are identical. Such tables were originally lined with baize, leather, or fabric.

TURRETS—The turrets were used to support candlesticks. They are outset so as not to interfere with the action of the players. The sunken ovals were used to hold money or mother-of-pearl counters—the equivalent of our present-day poker chips.

FRIEZE—Also called the skirt, the frieze follows the contour of the hinged top and has a gadrooned border. Gadrooning was favored by New York and Philadelphia cabinetmakers.

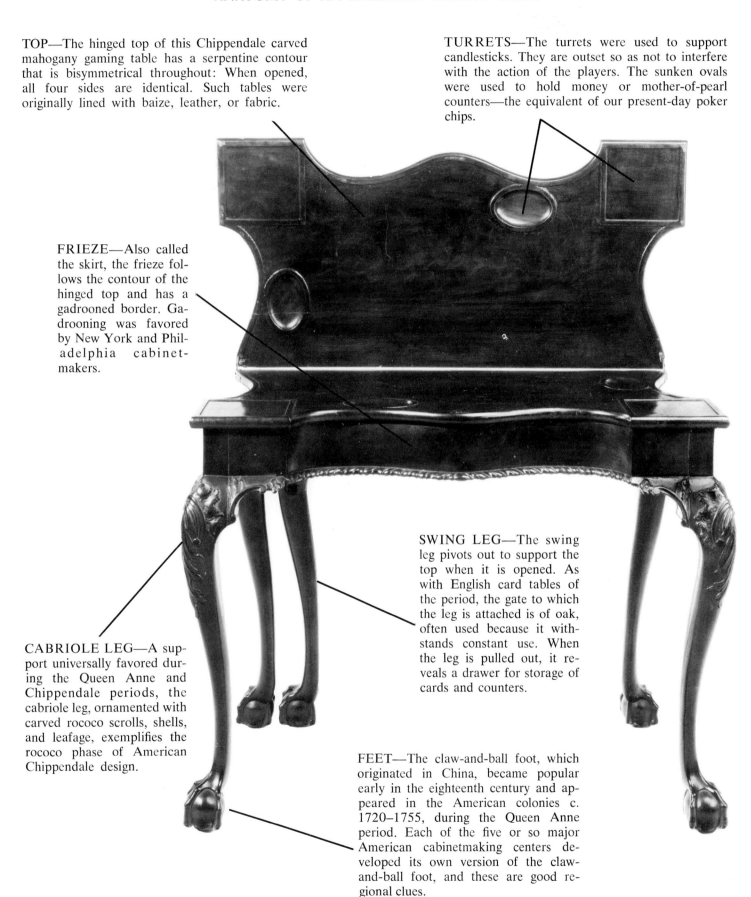

SWING LEG—The swing leg pivots out to support the top when it is opened. As with English card tables of the period, the gate to which the leg is attached is of oak, often used because it withstands constant use. When the leg is pulled out, it reveals a drawer for storage of cards and counters.

CABRIOLE LEG—A support universally favored during the Queen Anne and Chippendale periods, the cabriole leg, ornamented with carved rococo scrolls, shells, and leafage, exemplifies the rococo phase of American Chippendale design.

FEET—The claw-and-ball foot, which originated in China, became popular early in the eighteenth century and appeared in the American colonies c. 1720–1755, during the Queen Anne period. Each of the five or so major American cabinetmaking centers developed its own version of the claw-and-ball foot, and these are good regional clues.

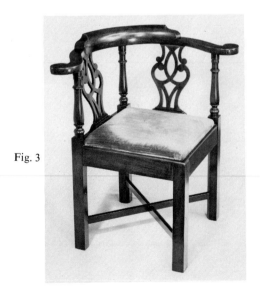

Fig. 1

Fig. 2

Fig. 3

AMERICAN
CORNER CHAIRS

The many innovative furniture forms introduced during the William and Mary period (1685–1720) include the highboy and lowboy, wing chairs or easy chairs, daybeds and corner chairs, to mention the most noteworthy. Comfort and convenience were emphasized, as evidenced by the existence of four upholstery shops in Boston in 1688.

Corner chairs were made in the American colonies throughout the eighteenth century. They followed all of the major style trends but passed from fashion during the Federal period.

The outstanding corner chair illustrated opposite is one of a pair made for John Brown of Providence, Rhode Island, probably by John Goddard of Newport, who is known from existing letters to have supplied furniture to the Brown family. If the provenance is impressive, the chair itself is even more so. It is a truly great example of Rhode Island design.

A related chair, shown in Fig. 1, though fine, lacks some of the grace of the Brown chair. The juxtaposition of turned and curved elements is not so successful as the total reliance upon curved members in the Brown chair. The third Newport corner chair (Fig. 2) is lighter in scale.

The Rhode Island Chippendale corner chair with straight, square legs (Fig. 3) is a simpler version of the first three examples. Because of its square legs, it is not considered as desirable as the chairs with cabriole legs. As with most popular items of furniture, cabinetmakers in country towns tried to copy fashionable city prototypes, often with naïve and charming results. An example is the Connecticut corner chair in Fig. 4, which would be an attractive purchase for a modest collector avoiding the substantial prices commanded by American furniture masterpieces from Newport, New York, or Philadelphia.

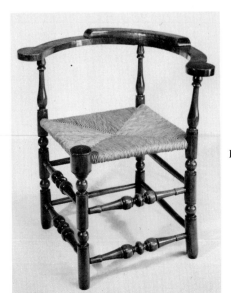

Fig. 4

CREST—Corner chairs range from high-styled examples, such as this classic John Goddard piece of about 1760, to primitive turned-wood chairs with splint seats. They are also called roundabout and writing chairs. Most examples have a "pillow" crest, a feature often found on low-back Windsor chairs. On some rare examples the pillow crest supports an additional splat and crest.

SEAT—Cyma-curved seat frames are found on many Philadelphia, New York, and Newport corner chairs, but few are as deeply curved as this example. The slip seat came to America with the introduction of the Queen Anne style in the first quarter of the eighteenth century. Before that, rush, cane, or upholstered seats were used.

ARMS—The outward curve of the arm terminals is standard for this form; some examples terminate in carved knuckles. The concave disks on each arm are a rare feature and may have been intended as elbow rests.

SPLAT—The pierced "pretzel" splats on this chair are seen on other Newport and New York chairs. Although some regions favored specific splat designs, there was a certain amount of duplication, especially in the Chippendale period when design books by Manwaring, Chippendale, and others were in use in most of the major American cabinetmaking centers.

ARM SUPPORTS—The inverted cabriole arm supports are more often found on Philadelphia and New York corner chairs. The usual arm support in most regions is a turned vertical one.

CABRIOLE LEG—Introduced into the American colonies with the Queen Anne style and widely adopted, the cabriole leg is often an indicator of region. In Newport the cabriole leg is broad and rounded, but square and sharp at the back. The feet generally lack webbing between the toes, and the talons are often undercut and raised above the high ovoid ball.

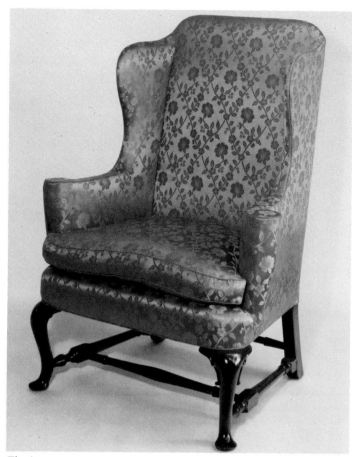

Fig. 1

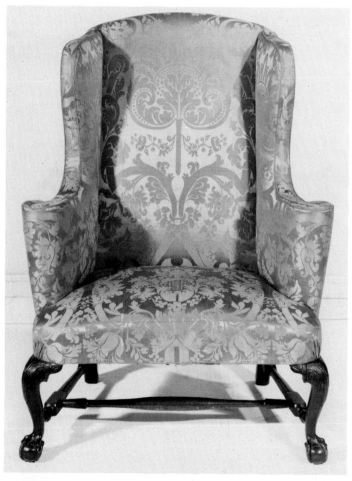

Fig. 2

AMERICAN
WING CHAIRS

"Easie" chairs, as wing chairs were then called, were introduced to the American colonies during the William and Mary period. This style has been described by one historian as the most important single contribution of that period to solid comfort.

The basic design of the wing chair is so successful that it has never really gone out of fashion, except for a brief period during the Victorian era. It adapted well to the successive style changes that followed its introduction. These changes were not fundamental but involved only grafting front legs and (sometimes) stretchers in the latest style onto a proved and popular form.

The wing chair seen opposite is, in many respects, one of the great chairs of the Philadelphia school. The back is canted; the wings are beautifully shaped and flow into the finely scrolled flaring arms.

Another classic example in the Queen Anne style, shown in Fig. 1, was made in Newport, Rhode Island—as evidenced by the high, arched crest that stands well above the wings, and the *C*-scrolls on each side of the broad knees. It is one of the finest of its type.

The walnut wing chair in Fig. 2 is from Massachusetts; its acanthus-carved cabriole legs and claw-and-ball feet are characteristic of the Chippendale style. Wing chairs were exceedingly popular throughout the eighteenth century because they shielded their occupants from drafts and the direct heat of open fires, and the high backs and wings also provided a headrest.

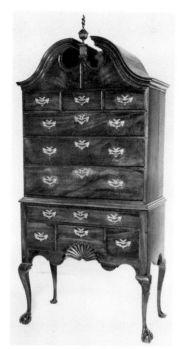

Fig. 1

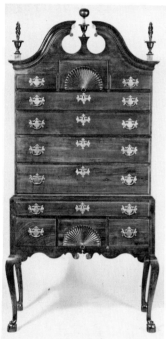

Fig. 2

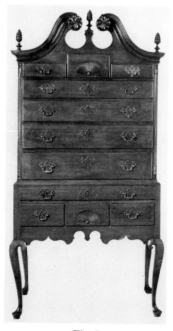

Fig. 3

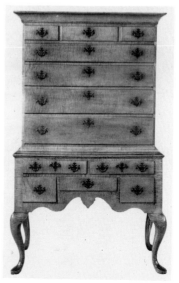

Fig. 4

Without doubt, highboys are the items of early American furniture most eagerly sought after. It is the one form that collectors dream of owning. Both highboys and lowboys were introduced into the American colonies during the William and Mary era (1690–1720) and remained in favor until the end of the Chippendale period.

American highboys reached their zenith in the work of Philadelphia cabinetmakers. By 1710 the form was less in demand in England, and the American innovations would surely have been considered old-fashioned there.

Every element in the highboy seen opposite is perfectly proportioned—the rosettes of the swan-neck crest, the carved scrollboard and the graduated drawers, the scrolled skirt and carved feet.

Highboys were produced in all the American colonies and generally reflect regional preferences. The beautiful Townsend–Goddard highboy in Fig. 1 was made in Newport between 1760 and 1780 and includes the paneled scrollboard, shell, acanthus-carved knees, and undercut talons in the claw-and-ball feet favored by that school of cabinetmakers.

Tiny carved rosettes, diamond-pierced skirt, and high claw-and-ball feet are all marks of Salem, Massachusetts, craftsmanship (Fig. 2).

Connecticut cabinetmakers favored cherrywood. The Connecticut cherrywood highboy, shown in Fig. 3, has pinwheel rosettes, spiral flame finials, and carved fans ornamented with stamped decoration. These features, as well as the valanced skirt and slender cabriole legs, are to be found on many of the highboys produced in that region.

As New York cabinetmakers generally preferred the chest-on-chest, relatively few New York highboys are to be found. The Queen Anne tiger maple flat-top highboy in Fig. 4 has the vigorous cabriole legs and slipper feet favored by New York cabinetmakers of the Queen Anne period.

TOP—Depending upon the period or region in which an American chest of drawers was made, the top may be elaborately molded or shaped or a simple hard-edged rectangle. Townsend–Goddard desks and chests of drawers, of which this rare Chippendale mahogany chest is an example, have intricately molded tops above deeply coved frieze moldings.

CARVED SHELLS—A decorative device, carved shells were developed by the Townsend–Goddard family of Newport, Rhode Island, perhaps as early as 1735. Some were carved from solid mahogany; others, as in this case, were carved separately and then applied to the drawer front. Except for highboys, case pieces by this family of cabinetmakers are generally ornamented with two convex shells flanking a concave central shell.

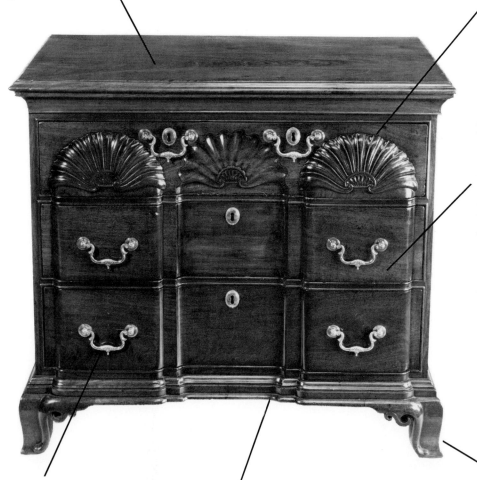

DRAWERS—The drawers are subtly graduated, a feature of fine American Queen Anne and Chippendale case pieces, and are blocked to conform to the shells of the top drawer, as well as being divided by channel moldings. Similar divided moldings are generally to be found on block-front case pieces made elsewhere in New England. This piece was probably made about 1750.

HANDLES—The unusual brass bail handles, original to the chest, are ornamented with shells which effectively complement the shells of the upper drawer. Such fine brasses as these, as well as more ordinary furniture brasses, were imported from England. American brass founders often could not compete with their English counterparts in either quality or price.

BASE—Intricately blocked and molded, the base repeats the outward thrust of the top. As with the top, the base molding generally follows the contour of the case.

BRACKET FEET—The feet have an ogee curve straighter than that usually found on Townsend–Goddard chests, but the inside vertical scroll is almost a signature of their work. The S-shaped winged brackets are unusual.

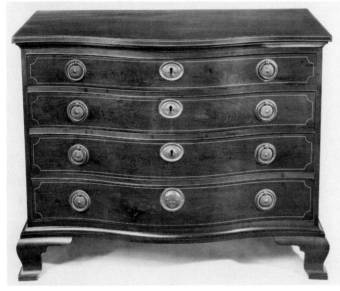

Fig. 1

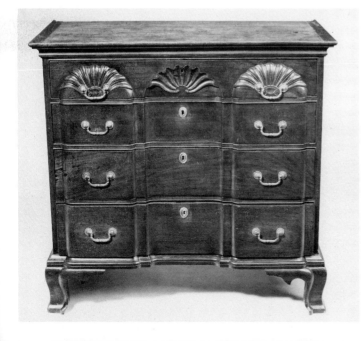

Fig. 2

AMERICAN
CHESTS OF DRAWERS

The block-and-shell-carved furniture developed and produced by the Townsend–Goddard family of Newport, Rhode Island, is highly distinctive: It has no known exact counterpart in either Continental or English furniture design. Blocking as such is frequently seen in European furniture, but its combination with shell carving was unique to New England.

Founded in 1639, Newport was a thriving center by 1680. Legitimate trade, privateering and piracy on the high seas combined to stimulate its commercial and physical growth. By 1750 Rhode Island had more than three hundred ships, and Newport merchants were selling ships, whale oil, dried fish, rum, and slaves to the West Indies, England, Portugal, Spain, Italy, and ports as far away as the Red Sea. Many of the great houses and public buildings that stand today in Newport were built at this time. The Townsend–Goddard family of cabinetmakers was productive not only during Newport's most brilliant period but also during and after its economic decline, which followed the Revolutionary War, when the city was blockaded.

The chest of drawers with rounded blocking repeated in its top and base (Fig. 1) was produced at about the same time as the Townsend–Goddard chest opposite. It is another example of Newport cabinetwork, as is the serpentine-front chest in Fig. 2, which embodies features of both the Chippendale and Federal styles (1785–1820). The bracket feet on the serpentine-front chest are quite similar to those on several Townsend–Goddard slant-front desks.

The cabinetmakers of Connecticut, especially those close to the Rhode Island border, were quick to adopt the Townsend–Goddard line. But unlike the maker of the great Connecticut tray-top, block-front chest in Fig. 3, most of them handled this new design with less success than did the Newport cabinetmakers.

Fig. 3

BACK—In fine wing chairs the back is canted for comfort. The shape of the crest is often a regional indicator. The classic 1700 Queen Anne chair had a high and relatively narrow back, while in later versions the back was lower but wider.

WINGS—These panels attached to either side of the back are generally of ogival form. In combination with the high back, the wings helped to ward off drafts and are evidence of the concern with comfort that characterized English court furniture after the Restoration.

ARMS—The arms of this Queen Anne carved walnut chair, c. 1750, are both horizontally and vertically scrolled. Such double scrolling is a feature of Philadelphia wing chairs. On New York and New England chairs the arms usually terminate in vertical scrolls.

SEAT—On Philadelphia wing chairs the seat is, more often than not, deeply curved at the front. This example does not demonstrate that particular characteristic.

LEGS—Here the cabriole legs have intaglio-cut knees, a Philadelphia characteristic, as is the rear "stump" leg. Legs on later chairs were joined by turned stretchers for sturdiness.

UPHOLSTERY—Whether of English or American origin, easy chairs were usually elegantly upholstered. This one is in the original fabric, rose-crimson damask. On occasion, upholsterers were allowed to apply their own labels to easy chairs. The framework beneath the upholstery is often definitive in attributing easy chairs to a region or maker.

FEET—The style shown here is known as trifid, while the plain slipper foot, more usual in the Queen Anne style, and the claw-and-ball foot of the Chippendale style are shown on the preceding page.

ANATOMY OF AN AMERICAN HIGHBOY
(See Color Plate 11.)

SWAN-NECK CRESTING—A deeply molded swan-neck crest ends here in the type of carved rosette often found in Philadelphia examples. Usually the rosettes are carved separately and then applied to the crest.

VOIDS—The voids at the juncture of the crest and scrollboard are oval in form, a feature of Pennsylvania and especially of Philadelphia Chippendale highboys, chest-on-chests, and secretaries.

SCROLLBOARD—The carved ornamentation on Philadelphia Chippendale highboys is usually restricted to the topmost central drawer. Only in the finest examples, such as this, does the carving extend across the entire scrollboard.

QUARTER COLUMNS —Queen Anne and Chippendale case pieces are essentially architectonic. The quarter columns shown are architectural elements applied to furniture as ornament and were intended to soften the hard-edged front corners. Chamfering of the corners was often used in place of quarter columns but is less desirable.

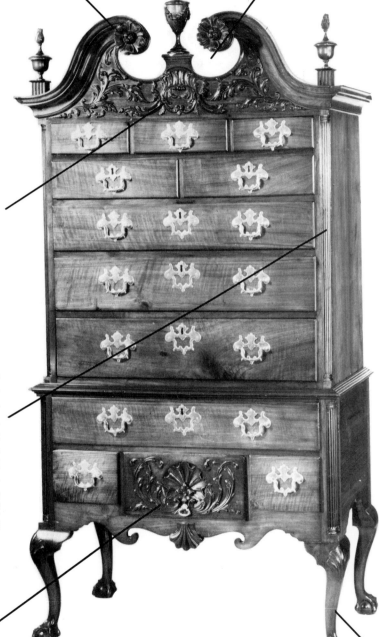

CENTRAL DRAWER—A carved cockleshell surrounded by applied grasses usually ornaments the lower and upper central drawers on Philadelphia highboys; here the beautifully executed shell with its graceful leaf surround occurs only on the lower. Note the shaped skirt with its pendent convex shell.

CABRIOLE LEG—Ornamented at the knee with carved shells, the legs end in vigorously carved claw-and-ball feet.

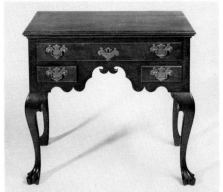

Fig. 1

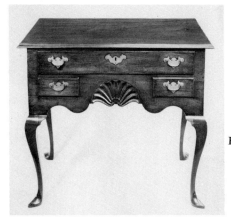

Fig. 3

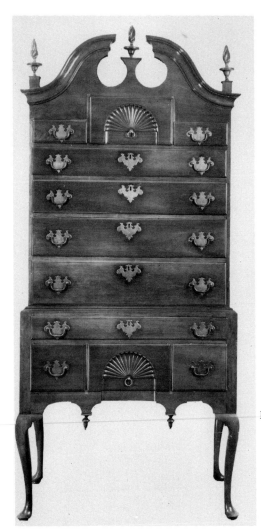

Fig. 2

AMERICAN LOWBOYS

Among today's collectors of American antique furniture, lowboys rank second only to highboys as the most desirable furniture form. Lowboys were called "dressing tables" in the eighteenth century.

The attractive example shown opposite was made in Massachusetts or New Hampshire between 1725 and 1735. Line inlay very effectively emphasizes all of the elements in its design. The concave blocking of the central drawer is to be found on a number of Queen Anne highboys and lowboys made in Massachusetts and Connecticut.

The Pennsylvania Queen Anne lowboy in Fig. 1 has a "fishtail" skirt. Its robust cabriole legs end in trifid feet—a foot design found almost exclusively on Queen Anne furniture produced in Pennsylvania or southern New Jersey.

The Townsend–Goddard lowboy in Fig. 2 has a well-executed shell, and its angular cabriole legs terminate in slipper feet. It is relatively plain but beautifully proportioned in the tradition of Newport furniture.

Highboys and lowboys were made, more often than not, as matched sets (Figs. 3 and 4). Few such sets have survived intact, and only a small number are known. These are much sought after and command high prices whenever they reach the marketplace together.

Fig. 4

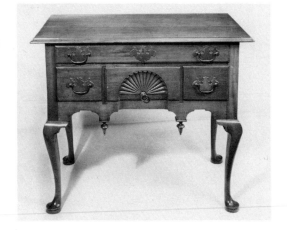

TOP—The molded edge of this Queen Anne inlaid maple lowboy made c. 1725–1735 is outlined with light stringing and has a "compass" inlay—a twelve-pointed stellate device—at center.

DRAWERS—The disposition of the drawers is standard for all regions—one long drawer above two or three short drawers. The cockbead around the outside of the drawer openings indicates an early date. Cockbeading is generally used to ornament the drawer facings themselves.

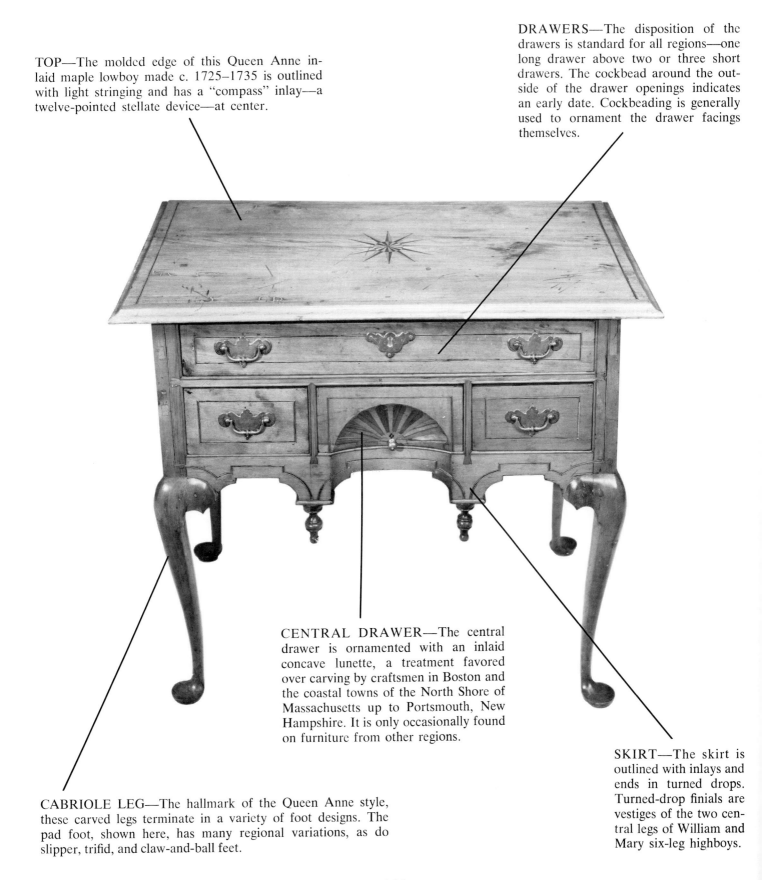

CENTRAL DRAWER—The central drawer is ornamented with an inlaid concave lunette, a treatment favored over carving by craftsmen in Boston and the coastal towns of the North Shore of Massachusetts up to Portsmouth, New Hampshire. It is only occasionally found on furniture from other regions.

SKIRT—The skirt is outlined with inlays and ends in turned drops. Turned-drop finials are vestiges of the two central legs of William and Mary six-leg highboys.

CABRIOLE LEG—The hallmark of the Queen Anne style, these carved legs terminate in a variety of foot designs. The pad foot, shown here, has many regional variations, as do slipper, trifid, and claw-and-ball feet.

AMERICAN
CHEST-ON-CHESTS

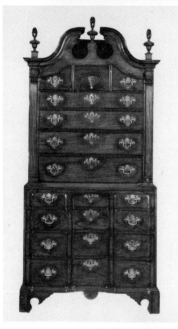

Fig. 1

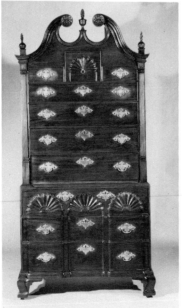

Fig. 2

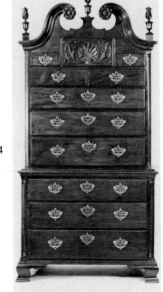

Fig. 3

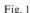

Fig. 4

The chest-on-chest was derived from the seventeenth-century chest or desk raised on a high separate frame or turned supports. By adding drawers to the frame, beginning in the William and Mary period, the chest was transformed into the highboy or the chest-on-chest.

In rural parts of New England and Pennsylvania, chests-on-frame (Fig. 1) and chest-on-chests continued to be made with separate bases well into the Chippendale period (1755–1780).

The *bombé* or kettle shape illustrated opposite was expensive to produce. American cabinetmakers, with their source of fine mahogany close at hand, cut this form from solid four-to-five-inch-thick planks of mahogany. European cabinetmakers generally were forced to laminate small pieces of walnut or mahogany or to apply mahogany veneers to lesser woods to produce the same shape. This superb *bombé* chest-on-chest is one of two such pieces extant, the other being in the Colonial Williamsburg collection.

Another chest-on-chest (Fig. 2) made by Benjamin Frothingham of Charlestown, is an example of the fine block case pieces made by Massachusetts cabinetmakers.

Regional variations are to be seen in a rare Townsend–Goddard piece (Fig. 3) made between 1760 and 1780 with a block-and-shell carved base and a rare use of applied pilasters in place of the usual quarter columns, and in the superb Pennsylvania chest-on-chest (Fig. 4), probably made in Lancaster or York counties, with its Philadelphia-influenced carved rosettes and carved shell with applied leaf surround.

CRESTING—This particular form is known as swan-neck cresting. It is found on American Queen Anne and Chippendale case pieces with or without carved or scrolled volutes. The crest generally supports urn-and-flame finials, in this case corkscrew finials typical of New England. This Chippendale mahogany *bombé* chest-on-chest was made in Boston about 1765–1780.

VOIDS—The voids created by the junction of the scroll-board and swan-neck crest are often an indication of the region in which a case piece was made. Circular voids are to be found almost exclusively on New England case pieces.

CARVINGS—In Pennsylvania and Maryland case pieces the carved fan, seen here on the topmost central drawer, is usually replaced by an elaborately carved shell with leaf surround.

DRAWERS—The size of the drawers in early-American high-style case pieces was generally based upon a system of proportion: The outer edges of the topmost small drawers are one-half the height of the lowest drawer of the upper section, and the drawers of the base repeat the gradation.

PILASTERS—A decorative feature often found on Massachusetts Queen Anne and Chippendale chest-on-chests, highboys, and secretary-bookcases are the pilasters. Connecticut cabinetmakers also employed decorated applied pilasters, although not as frequently.

FOOT—This particular support is known as an ogee bracket foot. It is a form of support introduced into the American colonies early in the eighteenth century. Bracket feet can be straight, or blocked, or curved, as in this example.

BASE—Called a *bombé* or kettle base, this is a form which was almost exclusively employed by Massachusetts cabinetmakers beginning about 1750. In the best examples the drawers follow the outline of the sides and are of serpentine contour.

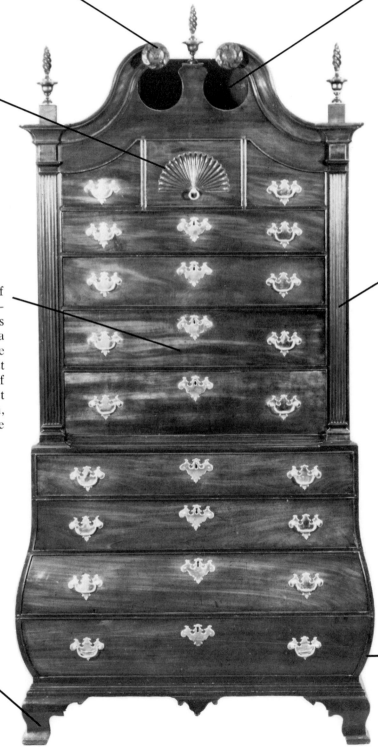

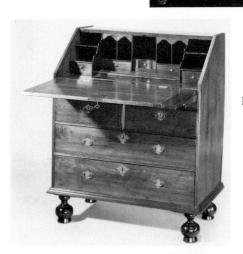

Fig. 1

AMERICAN DESKS

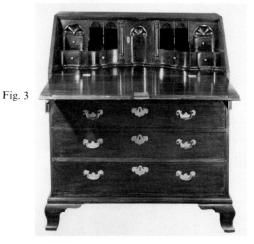

Fig. 2

The desk form emerged in the seventeenth century as a simple box on frame with a winged lid serving as a writing surface. It developed into the desk-on-frame, like the early Rhode Island Queen Anne maple child's desk in Fig. 1. With the addition of drawers during the William and Mary period, the slant-front desk came into existence.

The Rhode Island William and Mary desk in Fig. 2 featured blocking in the interior, which in more elaborate form became a design distinction of case pieces produced in the Queen Anne and Chippendale periods in Rhode Island, Massachusetts, and Connecticut. Note the beautifully blocked interior of the Townsend–Goddard slant-front desk in Fig. 3.

During the Chippendale period (1755–1770), kneehole desks were produced in most of the major cabinet-making centers of America. Handsome block-front examples were turned out by craftsmen in New York, Massachusetts, and Rhode Island. Most authorities agree that the kneehole desks made by the Townsends and Goddards of Newport, Rhode Island, are rivaled only by the Chippendale highboys and lowboys of Philadelphia.

In assessing a block-front desk, the critical element is the decoration of the interior. The interiors of two Massachusetts Chippendale block-front desks (Figs. 4 and 5) demonstrate the differences that occur.

Fig. 3

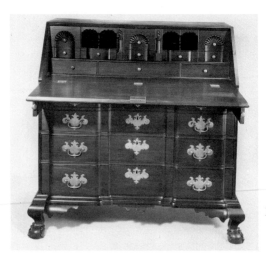

Fig. 4

Fig. 5

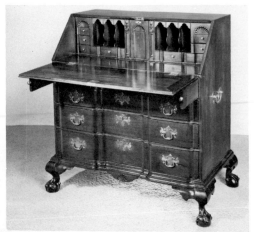

TOP—The rectangular top has a finely molded edge above a deeply coved frieze molding. Over-all, the desk is an important example of Townsend–Goddard block-and-shell-carved kneehole desks, possibly by Edward Townsend, Newport, Rhode Island, 1760–1780.

CARVED SHELLS—In this example, the convex shells are applied to the drawer front, and not carved "from the solid." On some Townsend–Goddard kneehole desks, which may also have served as dressing tables, the front of the topmost drawer is hinged and opens to reveal an interior fitted with small drawers and pigeonholes; the drawer front itself serves as a writing surface.

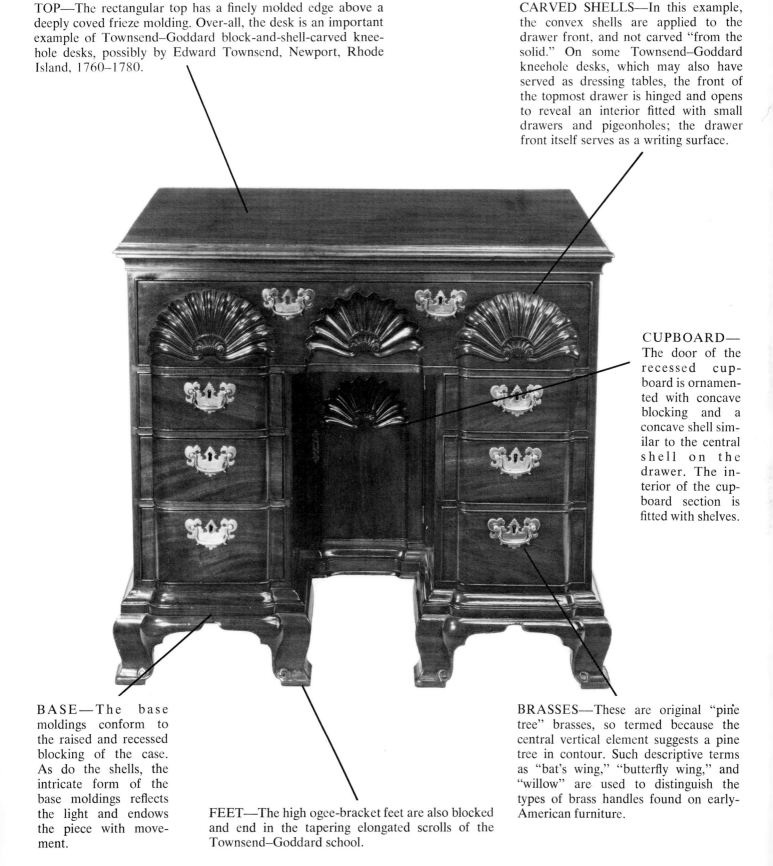

CUPBOARD— The door of the recessed cupboard is ornamented with concave blocking and a concave shell similar to the central shell on the drawer. The interior of the cupboard section is fitted with shelves.

BASE—The base moldings conform to the raised and recessed blocking of the case. As do the shells, the intricate form of the base moldings reflects the light and endows the piece with movement.

FEET—The high ogee-bracket feet are also blocked and end in the tapering elongated scrolls of the Townsend–Goddard school.

BRASSES—These are original "pine tree" brasses, so termed because the central vertical element suggests a pine tree in contour. Such descriptive terms as "bat's wing," "butterfly wing," and "willow" are used to distinguish the types of brass handles found on early-American furniture.

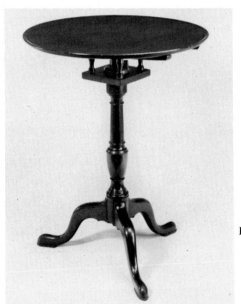

Fig. 1

AMERICAN
TILT-TOP TABLES

The tilt-top table is representative of the wide variety of small tables and stands which, because of their usefulness and versatility, became very popular during the Queen Anne and Chippendale periods. Often these small tables were used as candlestands.

The table seen opposite has been described by a leading authority as "one of the supreme Philadelphia tip-and-turn tables." The base and turned standard are models of perfection, and the piecrust top is uncommon.

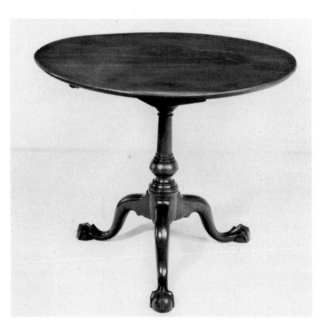

Fig. 2

Fig. 3

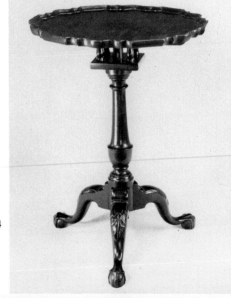

Fig. 4

The Philadelphia candlestand (Fig. 1) and table (Fig. 2) end in snake feet. The candlestand has a square top, a rare feature; the other a dished top and an urn standard. Larger tilt-top tables, such as the one shown in Fig. 3, were used as tea tables, and an extremely large tilt-top dining table is known to exist.

New York cabinetmakers were not far behind their Philadelphia counterparts in the production of fine tilt-top tables. This is seen in the New York Chippendale piecrust table in Fig. 4. The flaring urn standard is typical of the region.

TOP—This Chippendale table is illustrative of the wide variety of candlestands and tea and other tables which came into widespread use during the Queen Anne period. They are to be found with flat or dished (raised-edge) tops or with a dished top with piecrust edge, as in this example. It is of carved mahogany, dated c. 1760–1780, and attributed to Philadelphia.

STANDARD—The turned standard often reflects regional preferences. Philadelphia and other Pennsylvania craftsmen favored plain ring-turned or fluted standards above a flattened ball. They also made use of urn- and pestle-shaped standards, as did New York cabinetmakers.

BIRDCAGE—The hinged birdcage support allows the top not only to tilt upward so the table can be placed against the wall when not in use, but also permits it to revolve completely, in the manner of a lazy Susan. Such supports occur mainly on tables by Pennsylvania and New York cabinetmakers but can occasionally be seen on tables made in Connecticut, Massachusetts, and Charleston, South Carolina.

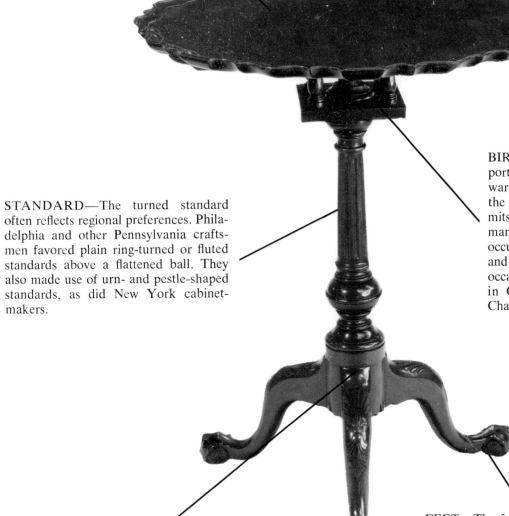

TRIPOD SUPPORT—It is formed of three deeply curved cabriole legs, usually unornamented. In major style centers, such as Boston, New York, and Philadelphia, cabinetmakers ornamented table legs with carved leaves, rococo scrolls, and shells.

FEET—The feet of tilt-top tables and stands are found in a variety of forms. When left unadorned, they are *snake feet*, because of their resemblance to the head of a serpent. *Rat-claw* feet were used as often as claw-and-ball feet. The French scroll foot is another type, but this is rarely encountered on American examples.

Fig. 1

Beginning about 1785, the sideboard was introduced into the American domestic interior. Its quick adoption was facilitated by the design books of Hepplewhite and Sheraton and by English price books illustrated with drawings and diagrams. They helped American cabinetmakers to produce this functional piece, which was often given a prominent place in those rooms beginning to be used exclusively for dining.

Sideboards were produced in all the principal cities of the United States, generally reflecting regional stylistic differences in size, shape, and inlays. The most elaborate, by all accounts, were the pieces made in Baltimore and Annapolis, Maryland, as seen in the corner sideboard in Fig. 1. The hunt board was also popular in that region. Hunt boards are small sideboards on high legs, such as the example illustrated in Fig. 2, which was probably made in New York about 1800. Rhode Island versions of the hunt board are also known (see Fig. 3); most of the latter are attributed to Thomas Howard, a Providence cabinetmaker.

Another version of the sideboard is the mixing board, or "drink table." It has a marble top, marble being impervious to alcohol. The example shown in Fig. 4 was made in Wilmington, Delaware, about 1800 and has a top of Chester County marble.

Sideboards are especially distinguished by the fine lines and delicate inlays so adroitly used by cabinetmakers of the early nineteenth century. They demonstrate the neoclassical preference for inlay instead of carving.

Fig. 2

Fig. 4

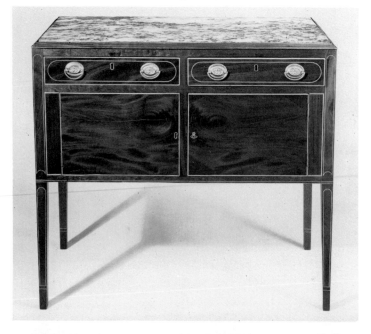

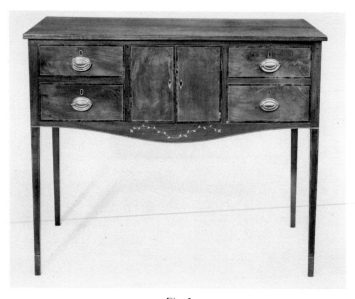

Fig. 3

TOP—The serpentine top, which conforms to the contour of the case, is outlined with pattern stringing. The canted corners are a design element found on sideboards made in Baltimore and the South.

BOTTLE DRAWER—The mock frieze drawer is actually part of the bottle drawer. The interiors of bottle drawers are fitted with dividers for wine bottles, a handy feature found on most Federal sideboards.

FRIEZE DRAWERS—Two of the frieze drawers are working drawers. All are veneered and inlaid with oval medallions, repeating the oval form of the stamped brass pulls, and are shaped to follow the contour of the case. On some examples the central frieze drawer is fitted up as a writing desk.

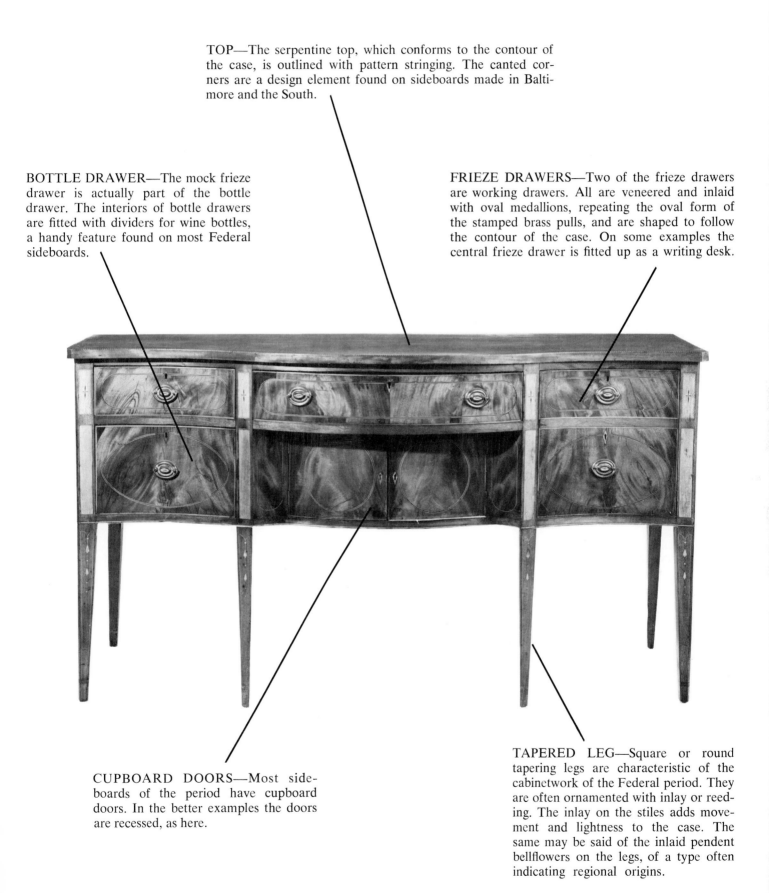

CUPBOARD DOORS—Most sideboards of the period have cupboard doors. In the better examples the doors are recessed, as here.

TAPERED LEG—Square or round tapering legs are characteristic of the cabinetwork of the Federal period. They are often ornamented with inlay or reeding. The inlay on the stiles adds movement and lightness to the case. The same may be said of the inlaid pendent bellflowers on the legs, of a type often indicating regional origins.

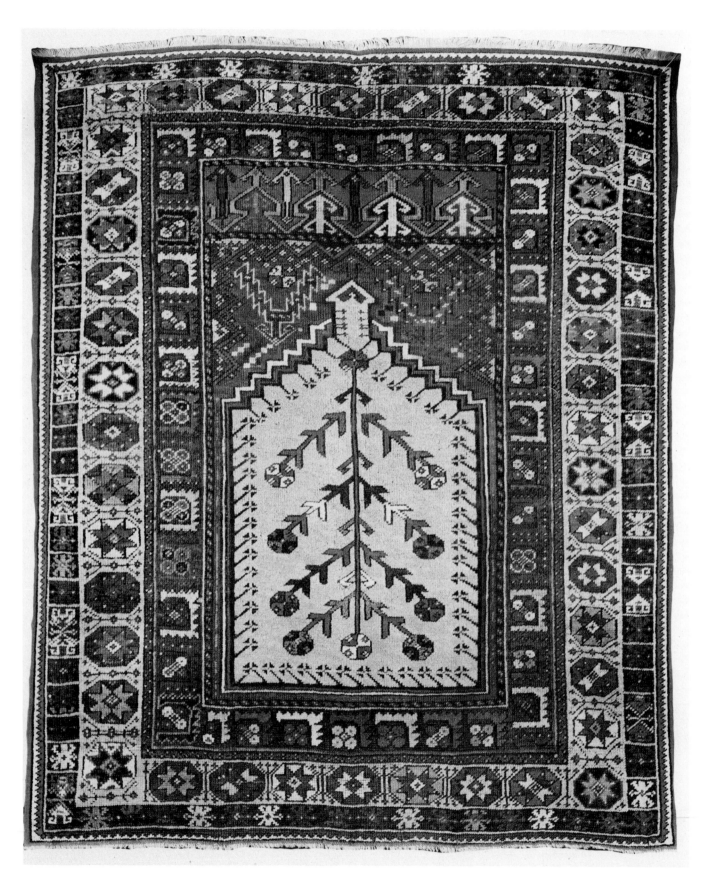

Tapestries have been woven since at least the end of the fourteenth century. They reached their apotheosis in the great products of the Brussels workshops at the end of the fifteenth and beginning of the sixteenth centuries—and again in the Gobelins masterpieces of the middle of the eighteenth century.

The four Gobelins tapestries seen here (opposite and in Figs. 1, 2, and 3) are examples of the final and perhaps greatest flowering of an art that skillfully combined design, technique, and decorative appeal.

The Gobelins workshops were bought by the French crown in 1662. From the beginning the factory employed the best artists and artisans in making tapestries of very high quality, many of them containing gold and silver thread. However, relatively few survive, largely because during the French Revolution many were stripped and sold for the value of their gold thread.

Gobelins was not alone in producing tapestries in Europe in the eighteenth century; there were similar workshops all over the Continent. In France Beauvais and Aubusson turned out a wide range of weavings. To the north, Brussels weavers were kept busy with the production of the so-called Teniers tapestries, which depicted Flemish yokels at play in rustic settings—a theme that echoed Jean Jacques Rousseau's romanticism and extolled the simple virtues to be found in the untouched beauty of country life.

By the end of the eighteenth century tapestry weaving had all but disappeared because of political upheaval and changing styles. The increased strength of national governments reduced the power of the guilds. There was little interest in traditional themes, and quickly shifting governments disapproved of subjects reminiscent of the old regimes.

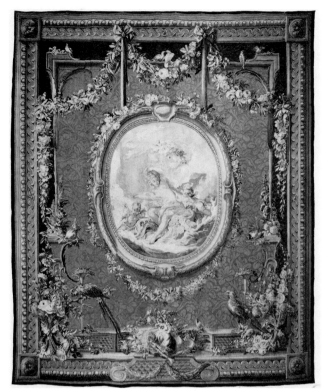

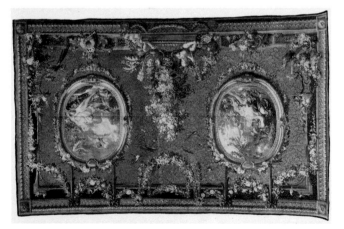

Fig. 1

Fig. 2

Fig. 3

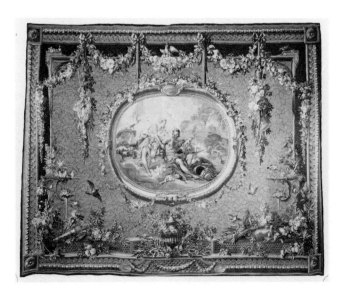

SUBJECT—Two of the favorite amusements of the emerging aristocracy of Europe, gambling and hunting, are portrayed here by the noble couple playing at draughts (or checkers) surrounded by four courtly hunters.

STYLE—This type of tapestry is known as *mille fleurs* (literally, a thousand flowers) because of the over-all profusion of blossoming trees and flowers surrounding the figures.

DESIGN—No attempt was made by the weaver to indicate depth or perspective. Instead the entire surface of trees, flowers, and figures is treated as a decorative pattern.

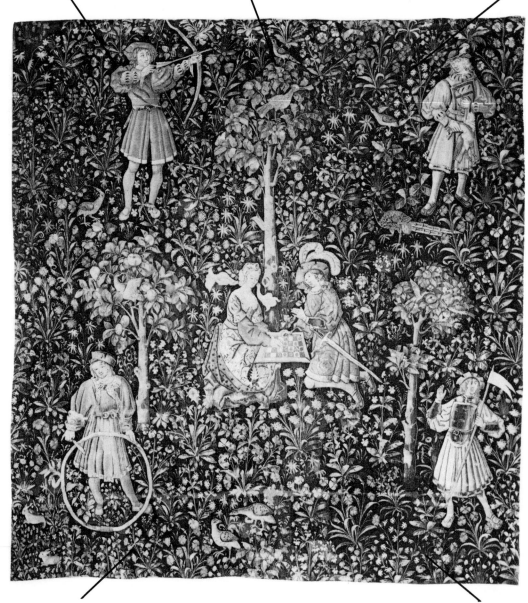

CONDITION—Because many of the vegetable colors tend to fade and the warp and woof are susceptible to dry rot, very few tapestries of this period (early sixteenth century) have survived, and these have often been restored.

WEAVE—This tapestry was woven of vegetable-dyed wool thread on a large loom. Because of its size and the intricacy of its design, it probably took a year or more to complete.

EARLY
FLEMISH TAPESTRIES

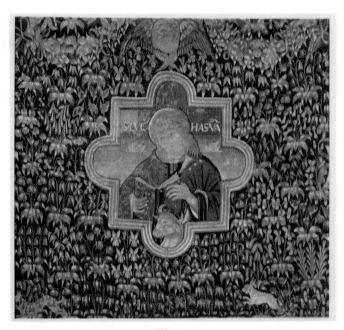

Fig. 1

Fig. 2

Early tapestries reflect the love of detail expressed in illuminated manuscripts—flowers, animals, and figures occupy every available inch of the surface. Normally these decorations served as a background for historical, mythological, or religious themes from both the Old and New Testaments, as evidenced in the early-sixteenth-century tapestry in Fig. 1. But as the spirit of the Renaissance grew, courtly, secular, and proverbial subjects became popular (see Fig. 2).

Tapestries represented a perfect solution to the problem of decorating bare stone walls. Tapestries helped keep out drafts and added color to the gloomy, almost windowless interiors of the medieval fortified castles.

Of course, only the very wealthy could afford the expensive materials (fine wool, exotic silk, and even spun gold and silver) and the wages paid to the skilled tapestry weavers. The industry thrived particularly in the Low Countries, where many of the townspeople were trained in the art. By the beginning of the eighteenth century virtually every major court in Europe had experimented with setting up its own workshop.

Although some tapestries were woven with specific subjects and themes, many tapestries were intended to be purely decorative. These depict rural or landscape scenes and were called verdures, due to the predominance of vegetation in the design. A fine example of this is the Albany Oudenaarde tapestry (Fig. 3). The seventeenth century witnessed an enormous output of these, and they account for perhaps as many as half of the tapestries that appear on the market today.

Fig. 3

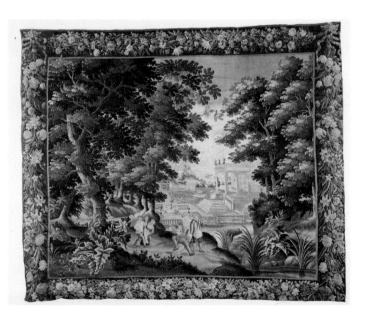

TEXTILES, TAPESTRIES, AND RUGS

Man's ability to make use of the raw materials of animal hair and vegetable fibre is as old as civilization itself. Perhaps the earliest approximations of textiles were beaten fabrics similar to felt, but the superiority of woven textiles soon became apparent, and these have been used ever since for clothing, floor coverings, and decorative hangings. The materials used and techniques employed depend upon availability in a given area and the use to which the fabric is to be put. Thus, rugs and carpets are usually characterized by a thick pile (to withstand heavy wear), while wall coverings and upholstery fabrics can be lighter in texture and weight. The development of weaving in Europe owes much to the influence of the Turks and Arabs, who were far more advanced than were Europeans, and from whom the Italians and Spaniards acquired most of their weaving techniques. From the late Middle Ages onward, fine textiles in Europe were characterized by elaborate designs, lavish use of gold and silver thread, and a high degree of craftmanship. Very often fairly large manufactories were set up, but it was more common for craftsmen and merchants to form guilds. Individuals or groups (such as nuns in a convent) sometimes worked for long periods of time in making and decorating fabrics for ecclesiastical and domestic use.

The variety of techniques, designs, and decorative possibilities contained in the term "textiles" is enormous. Carpets (with or without pile), tapestries, velvets, silks, damasks (derived from the word "Damascus"), needlework, lace, embroidery, appliqué work, and printed materials are the principal subdivisions.

COLOR—The consummate achievement of tapestry weaving in the mid-eighteenth century is due largely to the enormous variation and brilliance of the dyes then available. Of special note here is the unusual rose hue first associated with Madame de Pompadour, the favorite of Louis XV.

DECORATIVE ELEMENTS—These include great richness and multiplicity of motifs, architectural details, and such objects as floral garlands, exotic birds, and emblematic trophies. They combine the taste of the rococo era with that of budding neoclassicism.

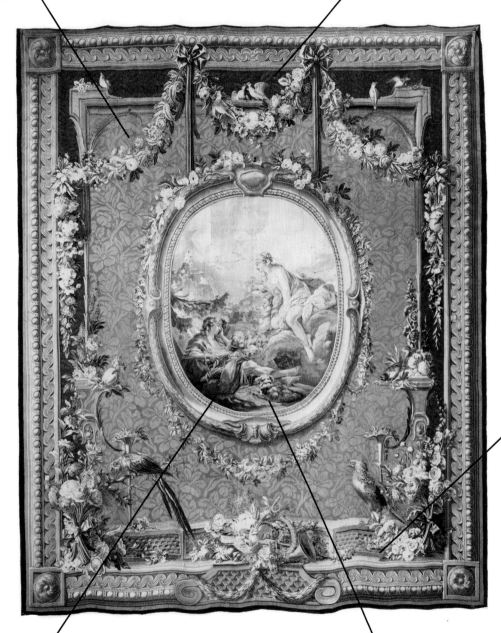

SIGNATURE—*Neilson Ex.*, for Jacques Neilson, director of the Manufacture des Gobelins from 1751 to 1788, indicates a particularly important weaving.

SUBJECT—The central medallion depicts Aurora, goddess of dawn, gazing down at a youth, Cephalus, the object of her desires. Interest in the more erotic aspects of classical mythology reflected the sophisticated tastes of the pleasure-centered French court of Louis XVI and Marie Antoinette.

DESIGN—The original drawings (or cartoons) are by François Boucher and Maurice Jacques. Many arts profited from extraordinary cooperation among different guilds—in this instance between painters and weavers.

179

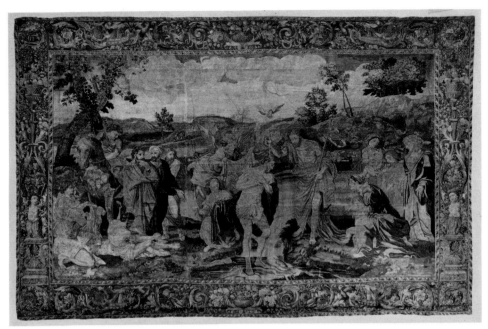

Fig. 1

EARLY NEEDLEWORK

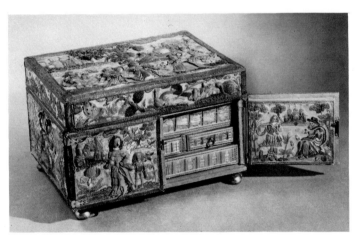

Fig. 2

The hanging illustrated on the opposite page is an elegant late-sixteenth- or early-seventeenth-century rendering of such stories as the Rape of Europa, the race between Atalanta and Hippomenes, and the Judgment of Paris, all placed in contemporary settings. Many of the panels were probably based on Flemish engravings, which were widely circulated. It is difficult to determine whether the panels are of Continental or English origin.

Large Renaissance or Baroque embroideries are rare today. However, one piece appeared recently: an extremely large silk embroidery, probably Italian, depicting the Baptism of Christ (Fig. 1). Such textiles, as opposed to tapestries, were frequently the work of individuals or small home workshops. One often discovers here a charm and spontaneity lacking in tapestries from the large, well-known centers.

Among the most interesting types of needlework of the seventeenth century are the caskets or workboxes done by aristocratic ladies during the Stuart period. The casket shown in Fig. 2, bearing the date 1671 and the monogram *EC,* is an excellent example of several techniques. Figures, animals, and flowers are executed in a raised technique (known as stump work) and cutout embroidery, applied to a ground of cream-colored satin. Beadwork also was often employed. The range of possible combinations of techniques allowed the worker great freedom. Boxes bearing dates are of particular importance, as they enable us to isolate a style and technique of otherwise uncertain origin.

SUBJECT—A fanciful combination of stories from mythology, the classics, and everyday life, including Vertumnus and Pomona, Apollo and Daphne, and mortal lovers in garden settings, was typical subject matter of a period when religion was being supplanted by humanism and a fascination with classical studies was prevalent.

DECORATIVE ELEMENTS—The needlepoint was commonly decorated with a wealth of ornamental details and objects of daily use. The costumes are a fashion catalogue of late Elizabethan dress.

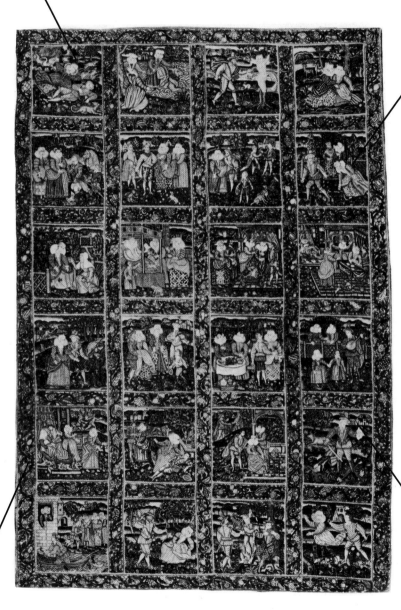

NEEDLEPOINT—Court ladies spent much of their leisure time doing fancy needlework. Here, large stitches (gros point) were employed for the background and borders, while fine stitching (petit point) was used for the faces. In addition, silver thread was employed to represent jewels and armor worn by the figures.

ICONOGRAPHY—There were amusing combinations of mythological personalities with contemporary costumes and settings. For example, the Greek god Hermes' wings placed on a late-sixteenth-century hat.

ORIENTAL
RUGS AND CARPETS

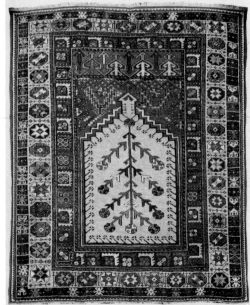

Fig. 1

Fig. 2

Fig. 3

These terms are used to describe the entire range of hand-knotted woven floor coverings and other forms made in Asia, from Turkey to China. The broadest subdivisions are: Persian, Turkish, Caucasian, Turkestan, and Chinese. Indian and Japanese weaving, although very often of high quality technically, so often employed borrowed designs, some even of Western origin, that they are not considered in the same category. The terms "rug" and "carpet" are very often confusing, and many collectors prefer the traditional English terminology which restricts the word "rug" to those smaller than about six by nine feet, and reserves "carpet" for the larger sizes. A "runner" is a long, narrow rug.

Most of the trade names given to the various types of Oriental rugs denote the geographical or tribal areas where certain types were originally produced. Now, however, the names most often apply to the design associated with the geographical area, even though the rug or carpet may be woven elsewhere.

Recent discoveries indicate that these hand-knotted rugs and carpets may have been made as early as the fifth century B.C. Europeans have been enthusiastic collectors of Oriental rugs since the late Middle Ages, when Marco Polo and others brought back stories about their fabulous beauty and the opening of trade routes allowed their importation. In many cases, since the rugs themselves have not survived, all we know about these early rugs in Europe is derived from contemporary paintings. Their preciousness is indicated by the fact that very often they are seen as table coverings rather than floor coverings.

There are two principal knotting techniques used in the weaving of these carpets: the Persian (or Sehna) knot and the Turkish (or Ghiordes) knot. In both cases, the material of the pile, whether wool, camel's hair, goat hair, or silk, is knotted onto a framework of threads, which may be of cotton or wool, and which run horizontally (the warp) and vertically (the weft).

Persian rugs: Perhaps because they derived from the legendary "Spring Carpet," said to have been woven for the palace at Ctesiphon in the seventh century, Persian rugs have always been considered the most luxurious of the Oriental examples. More than eighty feet square in size, the value of this fabulous carpet has been estimated at upward of $200 million—no doubt due to the immense number of precious stones woven into the fabric. Its theme was a colorful garden, and even today many Persian rugs, with their animals, floral patterns, and leafy scrolls, suggest beautiful formal gardens.

Fig. 1 shows a silk Heriz carpet with circular medallions surrounded by stylized flowers and trees within multiple guard bands and a floral border. Another distinctly Persian type is the Kirman pictorial carpet illustrated opposite; its subject matter, representative of the human fig-

SIZE—The area of this carpet measures 12 by 8 feet.

SUBJECT—Pictorial subjects such as this were made at Kirman (and seldom elsewhere), often inspired by legends, myths or—as in this instance—by a European model. The colors tend toward rose-pink, beige, blue, and green.

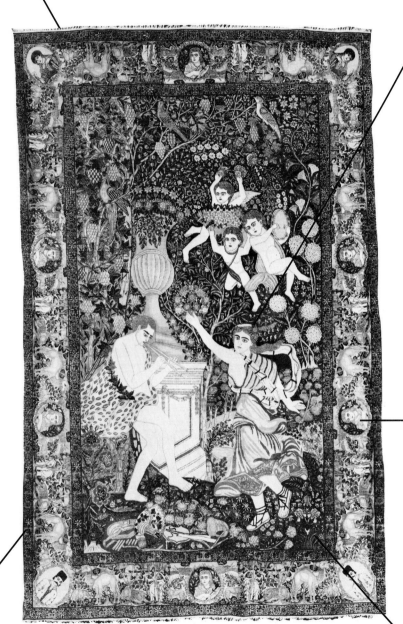

BORDERS—Larger, freer in design, the border is usually of scrolling leafage. Here is an interesting arrangement of human beings and animals amid flowering trees.

GUARD BANDS—Conventional stylized flowers and leafage are typical of Persian carpets. Although the designs of the border and the center may be freer, the guard bands, which are comparable to hedgerows dividing a garden, are usually composed of small, neatly arranged flowers or are completely plain, to form a contrast with the other design elements.

BACKGROUND—Reminiscent of European *mille fleurs* tapestries, in which the weaver attempts to show his skill by the variety and exactness of his botanical portrayals, the background consists of a free arrangement of blossoms, birds, and vegetation, almost obscuring the ground color.

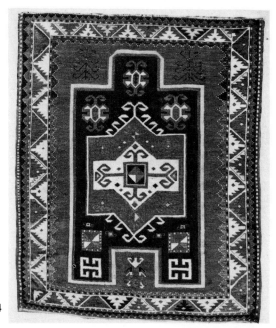

Fig. 4

ure, is never found in other types of Oriental rugs. Besides Kirman and Heriz, well-known types of Persian carpets include Isfahan, Tabriz, Sarouk, and Kashan. All exhibit the Persian weavers' fondness for curvilinear, free-flowing forms and soft, mellow colors.

Turkish carpets: The prayer rug, characterized by the presence of a *mihrab,* or pointed arch panel which the Mohammedan worshiper places in the direction of Mecca when he kneels to pray at the prescribed Islamic hours, is perhaps the most distinctive Turkish type. Fig. 2 is a Ghiordes prayer rug with the *mihrab*'s outline enhanced by stylized blossoms. Fig. 3 is a Mudjur prayer rug with bold geometric patterns, including a stylized tree. Other types of prayer rugs often have lamps hanging from the archway or from columns at the sides. Among the various types of Turkish rugs and carpets are: Hereke, Koula, and Oushak.

Caucasian rugs: The bold geometric forms and brilliant primary colors used by Caucasian weavers are particularly popular today among collectors of both antique and modern furniture. The pointed and jagged forms and the heavy pile are directly related to the rugged mountainous terrain of the region and the thick wool of the mountain sheep. Caucasian rugs employ the Ghiordes knot. The illustration opposite shows a fine example of a Kazak rug. Another variation of the Kazak design is found in Fig. 4; Fig. 5 is a Kazak "eagle" rug with a more complicated design. Other typical Caucasian rugs are a Kouba (Fig. 6), with its five medallions within an elaborate border; and the Chichi rug (Fig. 7) woven with stylized flowers and stars, surrounded by the distinctive Chichi border of eight-petal flowers alternating with striped diagonal forms.

Turkestan rugs: As the Yarkand (Fig. 8), Turkestan rugs have designs which derive from both Turkish patterns from the West and Chinese patterns from the East.

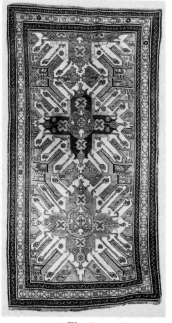

Fig. 5

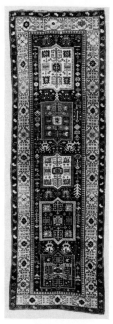

Fig. 6

Fig. 7

Fig. 8

ANATOMY OF A KAZAK RUG
(See Color Plate 19.)

KAZAK—The area where Russia, Turkey, and Iran meet is known as Kazak, though the name itself is thought to have derived from the word "Cossack."

MEDALLIONS—The irregularly outlined blue and green medallions, each having in the center a swastika, the ancient primitive symbol of good luck and happiness, are surrounded by stylized cloud bands.

GUARD BANDS—Narrow rows in geometric patterns, the guard bands separate the outer border from the central field.

FIELD—The brick-red field here is decorated with scattered flowers, birds, and geometric forms.

BORDER—The border design is of a stylized floral pattern.

PILE—The thick pile is tied with Ghiordes knots.

FRINGE—The fringe is of wool (occasionally mixed with goat's hair) at both ends, representing the trimmed selvage of the warp and weft, the framework upon which the carpet knots are tied.

SIZE—The area of a Kazak rug usually ranges from three by five to five by eight feet, and is hardly ever found in larger sizes.

LATCH-HOOK BORDER—Used very widely in Caucasian rugs, this latch-hook border is related to the swastika motif.

Carpets are known to have been made in Continental Europe from the time of the Crusades, but until the beginning of the seventeenth century most carpets in European inventories were imported from Persia, Turkey, or Egypt. Since they were luxury items that only the very rich could afford, their importation was a drain on national economies. In 1605, to encourage native crafts and to stem the outflow of currency, the French king Henry IV installed Pierre Dupont in the Louvre as a carpet manufacturer. Dupont was an amateur weaver who perfected a carpet called *façon du levant,* which was comparable to Near Eastern examples. In 1627 he joined with Simon Lourdet at Savonnerie to start a second royal carpet factory. Savonnerie carpets were made solely for French royal use and were the standard throughout Europe from the inception of the factory through the reign of Napoleon III. The carpets were so fine that they were prized as diplomatic gifts for foreign potentates, such as the Shah of Persia.

The Savonnerie carpet opposite is a fine early example from the period of Louis XIV, showing a full design of rich deep-colored flowers in contrast to the somber *tête de nègre* ground. A carpet of this type was very expensive to make, since the average workman produced only three square yards of carpeting in an entire year. In the past sixteen years the price of such a carpet has jumped from $33,500 to $150,000.

The Aubusson factory was started in France in 1743 to satisfy the demands of the rich nobles who were prohibited by royal decree (as well as by excessive price) from purchasing Savonnerie carpets. Although Aubusson copied the popular pile carpets of the king, they also produced a *tapis ras*—a flat, woven carpet much less expensive to manufacture. Aubusson carpets reflected the tastes of the rococo and the subsequent neoclassic periods.

An example from the beginning of the nineteenth century (Fig. 1) shows an open field with birds and swags in an architectural arrangement woven in bright pastel colors. These carpets were made in large numbers, and because they often were intended for small *appartements* where they complemented the woodwork and furnishings, they remain popular today. Another carpet manufactured about forty years later (Fig. 3) shows the change in fashion during the reign of Louis Philippe. The colors are much more vivid and the pattern is fuller and livelier, anticipating the heavy, ornate designs of the second half of the nineteenth century.

There were other carpet centers in France, the most noteworthy being that at the Beauvais Tapestry Factory from 1787 to 1791. Rugs were woven in Spain and Italy, but not in considerable quantity. In Russia, particularly from 1830 to 1914, carpets were woven in several centers

Fig. 1

ANATOMY OF A SAVONNERIE CARPET

SAVONNERIE—The name of this type of carpet is derived from the building in which it was made. This had been acquired by the French crown in 1627 for carpet manufacturing, but before that it had been used to manufacture soap (*savon*).

DESIGN—The design was influenced by Persian carpets, which had elaborate stylized floral patterns, but the inclusion of a central scrollwork cartouche reflects European baroque taste. The baskets of spring flowers at either end were probably inspired by the Flemish still-life paintings so popular at the time.

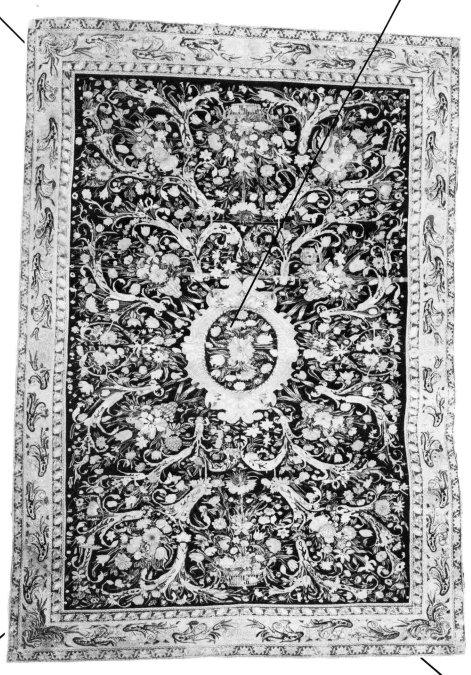

MANUFACTURE—This carpet was woven at the Savonnerie factory in the town of Chaillot c. 1660, under the direction of Simon Lourdet. The factory was entirely owned by the French king, Louis XIV.

RARITY—Pile carpets imitating Near-Eastern imports were the specialty of the Savonnerie factory. Only a limited number were made, all to royal commissions for French palaces and chapels. They were woven of the finest wools and silks. The pile was luxurious, sometimes reaching the height of one centimeter.

for wealthy landowners. Many of these carpets, recognizable by their colorful floral motifs, are now mistakenly called Bessarabian.

England, however, was the main rival to France in the manufacture of floor coverings in Europe. A few carpets had been made in London in the seventeenth century, and toward 1700 disgruntled workmen from the Savonnerie factory came to England. Peter Parisot, who established the first important English carpet factory, was the most famous of these *émigrés*.

An attractive late George III needlework carpet (Fig. 2) was possibly made at Axminster under the direction of

Fig. 2

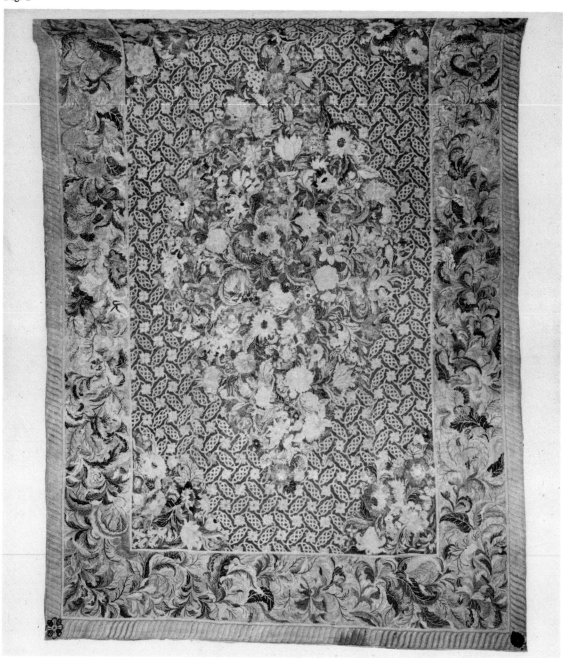

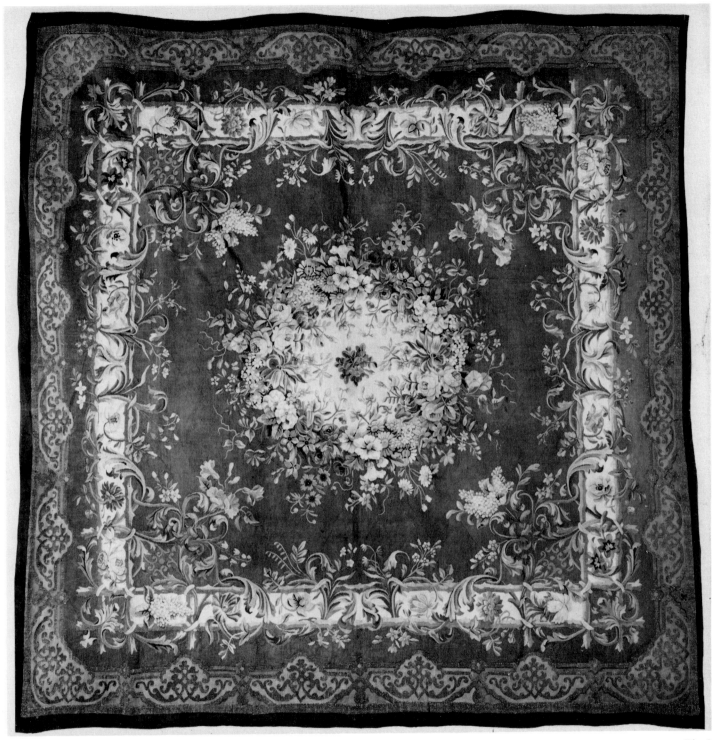

Thomas Whitty. It is not typical, as carpets of that era were usually less exuberant, making use of classical and geometric motifs influenced by the Adam brothers.

At Wilton, carpets were made in great numbers in the Victorian period because of technical advances in machine manufacturing. Strip carpeting could be made economically for wide distribution, and competition was felt from French factories using the Jacquard looms, weaving *tapis cloué*. These were predecessors of today's fitted carpeting.

189

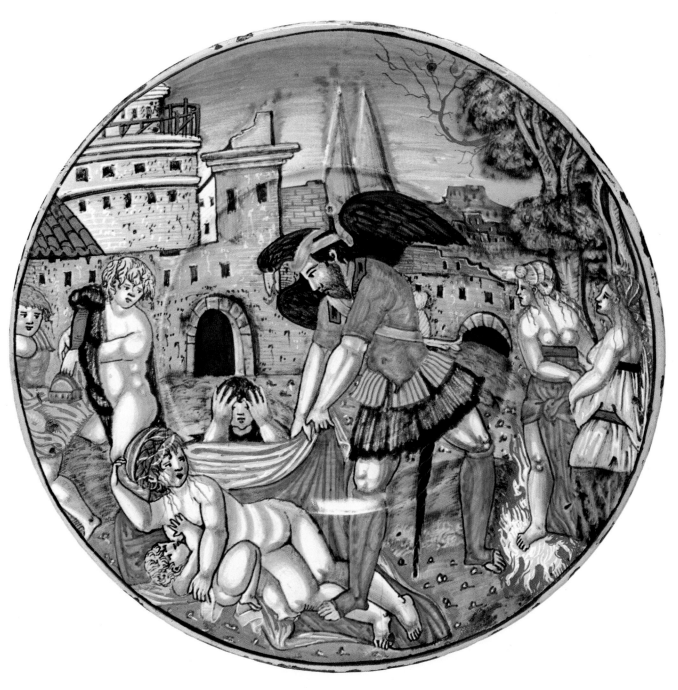

Plate 2 Majolica dish depicting Emperor Charles V, dated 1533.

Plate 3 Limoges Enamel panel, sixteenth century. (See also page 29.)

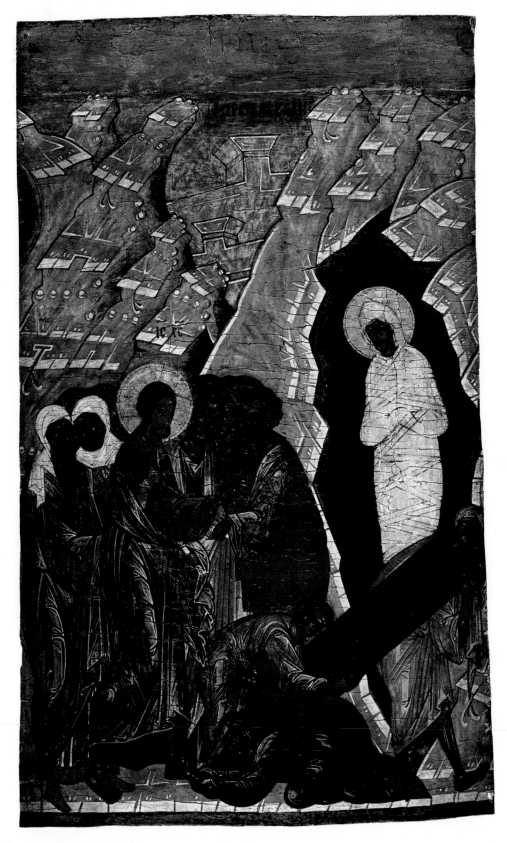

Plate 1 Russian icon of *The Raising of Lazarus,* Novgorod School, second half of the fifteenth century.

COLOR PLATES

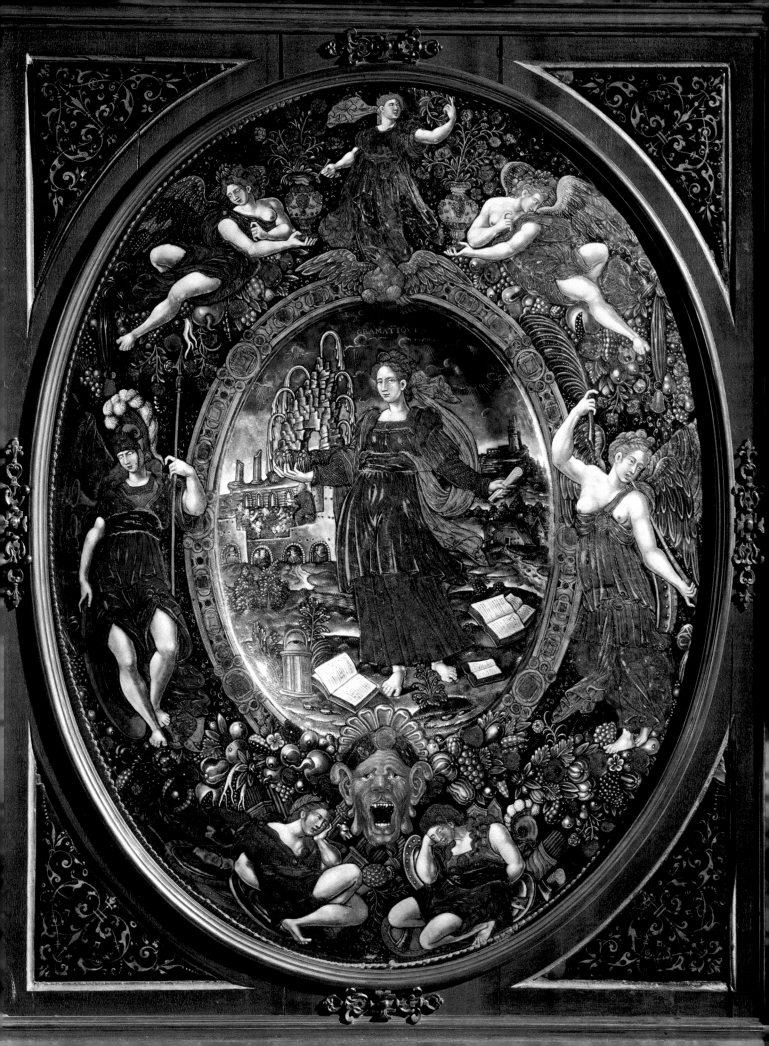

GRAMATIQVE

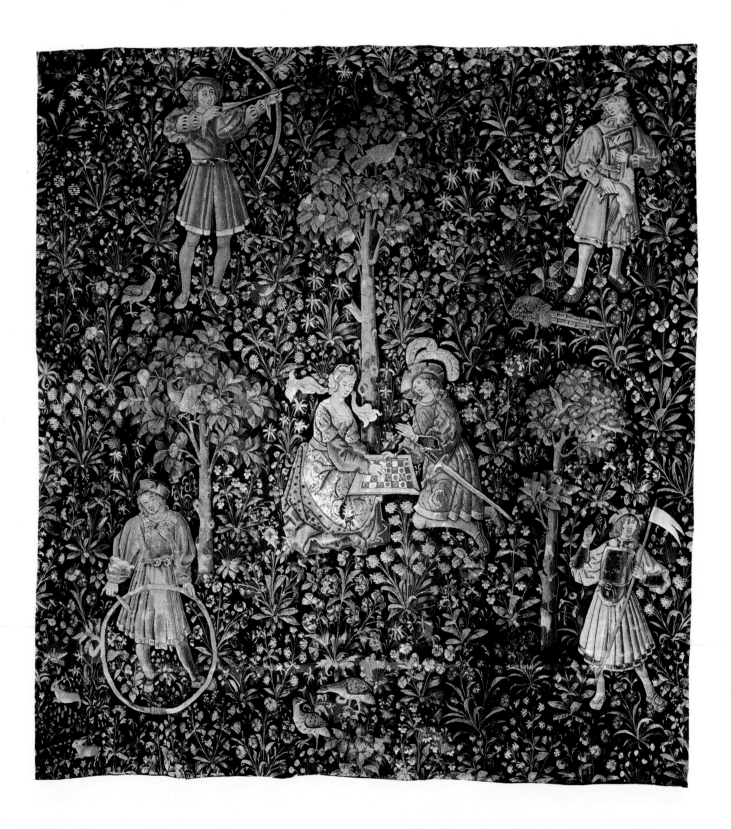

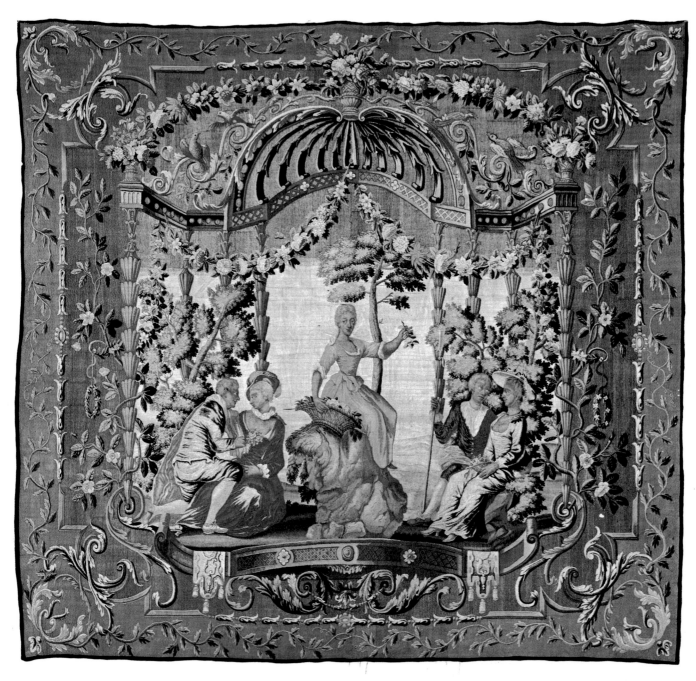

Plate 5 Berlin tapestry, eighteenth century.

Plate 4 Gobelins tapestry suite, eighteenth century. (See also page 179.)

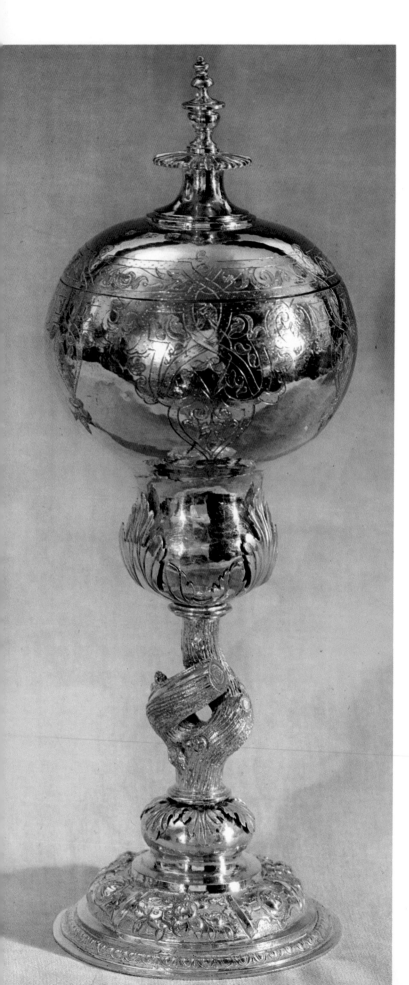

Plate 6 English silver-gilt covered cup, sixteenth century. (See also page 53.)

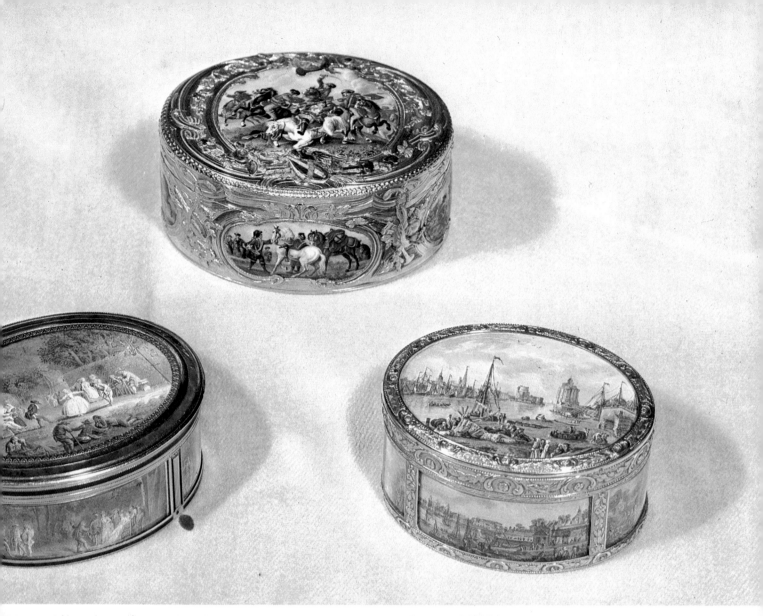

Plate 7 French gold snuffboxes, eighteenth century. (See also page 43.)

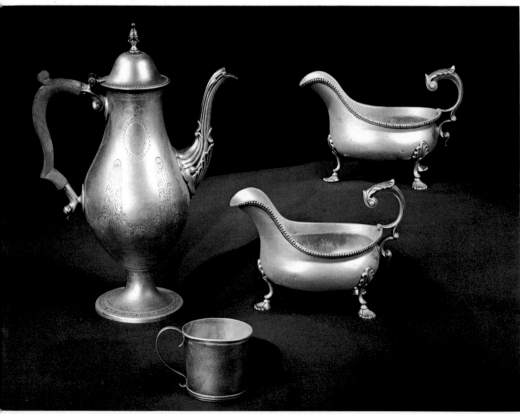

Plate 8 American silver coffee pot, cup, and sauceboats, Paul Revere, Jr., Boston, 1790s.

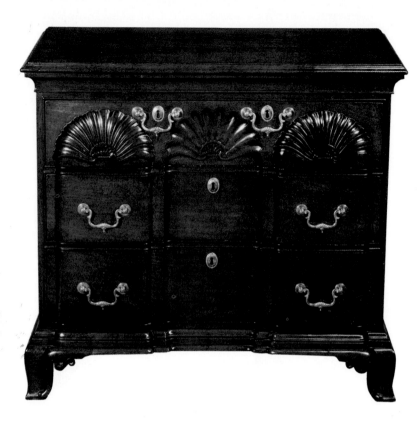

Plate 9 American chest of drawers, c. 1750. (See also page 161.)

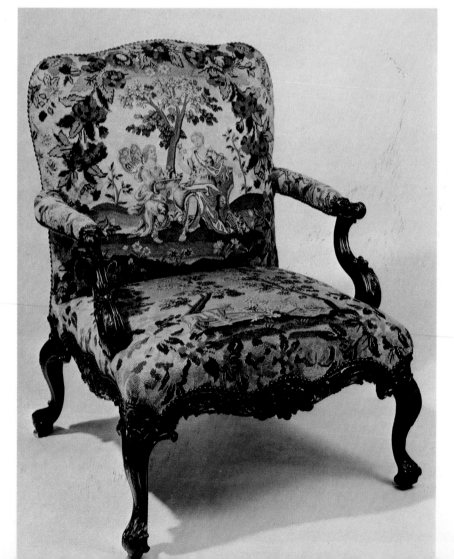

Plate 10 George II chair, second quarter of the eighteenth century.

Plate 11 American highboy, eighteenth century. (See also page 163.)

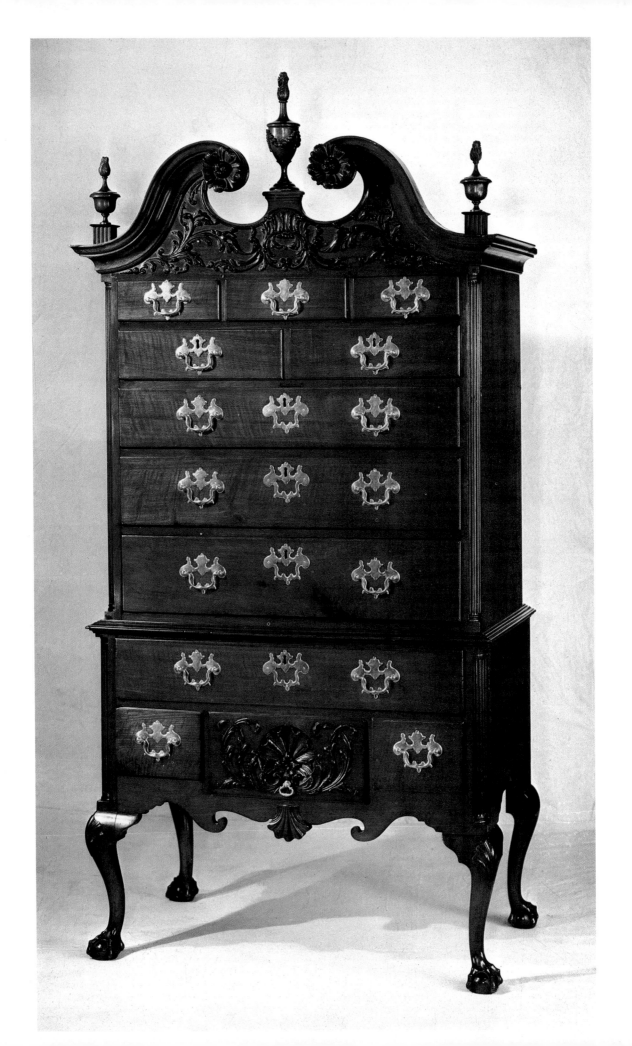

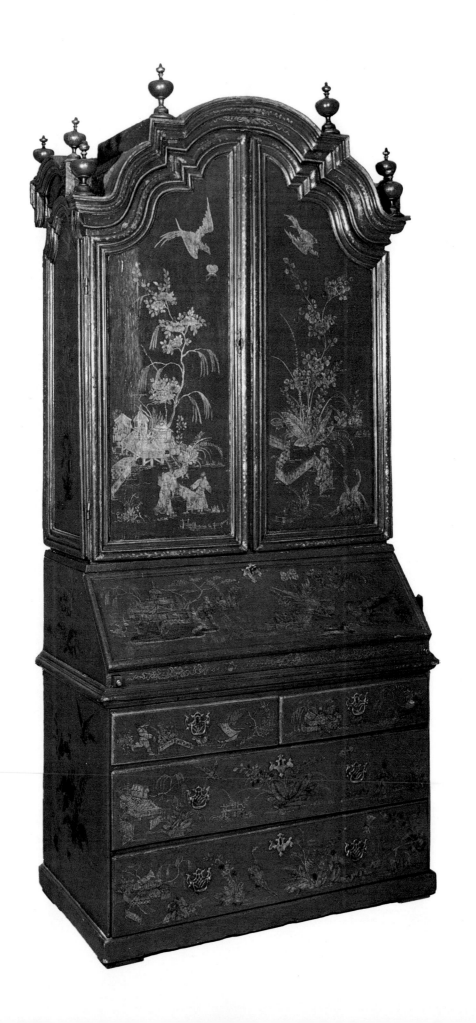

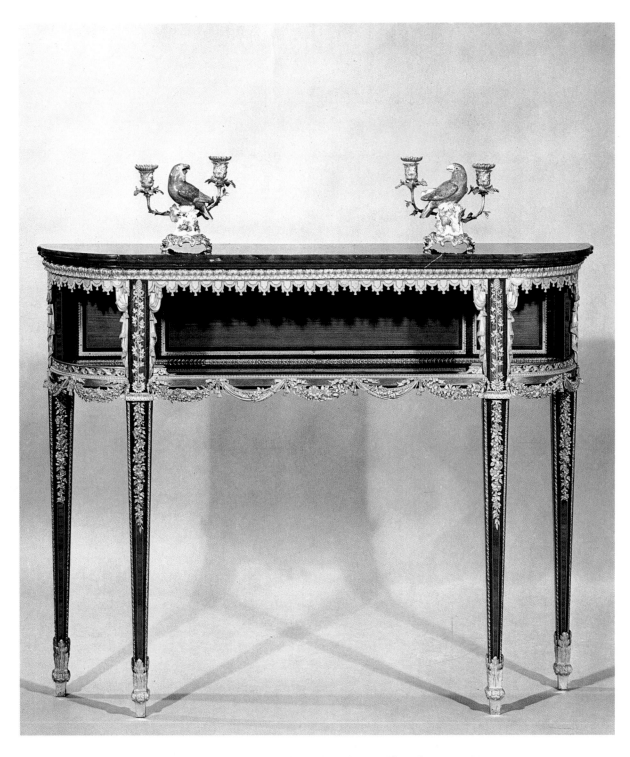

Plate 13 French console, eighteenth century. (See also page 123.)

Plate 12 Italian bureau bookcase, eighteenth century. (See also
page 133.)

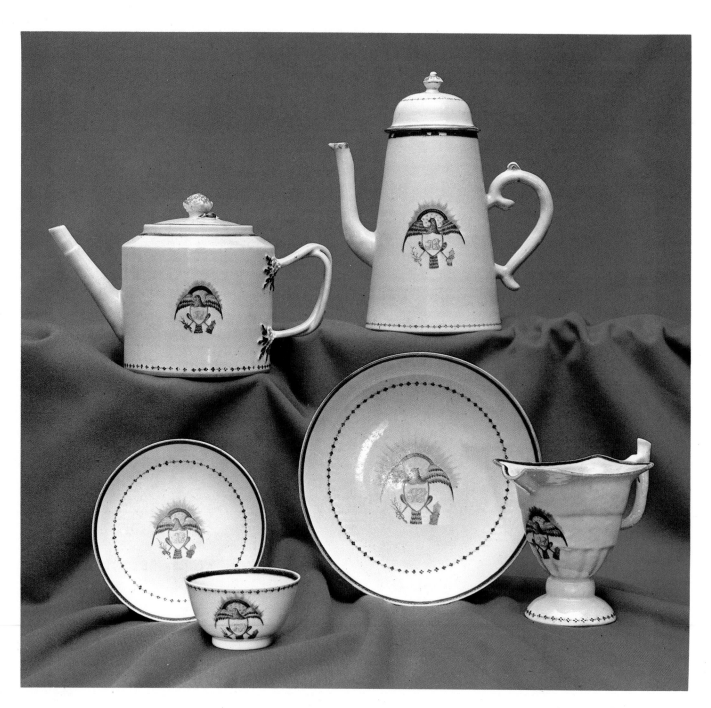

Plate 14 Chinese export part-tea and part-coffee service made for the American market, 1790–1810.

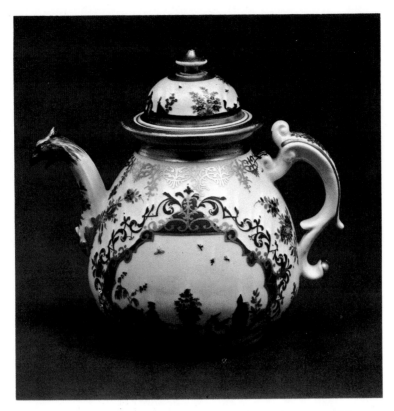

Plate 15 Meissen teapot, c. 1724. (See also page 87.)

Plate 16 Chelsea soup tureen, Red Anchor period (1753–1758.)

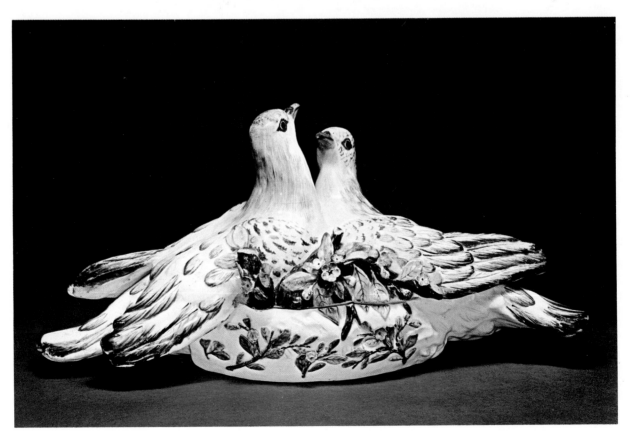

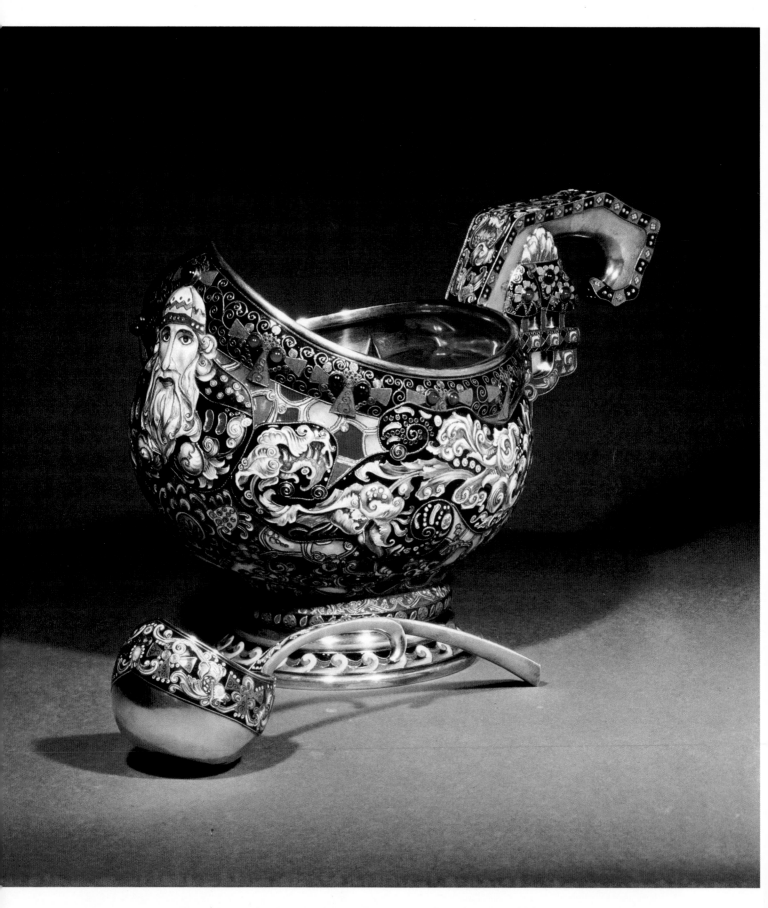

Plate 17 Russian *kovsh,* nineteenth century. (See also page 41.)

Plate 18 Fabergé goblet, nineteenth century. (See also page 45.)

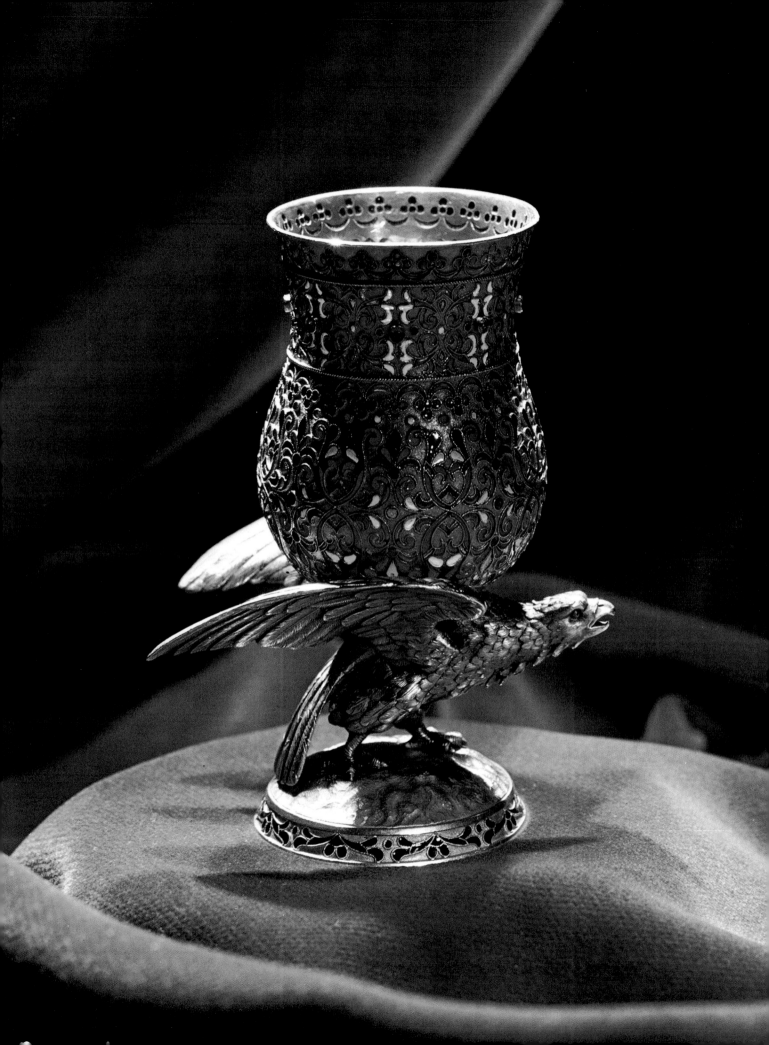

Plate 19 Kazak rug. (See also page 185.)